Puppets, Masks, and Performing Objects

TDR Books

Richard Schechner, series editor

Puppets, Masks, and Performing Objects, edited by John Bell
Experimental Sound & Radio, edited by Allen S. Weiss

Puppets, Masks, and Performing Objects

Edited by John Bell

A TDR Book

The MIT Press

Cambridge, Massachusetts

London, England

Library of Congress Cataloging-in-Publication Data

Puppets, masks, and performing objects / edited by John Bell.
 p. cm.—(TDR Books)
A TDR book.
Originally published as Drama review, v. 43, no. 3 (Fall 1999).
Includes bibliographical references and index.
Contents: Puppets, masks, and performing objects at the end of the century / John Bell — A puppet tree : a model for the field of puppet theatre / Stephen Kaplin — Julie Taymor / [interviewed by] Richard Schechner — What, at the end of this century, is the situation of puppets & performing objects? / Peter Schumann — The end of Our Domestic Resurrection Circus : bread and puppet theater and counterculture performance in the 1990s / John Bell — Performing the intelligent machine : deception and enchantment in the life of the automation chess player / Mark Sussman — Czech puppet theatre and Russian folk theatre / Pyotr Bogatyrev — Modicut Puppet Theatre : modernism, satire, and Yiddish culture / Edward Portnoy — Articulations : the history of all things / Theodora Skiptares — If Gandhi could fly — : dilemmas and directions in shadow puppetry in India / Salil Singh — Rediscovering mask performance in Peru : Gustavo Boada, maskmaker with Yuyachkani : an interview / with John Bell — The art of puppetry in the age of media production / Steve Tillis.
ISBN 978-0-262-52293-9 (pbk. : alk. paper)
1. Puppet theater. 2. Masks. I. Bell, John.
PN1972.P78 2000

791.5'3—dc21 00-063827

10 9 8 7 6

Contents

Entertainment, Spectacle, Crime

Puppetry in the Year 2000

John Bell

What reaches people? What power do live puppets have that video can't mimic or counter? Is it possible to make live performance somehow stronger than that fed to us by television, film, video, and the Internet? Is it possible that, in fact, it is very easy to make such performance, particularly with puppets?

Working with Outmoded Forms

This past June, the mother of one of the students in my New York University puppet workshop asks me "What is it like to work in such an outmoded form?" I briefly attempt to explain the current puppet renaissance to her, and the proliferation of puppet forms all over the place—television, film, avant-garde theater, the Henson International Festivals of Puppet Theater, political demonstrations, and advertising—but I sense that these have all somehow fallen below her cultural radar, perhaps invisible to a sensibility stuck on defining the form as only marionettes or handpuppets.

An African-American acting student in the class says he wants to study puppet theater because on Broadway, "truthfully speaking, the only parts open to me might be in *The Lion King*."

A few months earlier the head of NYU's undergraduate theater studios has rejected a proposal to make puppet theater a regular part of the program's offerings. "I don't know why our students would be interested in this," he says.

Puppets and World's Fair Spectacle

Later in the summer, I spend five weeks working with Bread and Puppet Theater at Expo 2000, the five-month-long world's fair in Hannover, Germany. Almost all of the exhibitions there are object performances, but the objects are for the most part video screens, computers, and sound systems. We seem to be the only participants fully engaged in the old art of puppetry, and certainly the only ones engaged in a critique of globalization and twenty-first-century capitalism.

World's fair spectacle a hundred years ago featured—or depended on—nonmechanical puppet and object performance. Miguel Utrillo, fresh from his shadow theater experience at Le Chat Noir cabaret in Paris, performed shadow puppet shows with Les Ombres Parisiennes at the Chicago World's Fair of 1893. The spellbinding American dancer Loie Fuller had her own pavilion at the 1900

Paris Universal Exhibition, where she created performances focused on yards of flowing cloth and a new invention: directed, colored theatrical lighting.

Over the century, such spectacle performance made increasing use of innovations in the means of mechanical reproduction of image and sound. Remo Bufano worked the 1939 New York World's Fair at the Hall of Pharmacy, performing a giant puppet spectacle, *From Sorcery to Science*, which incorporated an original score by Aaron Copland in one of the first recorded soundtracks for a live puppet show. In fact, the 1939 World's Fair employed most of the puppeteers in New York City in a wide variety of shows, but also used performers who operated pseudorobots (like Elektro, the Westinghouse Moto-Man), futuristic automata, and mechanized displays of hoped-for modernistic opulence.

At the 1958 Brussels World's Fair, stunning innovations were unveiled by Josef Svoboda's Laterna Magika company from Prague, which combined film, slide projections, recorded sound, and live actors and dancers in performances that announced the dawn of a new genre in search of a name: multimedia performance. At the 1965 World's Fair in New York Bil Baird made a chorus line of leggy engine-block marionettes (the Motor Blockettes) to animate the Chrysler Pavilion, but the trend toward automated displays with no performers present was making traditional marionette theater seem old fashioned and quaint, even if the puppets themselves represented machines.

Puppets at Expo 2000

Thirty-five years later, in the new century, puppeteers are a distinct minority at the Hannover World's Fair. The most dominant image there—which captures perfectly the spirit of Expo 2000—is the Deutsche Telekom corporation's giant outdoor video screen. Twice as big as the screens I've seen at Times Square, it faces a huge staircase connecting the two halves of the Expo fairgrounds. German fairgoers leave off their television watching at home and come to Expo and see Teletubbies, Pink Panther cartoons, Whitney Houston music videos, air disasters, fashion shows, and sporting events on the sixty-foot-square screen: Yes! television watching as giant participatory spectacle befitting the magnificent scale of a great international event!

Bread and Puppet's *Paper-Maché Cathedral of the Seven Basic Needs* is a notable contrast to this. It is comprised of hundreds of Peter Schumann's puppets, masks, banners, texts, and other objects, arrayed and animated on seven different stages by Bread and Puppeteers and German volunteers. Like a huge Dadaist assemblage, it contrasts gigantic human, animal, and nature images with texts by Friedrich Hölderlin, Karl Marx, the *New York Times*, Situationist Alan Bergman, and ex-International Monetary Fund economist Davison Budhoo, as well as traditional East European singing, American Sacred Harp music, and New Orleans brass band tunes. I first see the exhibit after passing through an overload of bombastic techno-futurism featuring metal, glass, and plastic, and I'm simply thankful and relieved to see wood, paper, and cloth the center of focus at the Bread and Puppet exhibit.

We perform shows seven days a week at Expo, and are continually exhausted. Between shows, I rest behind the scenes in a huge backstage shared with other exhibits. Behind the other exhibits there are only video projectors, giant screens, stacks of amplifiers and computers, and miles of electric cable—no human performers. Technicians hide out in little cubicles drinking Coke and monitoring their machines. Prerecorded tape loops play all day throughout the whole building, imbedding their sound effects ("cock-a-doodle-doo!") and repetitive chants ("Hello-o? Hell-ooo!") somewhere in our brains.

Every day at Expo 2000, there is a parade in the center of the fairgrounds, and Bread and Puppet enthusiastically takes part. The parades are different

from the exhibits, because they depend so much on people, not machines alone. It's exciting to make big theater in front of the live crowd, even if the street is not a real street. The organizers have wisely chosen an array of old and new parading forms: German folk dance groups with masks or elaborate *Fasnacht* headdresses; Belgian carnival stilt warriors and multiple obnoxious masked clowns with phallic noses; Portuguese sword dancers; old-fashioned hurdy-gurdy players; Brazilian samba schools; German street theater companies with stilters, jugglers, and funny perambulating machines; the avant-garde stars La Fura dels Baus, a Catalan techno-spectacle theater group parading with a gold Ceres puppet mounted on a black truck, and tossing handfuls of grain on the street; Trigo Limpo, a Portuguese theater group with a twenty-foot-tall yellow tricycle ridden by a giant puppet; the Hannover Star Trek club, seriously costumed as humans, Klingons, and others, and towing a scale model of the spaceship Enterprise; scores of medieval reenactors, equally dressed up and devoted to reliving the Middle Ages, even down to a vigorous evocation of the Black Plague; Berlin butoh dancers on stilts; brass bands from Pittsburgh and Poland playing Duke Ellington; and finally Bread and Puppet, with its life-size and giant garbagemen and washerwomen, masked animal figures, white birds, stilters, brass band, and a street skit criticizing Globalization and proposing the creation of art out of Expo garbage, which in part, is exactly what Bread and Puppet has done. Audiences take notice because ours is the only parade section in which any kind of dramatic conflict is performed.

Interlude: A Dire Situation in India?

In July, puppeteer Ravi Gopalan Nair has come from Kerala, India to work with Bread and Puppet Theater at Expo. Ravi explains to us how a master of South Indian shadow puppet performance now sometimes plays the traditional six-hour excerpts of the Ramayana to no one except the god Rama himself (similar to the situation Salil Singh describes in this reader). Old audiences and potential new ones can now watch the epic performed by actors on television, instead of by live puppeteers. Ravi is clearly intrigued by the idea of a puppet performance appreciated only by a god, as if this intensity made up for the alarming lack of human spectators.

Twenty-First Century Puppet Activism

Also in July, Hannover political activists, expressing a local discontent with Expo's effect on the city, as well as a general mistrust of the blithe future-by-corporate-globalization promoted everywhere at Expo, make a demonstration just outside the fairground gates, with the help of Bread and Puppeteers Clare Dolan and Ben Majchrzak. The giant puppet they make, and the Bread and Puppet banners used in the protest, are precisely the elements which make the demonstration spectacular.

Back in the U.S., at the end of the month, Bread and Puppet member Jason Norris and his Insurrection Landscapers go to Philadelphia to join other artist-activists gathering there to protest the focus of the Republican presidential convention—an extension of protests against the World Trade Organization and International Monetary Fund in Seattle the previous fall.

At Expo I read the *International Herald Tribune*'s coverage of the convention. An article about street protests there describes them as quaint, nostalgic, and of course ultimately ineffective and futile throwbacks to the sixties. This reminds me of *New York Times* writer Thomas Friedman's similar consternation about the WTO protests in Seattle: street demonstrations with puppets are *so* outmoded—these days all you really need is a good web site to get your message across.

Back in Philadelphia, Norris and other puppeteers conduct a week-long open workshop in puppet building and political street theater, which is infiltrated by undercover Philadelphia police posing as union members and serving as *agents provocateurs*. The City of Philadelphia is clearly wary of the kind of puppet street performances that made the Seattle protests a worldwide spectacle, and on the afternoon of August 1, 180 Philadelphia police officers without a search warrant surround the puppet workshop and arrest all those inside, including Norris. The three hundred puppets and one hundred banners the puppeteers had just completed are smashed in a trash compactor—a pre-emptive strike against political puppet spectacle. The puppeteers' sense of political activism is consequently heightened; they call themselves "puppetistas," and invent a new slogan: "Puppetry is not a crime!"

How is it that this outmoded art could be so threatening to the State in the year 2000?

Old Art in a New Century

In considering these events of the past summer, I think of all I learned in long, fascinating discussions two years ago with Bernice Silver, the vivacious and spirited puppeteer who, during the Depression, had become part of a radical political street theater group in New York City called Theater Advance. Bernice tells me of a street show she performed throughout the city in the mid-thirties: an agitprop piece denouncing Mussolini, Hitler, and William Randolph Hearst's tacit support of them through his control of the press. I realize the show was a *cantastoria*, or picture performance, one of the oldest forms of performing object theater in the world.

In the same city at the same time (1936 to be exact), young Jackson Pollock made giant puppets with Mexican painter David Siquieros in a political art workshop for radical New York City artists. The puppets they made paraded through Union Square as part of communist political demonstrations (but Pollock soon after turned away from socially engaged art to become the first modern art superstar, thanks in part to the splatter painting techniques he had discovered with Siquieros).

In other words, political puppet spectacle has been a consistent part of twentieth-century modernism, not only in the sixties, but throughout the entire century.

Persistent Powers of Paper-Maché

The constantly repeated message at Expo 2000, which simply reiterates what we hear everywhere today, is that new modes of media performance— machines and technology—will define life, progress, and culture in the twenty-first century. Are the insistent messengers right? Puppets in the streets of Hannover, Philadelphia, Seattle, Los Angeles, and New York echo the old gesture of the shadow theater master in India. Does anyone besides Rama and the other gods watch the outmoded forms?

(Yes.)

And if people watch, what do they see and discover from the images created by live puppet theater?

(They see great possibilities of thought and action.)

The question and its answers bother the calm vision of the messengers of corporate global spectacle.

Puppets, Masks, and Performing Objects at the End of the Century

John Bell

What is the situation of masks, puppets, and performing objects at the end of the century? Puppets and masks are central to some of the oldest forms of performance, and "performing object" is a term used by Frank Proschan to refer to "material images of humans, animals, or spirits that are created, displayed, or manipulated in narrative or dramatic performance" (1983:4). In the Euro-American tradition, puppets, masks, and objects have always had a strong connection to folk theatre, popular theatre, and religion, but (or perhaps consequently) they have rarely been the subjects of sustained systematic academic attention in this century. The purpose of this volume of the *TDR* book series is to give some attention to performing objects in the hope that more people will be inspired to examine this rich and wide area.

Much writing about puppet, mask, and object theatre is not distinctly defined as such. Instead, it often appears within the various literatures of folklore, anthropology, semiotics, art history, theatre history, drama, and performance studies. For example, Claude Lévi-Strauss wrote about Northwest Coast Indian masks in 1975 not so much to describe what they did in performance (he didn't), but to explain tribal kinship patterns. In his essay, Stephen Kaplin criticizes Scott Cutler Shershow (1995) and Harold B. Segel (1995) for eschewing direct attention to puppets themselves, in favor of a focus on definitions of popular culture or on the puppet as "a literary trope." These criticisms point to something good writing on performing objects needs, whatever its methodology or critical perspective: attention to the objects themselves in performance. The submersion of performing object writing into other disciplines has meant that to a large extent it has been an invisible field. This invisibility—due to a lack of close, unified attention—may have helped protect the field in some ways, but it has also in many cases prevented us from understanding the intense and revelatory connections between performing objects as they have occurred in vastly different times and places. At present, things are changing. It is possible to consider studies of performing objects as a continuing, connected dialogue about different techniques in different cultures: traditional puppet and mask theatres, machine performance, projected images (whether shadow theatre, film, video, or computer graphics), and rituals. This volume seeks to make a contribution to such studies, whose scope I would like to briefly outline.

In Europe, the idea that puppet and mask theatre is a subject worthy of serious theoretical consideration emerged during the period of German romanticism, and is particularly evident in Kleist's quirky and oblique 1810 essay "On the Marionette Theatre" (1918). Then, at the end of the 19th century, new thinking emerged in the suggestive, symbolist-oriented work of E.T.A. Hoffman ([1819–1822] 1946), Oscar Wilde (1909), Alfred Jarry (1965), W.B. Yeats (1921), and, above all, Edward Gordon Craig (1908, 1911, 1908–1929, 1918). The meaning of objects in philosophical, social, and psychological theory also covers a wide range, from Marx in *Capital* writing about the commodity as fetish object ([1867] 1972) to Merleau-Ponty's consideration of subject-object relations (1994), Heidegger's sense of "thingness" (1971), and Winnicott's "transitional object" (1971). Their thinking suggests the ways in which theories of objects can take us far (or not so far) from the modest predicament of the puppet or mask.

In the early decades of the 20th century, avantgarde practitioners such as F.T. Marinetti ([1909] 1986), Wassily Kandinsky ([1912] 1982), Fernand Léger ([1913–1925] 1973), André Breton ([1935] 1969), and Oskar Schlemmer ([1925] 1961) valorized the performing object in three new ways: as an important link between European and non-European ritual performance; as a central aspect of traditional popular theatre with contemporary experimental possibilities; and, in a particularly new manner, as the central focus of what Léger called "machine aesthetics" (see also Rischbeiter 1974; Plassard 1992). These practitioners' theories frequently took the form of manifestos, a way of proclaiming that the essay by Peter Schumann continues (see also Schumann 1991).

In Russia, futurist and constructivist interests in redefining art in terms of social and political functions coincided with the semiotic, structuralist analyses of the Moscow Linguistic School, fostering Pyotr Bogatyrev's 1923 "Czech Puppet Theatre and Russian Folk Theatre," translated into English for the first time on these pages. Bogatyrev's essay was the first effort in a sustained body of critical writing about puppets, masks, and objects in the 20th century. Following Bogatryev came writings by other members of the Prague School, including Jiří Veltruský ([1914] 1964, 1983), Jindřich Honzl ([1945–1947] 1982), collected in Ladislav Matejka and Irwin R. Titunik (1986). In 1983 Frank Proschan edited a special issue of *Semiotica*, collecting important examples of these writings and connecting them to later theoretical studies. However, poststructuralist theory by and large ignored performing objects in favor of the predicament of the text and the body. There were some exceptions, such as Barthes's essay on bunraku (1977). Besides Proschan, Henryk Jurkowski (1988, 1996) has served as a bridge from Prague School object theories to more recent analyses of performing objects such as those by Michael Meschke (1992), Scott Cutler Shershow (1995), Ana Maria Amaral (1997), Dina Sherzer and Joel Sherzer (1987), myself (1996a), and Steve Tillis (1992) who in his essay in this volume pays particular attention to the object in cyberspace. Also in this *TDR* Reader, Stephen Kaplin attempts to unify the field, from masks to computer images, with a paradigm based on the distance between performer(s) and the object(s) they are manipulating.

In the early 19th century, the romantic movement's attention to popular culture *forced* it to analyze puppet and mask theatre, and the same imperative forced the newly minted fields of folklore and anthropology to examine performing objects. Thomas Sharp's 1825 *Dissertation on the Pageants Anciently Performed at Coventry* (as well as Fairholt 1859) dealt with the giant puppets used in medieval theatre. In 1852 Charles Magnin made the first attempt at an inclusive history of European puppet theatre, and in 1902 Richard Pischel made one of the first attempts to find the roots of European puppet performance in

Asian forms. The wide scope of Magnin's initial effort was followed by specific studies of puppet and mask history in different European countries.

For example, at regular intervals since 1900, commedia dell'arte mask theatre has been recognized as an integral European performance tradition (Miklachevski 1914, Duchartre [1929] 1966, Bragaglia 1943 and 1953, Nicoll 1963a, Rudlin 1994). George Speaight ([1955] 1990, 1969, 1970) has chronicled English puppet traditions, especially the handpuppet character Punch. Paul Fournel (1981) has chronicled France's Guignol, and Catriona Kelly (1990) and Russell Zguta (1978), the Russian character Petrushka. A rich variety of writers—Gaston Baty (1942), Mathilde Camacho (1939), Armond Fields (1993), Julia Bloch Frey (1977), Daniel Gerould (1981), John Houchin (1984), René Meurant (1967), and Reginald S. Sibbald (1936)—have covered particular aspects of French puppet theatre. Francis George Very (1957) and J.E. Varey (1995) have documented Spanish puppet theatre. Hans Richard Purschke (1983), Wolfgang Till (1986), Manfred Wegner (1989), and Reinhard Valenta (1991), have studied German forms. Antonio Pasqualino (1975), Italian futurist Anton Giulio Bragaglia (1947), and even Eric Bentley (1953) have studied specific puppet or mask theatres of Italy. Nina Efimova (1935), Sergei Obratsov (1950), James R. von Geldern (1987), and Vladimir Tolstoy, et al. (1990) have looked at particular puppet forms in Russia. Folklorists such as Léopold Schmidt (1972) and Joan Sheffler (1984) have studied the persistent mask and puppet rituals of central and eastern Europe. Other writers have attempted to trace particular forms across Europe and the entire world (Alford 1978, Boehn [1929] 1972, Böhmer 1977, Drux 1986, Gilles 1993, Segel 1995, Smith 1984, Sorell 1973, Taube 1995, Macgowan and Ross 1923), or to consider all puppet history as a unified field (Jurkowski 1996, Baird 1973, Kipsch 1992, Malkin 1977, UNIMA 1967). The latest such efforts are John McCormick and Bennie Pratasik's study of 19th-century European puppet theatre (1998), and Didier Plassard's anthology of writings on puppet theatre (1996). The Centre National de Recherche Scientifique has been particularly consistent in its attention to puppet and mask history (Bablet 1985, Corvin n.d., and Lista 1989), as has the Institut Internationale de la Marionette in Charleville-Mézières, France. Other historical studies have continued the work of Frederick W. Fairholt (1859) and Thomas Sharp (1825) by looking at the historical use of puppets, masks, and objects in medieval, Greek, and Roman theatre (Wiles 1993, Nicoll 1963a, Prosperi 1982, Twycross and Carpenter 1981).

The history of puppet and mask performance in the Americas is a complicated mix of Native American, European, African, and Asian performance styles, which all, in one way or another, use masks, puppets, and other objects. In 1883 Daniel Brinton described and analyzed the *Güegüence* mask and puppet dances of Nicaragua (1969) and in 1903 Jesse Walter Fewkes did the same with Hopi mask and puppet performance (1985). Both Brinton and Fewkes were bound to European theatre traditions—the French comédie-ballet and Greek tragedy respectively—as analytical models for these very different performing object forms. This put them in a situation similar to that of Lévi-Strauss a few decades later. More recent studies (Cordry 1980, Geertz and Lomatuway'ma 1987, Vidal 1983, Amaral 1994, Barreiro and Guijosa 1997, Nunley and Bettelheim 1988) have analyzed such indigenous and popular performance forms without justifying them in terms of European traditions. The interview with Gustavo Boada of Yuyachkani in this *TDR* Reader underlines the particular debt of one of Peru's most important theatre groups to indigenous traditions.

In 1969 Paul McPharlin and Marjorie Batchelder laid the foundation for serious studies of puppet theatre in North America with *The Puppet Theatre in*

America. Bil Baird popularized their approach, extending it around the world in *The Art of the Puppet* (1973). Bauhaus refugee Xanti Schawinsky (1971) analyzed the particular emergence of avantgarde performing object theatre on this continent (which he instigated) at Black Mountain College. More recent studies—such as George Forman Brown's history of the Yale Puppeteers (1980), Stefan Brecht's extensive history of Bread and Puppet Theater (1988), Christopher Finch's study of Jim Henson (1993), and Eileen Blumenthal's analysis of Julie Taymor (1995)—have attended to particular examples of high-culture modern American puppet performance. Studies such as I. Sheldon Posen's 1986 analysis of the Brooklyn *giglio* have examined the continuing importance of urban performing object rituals. In this volume, Edward Portnoy's analysis of the Modicut theatre—a New York Yiddish political puppet theatre of the 1920s and 1930s—furthers our understanding of the complexity, richness, and popularity of puppet theatre and Yiddish culture. In my essay on the life and death of the Bread and Puppet Theater's *Domestic Resurrection Circus* I explain the development of one of that theatre's important contributions to the spectacle economy of the U.S. Richard Schechner's interview with Julie Taymor helps elucidate the development and artistic motivations of the American puppeteer—deeply influenced by her experiences in Indonesia—who has successfully used performing objects on Broadway. Theodora Skipitares's photo essay documents some of her contributions to the extraordinarily rich body of puppet work done by downtown New York theatremakers in the past three decades—a group which includes Taymor, Skipitares, Janie Geiser, Ralph Lee, Roman Paska, Lee Breuer, Basil Twist, Paul Zaloom, Amy Trompetter, Great Small Works, Hanne Tierney, Robert Anton, Stuart Sherman, Michael Romanyshyn, Jonathan Cross, and Charles Ludlam.

Just as anthropologists and folklorists examining European and American performance forms were forced to write about mask and puppet theatre, so were their counterparts who arrived in Asia on the waves of colonialism. The performance traditions of India, Java, Bali, China, Japan, Korea, Vietnam, and other areas of the continent inspired a huge body of 20th-century literature on Asian mask and puppet forms. This literature is too extensive to attempt to even partially cover here. We must note, however, James R. Brandon's *On Thrones of Gold* (1970), an anthology of Javanese wayang kulit shadow plays, which placed the epic literature of that dramatic form into the center of world theatre studies. Brandon's studies of Southeast Asian (1967) and Japanese theatre forms (1982), in which puppets and masks are central, were also seminal. R.L. Mellema (1954), John Emigh (1996), Richard Schechner (1993), and others have also studied mask and puppet forms of the Indonesian archipelago, and Amin Sweeney (1980) has followed related forms of shadow theatre in Malaysia.

The Euro-American appraisal of Japanese forms has been strong throughout the 20th century. French symbolist playwright Paul Claudel is particularly important in this respect. While in Japan in the 1920s, he sought to analyze Japanese performance aesthetics without basing his assumptions on European models ([1938] 1972). After World War II Donald Keene similarly analyzed the great Japanese noh and bunraku traditions ([1965–1966] 1990). Jane Marie Law's more recent study of Awaji puppet theatre offers an in-depth analysis of a lesser-known Japanese form (1997). At the end of the century such closer analyses are now possible.

In 1961 Russian puppeteer Sergei Obratsov made an anecdotal study of Chinese puppet forms, and Roberta Stalberg (1984) continued this line with a tantalizingly brief history/theory/how-to book. Jacques Pimpaneau's 1977 study of Chinese shadow theatre demonstrates how such work can be highly rigorous and analytical. While Pischel gave an important early and extravagantly orientalist view of Indian puppet theatre as the progenitor of European forms,

numerous studies have since focused on particular Indian puppet and mask the-
atres (Blackburn 1996, Kamath 1995, Ṣarmā 1985, Venu 1990). Salil Singh's es-
say on these pages examines the challenges traditional Indian puppet forms now
face. In the Mediterranean area, the strong Turkish and Greek traditions of
Karagöz and Karaghiozis shadow theatre have been documented by Metin And
(1979), as well as by Stathis Damianakos (1986), who sets that form into a
worldwide context.

Colonialist interests in Africa led to studies of African mask and puppet tra-
ditions—again, an area too vast to cover here. European exhibitions of Afri-
can artifacts had a massive influence on avantgarde performance, for example,
Fernand Léger's 1923 *Création du Monde* with the Ballet Suédois (an intriguing
predecessor to Julie Taymor's *Lion King*). In the latter half of the 20th century,
studies of specific traditions in particular regions (such as Liking 1987 and
Arnoldi 1995) have been complemented by more general examinations of the
role of African masks, puppets, sculptures, and objects in performance (Sieber
and Walker 1987, Thompson 1974, Blier 1995, Liking 1996).

The notion of performing objects can include many performance forms that
are neither puppet- nor mask-centered. Léger analyzed the role of manufac-
tured objects in performance, picking up a historical thread which goes back
to the early history of automata offered by al-Jazari in the 12th century (1974).
In the 1920s Max von Boehn connected the history of automata to that of
puppets (1972), and in this volume Mark Sussman looks at a 19th-century au-
tomaton in a way that reflects our increasing awareness of the central ideo-
logical importance performing machines have had in this century and will
have in the next.

Another form whose importance has only recently emerged is picture per-
formance. Victor H. Mair (1988) links Chinese and Indian performance to
picture performance throughout Asia and Europe—returning, in a way, to
Pischel's search for originary ur-forms. Ulrike Eichler (1975) and Tom
Cheesman (1994) focused on the European history of this form. In an even
more particular study, Sammy McLean (1972) analyzed how picture perfor-
mance influenced the work of Bertolt Brecht. The panorama is a form of pic-
ture performance that, like the automaton, is particularly technical, and often
mechanized. Stephan Oettermann (1997), Dolf Sternberger (1977), and Ralph
Hyde (1988) have chronicled the development of this important precedent to
film and television, and I have analyzed the 19th-century form of American
panorama in terms of its function as political theatre (Bell 1996b). Other 19th-
century performing object forms have been studied by Gunter Böhmer (1971)
and Werner Nekes (1990).

The end of the century has seen an accumulation of resources on puppet,
mask, and performing object theatre. Bibliographies by Gladys Langevin and
Geneviève Leleu-Rouvray (1982, 1993), and by George Miller, Janet Harris,
and William Hannaford (1981) help organize existing research. *The Puppetry
Home Page* performs an ambitious but more limited service on the internet (see
Sage 1997). Under the auspices of the Union Internationale de la Marionette,
Henryk Jurkowski is editing an international encyclopedia of puppet theatre,
which should appear early in the 21st century. In addition, there are now a
number of journals devoted to the study of puppet theatre. *Puck* is published
by the Institut International de la Marionette, James Fisher edits *The Puppetry
Yearbook* from Wabash College, UNIMA-USA recently founded the journal
Puppetry International, *Animation* represents the views of English puppet writers,
and *The Puppetry Journal* has served for most of this century as the voice of the
Puppeteers of America. Educational opportunities in the field have recently
broadened as well. Puppetry schools in Moscow, Bremen, Prague, and
Charleville-Mézières have international reputations. The puppetry program at

the University of Connecticut has trained hundreds of active American puppeteers. And most recently, in 1999 New York puppeteer Janie Geiser began to direct a new puppet program at California Institute of the Arts. The Jim Henson Foundation's biannual series of international puppet theatre festivals in New York City has exposed large audiences to the idea of puppetry as a legitimate performance form.

Puppet, mask, and performing object theatre has deep roots connecting a vast array of contemporary and ancient performance practices. The usefulness of writing about and analyzing these practices, and the theories behind them, will increase our ability to link worldwide traditions with worldwide innovations.

Selected Bibliography

Alford, Violet
1978 *The Hobby Horse and Other Animal Masks.* London: The Merlin Press.

Amaral, Ana Maria
1994 *Teatro de bonecos no Brasil e em São Paulo de 1940 a 1980.* São Paulo: Com-Arte.
1997 *Teatro de animação: da teoria à prática.* São Paulo: Ateliê Editorial.

And, Metin
1979 *Karagöz: Turkish Shadow Theater.* Ankara: Dost.

Arnoldi, Mary Jo
1995 *Playing with Time: Art and Performance in Central Mali.* Bloomington: Indiana University Press.

Bablet, Denis, ed.
1985 *Le Masque: du rite au théâtre.* Paris: Centre National de la Recherche Scientifique.

Baird, Bil
1973 *The Art of the Puppet.* New York: Bonanza.

Barreiro, Juan José, and Marcela Guijosa
1997 *Titeres Mexicanos: memoria y retrato de automatas, fantoches y otros artistas ambulantes.* Mexico City: Roche.

Barthes, Roland
1977 "Lesson in Writing." In *Image-Music-Text,* 170–78. New York: Hill and Wang.

Baty, Gaston
1942 *Trois p'tits tours et puis s'en vont. Les Théâtres forains de marionettes à fils et leur repertoire 1800–1890.* Paris: O. Lieutier.

Bell, John
1996a "Death and Performing Objects." *P-Form* 41 (Fall):16–20.
1996b "The Sioux War Panorama and American Mythic History." *Theatre Journal* 48, 3 (October):279–300.

Bentley, Eric
1953 "South of Eboli." In *In Search of Theatre,* 91–101. New York: Knopf.

Blackburn, Stuart H.
1996 *Inside the Drama-House: Rama Stories and Shadow Puppets in South India.* Berkeley: University of California Press.

Blier, Suzanne Preston
1995 *African Vodun: Art, Psychology, and Power.* Chicago: University of Chicago Press.

Blumenthal, Eileen
1995 *Julie Taymor, Playing with Fire: Theater, Opera, Film.* New York: H.N. Abrams.

Boehn, Max von
1972 [1929] *Puppets and Automata*. Translated by Josephine Nicoll. New York: Dover.

Böhmer, Günter
1971 *Vues d'optiques. Collections du "Puppentheater-Sammlung der Stadt München" et Günter Böhmer*. Paris: Goethe Institute.
1977 *Puppentheater: Figuren und Dokumente aus der Puppentheater-Sammlung der Stadt München*. Munich: Bruckmann.

Bragaglia, Anton Giulio
1943 *La Commedia dell'arte*. Turin: SET.
1947 *Le Maschere romane*. Rome: Colombo.
1953 *Pulcinella*. Rome: G. Casini.

Brandon, James R.
1967 *Theatre in Southeast Asia*. Cambridge, MA: Harvard University Press.
1970 *On Thrones of Gold: Three Javanese Shadow Plays*. Cambridge, MA: Harvard University Press.
1982 *Chushingura: Studies in Kabuki and the Puppet Theater*. Honolulu: University of Hawai'i Press.

Brecht, Stefan
1988 *Peter Schumann's Bread and Puppet Theater*. 2 vols. New York: Routledge.

Breton, André
1969 [1935] "Surrealist Situation of the Object." In *Manifestoes of Surrealism*. Ann Arbor: University of Michigan Press.

Brinton, Daniel
1969 [1883] *The Güegüence: A Comedy Ballet*. New York: AMS Press.

Brown, George Forman
1980 *Small Wonder: The Story of the Yale Puppeteers and the Turnabout Theatre*. Metuchen, NJ: Scarecrow Press.

Camacho, Mathilde
1939 *Judith Gautier, sa vie et son oeuvre*. Paris: Droz.

Cheesman, Tom
1994 *The Shocking Ballad Picture Show: German Popular Literature and Cultural History*. Providence, RI: Berg Publishers.

Claudel, Paul
1972 [1938] "The Japanese Nō Drama." In *Claudel on the Theatre*, edited by Jacques Petit and Jean-Pierre Kempf, 101–08. Coral Gables, FL: University of Miami Press.

Cordry, Donald
1980 *Mexican Masks*. Austin: University of Texas Press.

Corvin, Michel
n.d. *Le Théâtre de recherche entre les deux guerres: Le Laboratoire Art et Action*. Lausanne: La Cité-L'Age d'Homme.

Craig, Edward Gordon
1908 "The Actor and the Übermarionette." *The Mask* 1:3b–16b.
1911 *On the Art of the Theatre*. New York: Theatre Arts Books.

Craig, Edward Gordon, ed.
1908–1929 *The Mask*. Florence, Italy.
1918 *The Marionnette*. Florence, Italy.

Damianakos, Stathis
1986 *Théâtres d'ombres: tradition et modernité*. Paris: Editions L'Harmattan.

Drux, Rudolf, ed.
1986 *Die Lebendige Puppe: Erzählungen aus der Zeit der Romantik*. Frankfurt am Main: Fischer Taschenbuch.

Duchartre, Pierre Louis
1966 [1929] *The Italian Comedy*. New York: Dover.

Efimova, Nina
1935 *Adventures of a Russian Puppet Theatre*. Translated by Elena Micoff. Birmingham, MI: Puppetry Imprints.

Eichler, Ulrike
1975 *Bänkelsang und Moritat*. Stuttgart: Staatsgalerie Stuttgart.

Emigh, John
1996 *Masked Performance*. Philadelphia: University of Pennsylvania Press.

Fairholt, Frederick W.
1859 *Gog and Magog. The Giants in Guildhall*. London: John Camden Hotten.

Fewkes, Jesse Walter
1985 [1903] *Hopi Katchinas*. New York: Dover.

Fields, Armond
1993 *Le Chat Noir: A Montmartre Cabaret and Its Artists in Turn-of-the-Century Paris*. Santa Barbara, CA: Santa Barbara Museum of Art.

Finch, Christopher
1993 *Jim Henson: The Works, the Art, the Magic, the Imagination*. New York: Random House.

Fisher, James, ed.
1995–1998 *The Puppetry Yearbook*. Lewiston, NY: Edwin Mellen Press.

Fournel, Paul
1981 *L'Histoire véritable de Guignol*. Paris: Slatkine.

Frey, Julia Bloch
1977 "Writers and Puppets in Nineteenth Century France: The Study of a Phenomenon." PhD diss., Yale University.

Geertz, Armin W., and Michael Lomatuway'ma
1987 *The Children of Cottonwood: Piety and Ceremonialism in Hopi Indian Puppetry*. Lincoln: University of Nebraska Press.

von Geldern, James R.
1987 "Festivals of the Revolution, 1917–1920: Art and Theater in the Formation of Soviet Culture." PhD diss., Brown University.

Gerould, Daniel
1981 "Henry Monnier and the Erotikon Theatron: The Pornography of Realism." *TDR* 25, 1 (T89):17–24.

Gilles, Annie
1993 *Images de la marionnette dans la litterature: textes écrits ou traduits en français de Cervantes à nos jours*. Charleville-Mézières: Éditions Institut International de la Marionnette.

Heidegger, Martin
1971 "The Thing." In *Poetry, Language, Thought*. Translated by Albert Hofstadter. New York: Harper/Colophon.

Hoffman, E.T.A.
1946 *Tales of Hoffman*. Edited by Christopher Lazare. New York: A.A. Wyn.
[1819–1822]

Honzl, Jindřich
1982 "Ritual and Theater." In *The Prague School: Selected Writings, 1929–1946*,
[1945–1947] edited by Peter Steiner, 135–73. Austin: University of Texas Press.

Houchin, John
1984 "The Origins of the *Cabaret Artistique*." *TDR* 28, 1 (T101):5–14.

Hyde, Ralph
1988 *Panoramania!: The Art and Entertainment of the 'All-Embracing' View*. London: Trefoil.

Jarry, Alfred
1965 *Selected Works of Alfred Jarry*. Edited by Roger Shattuck and Simon Watson Taylor. New York: Grove Press.

al-Jazari, Ibn al-Razzaz
1974 *The Book of Knowledge of Ingenious Mechanical Devices*. Translated by Donald R. Hill. Dordrecht and Boston: D. Reidel.

Jurkowski, Henryk
1988 *Aspects of Puppet Theatre*. Edited by Penny Francis. London: Puppet Center Trust.
1996 *A History of European Puppetry From Its Origins to the End of the 19th Century*. Collaborating Editor, Penny Francis. Lewiston, NY: Edwin Mellen Press.

Kamath, Bhaskar
1995 *Story of Kogga Kamath's Marionettes*. Udupi: Regional Resources Centre for Folk Performing Arts.

Kandinsky, Wassily
1982 [1912] "On Stage Composition." In *Complete Writings on Art*. Edited by Kenneth C. Lindsay and Peter Vergo, 257–65. Boston: G.K. Hall & Co.

Keene, Donald
1990 *Nō and Bunraku: Two Forms of Japanese Theatre*. New York: Columbia University
[1965–1966] Press.

Kelly, Catriona
1990 *Petrushka: The Russian Carnival Puppet Theatre*. Cambridge: Cambridge University Press.

Kipsch, Walter
1992 *Bemerkungen zum Puppenspiel: 1936–1990, eine Auswahl*. Frankfurt am Main: Puppen & Masken.

Kleist, Heinrich von
1918 [1810] "On the Marionnette Theatre," translated by Amadeo Foresti. *The Marionnette* 4:105–13.

Langevin, Gladys, and Geneviève Leleu-Rouvray
1982 *Bibliographie internationale des ouvrages sur la marionnette, 1945–1980*. Charleville-Mézières: Institut International de la Marionnette.
1993 *International Bibliography on Puppetry: English Books 1945–1990*. München: Saur.

Law, Jane Marie
1997 *Puppets of Nostalgia: The Life, Death, and Rebirth of the Japanese Awaji Ningyo Tradition*. Princeton, NJ: Princeton University Press.

Léger, Fernand
1973 *Functions of Painting*. Translated by Alexandra Anderson, edited by Edward F.
[1913–1925] Fry. New York: Viking Press.

Lévi-Strauss, Claude
1982 [1975] *The Way of the Masks*. Translated by Sylvia Modelski. Seattle: University of Washington.

Liking, Werewere
1987 *Marionnettes du Mali*. Paris: NEA-ARHIS.
1996 *African Ritual Theatre: The Power of Um; and, A New Earth*. Translated and edited by Jeanne N. Dingome, et al. San Francisco: International Scholars Publications.

Lista, Giovanni
1989 *La Scène futuriste*. Paris: Éditions du Centre National de la Recherche Scientifique.

Macgowan, Kenneth, and Herman Ross
1923 *Masks and Demons*. New York: Harcourt, Brace and Company.

Magnin, Charles
1852 *Histoire des marionnettes en Europe*. Paris: Michel Lévy Frères.

Mair, Victor H.
1988 *Painting and Performance: Chinese Recitation and Its Indian Genesis*. Honolulu: University of Hawai'i Press.

Malkin, Michael
1977 *Traditional and Folk Puppets of the World*. South Brunswick, NJ: A.S. Barnes.

Marinetti, Filippo T.
1986 [1909] "Futurist Manifesto." In *Futurism and Futurisms*, edited by Pontus Hulten, 514–16. New York: Abbeville Press.

Marx, Karl
1972 [1867] "The Fetishism of Commodities and the Secret Thereof [from *Capital*]." In *The Marx Engels Reader*, edited by Robert C. Tucker, 215–25. New York: Norton.

Matejka, Ladislav, and Irwin R. Titunik, eds.
1986 *Semiotics of Art: Prague School Contributions*. Cambridge, MA: MIT Press.

McCormick, John, and Bennie Pratasik
1998 *Popular Puppet Theatre in Europe, 1800–1914*. Cambridge: Cambridge University Press.

McLean, Sammy
1972 *The Bänkelsang and the Work of Bertolt Brecht*. The Hague: Mouton.

McPharlin, Paul, and Marjorie Batchelder
1969 *The Puppet Theatre in America: a History, 1524–1948*. With a supplement: "Puppets in America Since 1948," by Marjorie Batchelder. Boston: Plays, Inc.

Mellema, R.L.
1954 *Wayang Puppets: Carving, Colouring, and Symbolism*. Amsterdam: Koninklijk Instituut voor de Tropen.

Merleau-Ponty, Maurice
1994 *Phenomenology of Perception*. Translated by Colin Smith. New York: Routledge.

Meschke, Michael
1992 *In Search of Aesthetics for the Puppet Theatre*. In collaboration with Margareta Sorenson. Translation from the Swedish by Susanna Stevens. New Delhi: Indira Gandhi National Centre for the Arts.

Meurant, René
1967 *Contribution a l'étude des géants processionels et de cortege*. Paris: Éditions G.-P. Maisonneuve et Larose.

Miklachevski, Konstantin [Constant Mic]
1914 *La Commedia dell'arte ou le théâtre des comédiens italiens des XVIe, XVIIe et XVIIIe siècles*. Petersburg: Édition N. Boutskovskaïa.

Miller, George B., Jr., Janet Harris, and William E. Hannaford, Jr., eds.
1981 *Puppetry Library: An Annotated Bibliography Based on the Batchelder-McPharlin Collection at the University of New Mexico*. Westport: Greenwood Press.

Nekes, Werner
1990 *Film before Film*. Videorecording. New York: Kino on Video.

Nicoll, Allardyce
1963a *Masks, Mimes and Miracles: Studies in the Popular Theatre*. New York: Cooper Square.
1963b *The World of Harlequin*. Cambridge: Cambridge University Press.

Nunley, John W., and Judith Bettelheim
1988 *Caribbean Festival Arts*. Seattle: University of Washington Press.

Obratsov, Sergei Vladimirovich
1950 *My Profession*. Moscow, Foreign Languages Publishing House.
1961 *The Chinese Puppet Theatre*. Boston: Plays, Inc.

Oettermann, Stephan
1997 *The Panorama: History of a Mass Medium*. Translated by Deborah Schneider.
 New York: Zone Books.

Pasqualino, Antonio
1975 *I Pupi Siciliani*. Palermo Associazione per la conservazione delle tradizioni
 popolari.

Pimpaneau, Jacques
1977 *Des Poupées à l'ombre: le théâtre d'ombres et de poupées en Chine*. Paris: Centre
 de Publication Asie Orientale.

Pischel, Richard
1902 *The Home of the Puppet Play*. Translated by Mildred C. Tawney. London:
 Luzac & Co.

Plassard, Didier
1992 *L'Acteur en effigie: figures de l'homme artificiel dans le théâtre des avant-gardes
 historiques*. Lausanne: Institut International de la Marionette/L'Age
 d'Homme.

Plassard, Didier, ed.
1996 *Les Mains de la lumière: anthologie des écrits sur l'art de la marionnette*.
 Charleville-Mézières: Éditions Institut International de la Marionnette.

Posen, I. Sheldon
1986 "Storing Contexts: The Brooklyn *Giglio* as Folk Art." In *Folk Art and Art
 Worlds*, edited by John Michael Vlach and Simon Bronner, 171–91. Ann Ar-
 bor, MI: UMI Research Press.

Proschan, Frank
1983 "The Semiotic Study of Puppets, Masks, and Performing Objects." *Semiotica*
 47, 1/4:3–46.

Prosperi, Mario
1982 "The Masks of Lipari." *TDR* 26, 4 (T96):25–36.

Purschke, Hans Richard
1983 *Über das Puppenspiel und Seine Geschichte: Querschnitt aus dem Literarischen
 Schaffen des Puppenspiel-Historikers und -Theoretikers*. Frankfurt am Main:
 Puppen & Masken.

Rischbieter, Henning, ed.
1974 *Art and the Stage: Painters and Sculptors Work for the Theater*. New York: Abrams.

Rudlin, John
1994 *Commedia dell'Arte: An Actor's Handbook*. New York: Routledge.

Sage, Rose
1997 *The Puppetry Home Page*. <http://www.sagecraft.com/puppetry/index.html>.

Ṣarmā, M. Nāgabhūshana
1985 *Tolu Bommalat: The Shadow Puppet Theatre of Andhra Pradesh*. New Delhi:
 Sangeet Natak Akademi.

Schawinsky, Xanti
1971 "From Bauhaus to Black Mountain." *TDR* 15, 3a (T51):31–44.

Schechner, Richard
1993 "Wayang Kulit in the Colonial Margin." In *The Future of Ritual*, 184–227.
 New York: Routledge.

Schlemmer, Oskar
1961 [1925] "Man and Art Figure." In *The Theatre of the Bauhaus*, edited by Walter Gropius, 17–48. Middletown, CT: Wesleyan University Press.

Schmidt, Léopold
1972 *Perchtenmasken in Österreich: Carved Custom Masks of the Austrian Alps*. Vienna: Hermann Böhlaus Nachf.

Schumann, Peter
1991 "The Radicality of the Puppet Theater." *TDR* 35, 4 (T132):75–83.

Segel, Harold B.
1995 *Pinocchio's Progeny: Puppets, Marionettes, Automatons and Robots in Modernist and Avant–Garde Drama*. Baltimore: Johns Hopkins University Press.

Sharp, Thomas
1825 *A Dissertation on the Pageants Anciently Performed at Coventry*. Coventry: Merridew and Sons.

Sheffler, Joan
1984 "Mask Rituals of Bulgaria: The Pernik Festival, 1980." In *Papers for the V. Congress of Southeast European Studies*, 338–61. Columbus, OH: Slavica for the U.S. National Committee of AIESEE.

Shershow, Scott Cutler
1995 *Puppets and "Popular" Culture*. Ithaca, NY: Cornell University Press.

Sherzer, Dina, and Joel Sherzer, eds.
1987 *Humor and Comedy in Puppetry: Celebration in Popular Culture*. Bowling Green, OH: Bowling Green State University Popular Press.

Sibbald, Reginald S.
1936 *Marionettes in the North of France: A Dissertation*. Philadelphia: University of Pennsylvania Press.

Sieber, Roy, and Roslyn Adele Walker
1987 *African Art in the Cycle of Life*. Washington, DC: Smithsonian Press.

Smith, Susan Harris
1984 *Masks in Modern Drama*. Berkeley: University of California Press.

Sorell, Walter
1973 *The Other Face: The Mask in the Arts*. Indianapolis, IN: Bobbs-Merrill.

Speaight, George
1969 *The History of the English Toy Theatre*. London: Studio Vista.
1970 *Punch and Judy, A History*. Boston: Plays, Inc.
1990 [1955] *The History of the English Puppet Theatre*. Carbondale: Southern Illinois University Press.

Stalberg, Roberta
1984 *China's Puppets*. San Francisco: China Books.

Sternberger, Dolf
1977 *Panoramas of the Nineteenth Century*. Translated by Joachim Neugroschel. New York: Urizen.

Sweeney, Amin
1980 *Malay Shadow Puppets: The Wayang Siam of Kelantan*. London: British Museum Publications.

Taube, Gerd
1995 *Puppenspiel als Kulturhistorisches Phänomen: Vorstudien zu einer "Sozial-und Kulturgeschichte des Puppenspiels."* Tübingen: M. Niemeyer.

Thompson, Robert Farris
1974 *African Art in Motion: Icon and Act in the Collection of Katherine Coryton White*. Los Angeles: University of California Press.

Till, Wolfgang
1986 *Puppentheater: Bilder, Figuren, Dokumente*. Munich: C. Wolf und Sohn KG.

Tillis, Steve
1992 *Toward an Aesthetics of the Puppet: Puppetry as a Theatrical Art*. New York: Greenwood Press.

Tolstoy, Vladimir, Irina Bibikova, and Catherine Cooke, eds.
1990 *Street Art of the Revolution: Festivals and Celebrations in Russia 1918–33*. New York: Vendome Press.

Twycross, Meg, and Sarah Carpenter
1981 "Masks in Medieval English Theatre: The Mystery Plays." *Medieval English Theatre* 3:7–44, 69–113. Lancaster: Lancaster University.

UNIMA (Union Internationale de la Marionnette)
1967 *The Puppet Theatre of the Modern World*. Translated by Ewald Osers and Elizabeth Strick. Boston: Plays, Inc.

Valenta, Reinhard
1991 *Franz von Poccis Münchener Kulturrebellion: Alternatives Theater in der Zeit des Bürgerlichen Realismus*. München: W. Ludwig.

Varey, J.E.
1995 *Cartelera de los titeres y otras diversiones populares de Madrid (1758–1840): estudio y documentos*. Madrid: Tamesis.

Veltruský, Jiří
1964 [1914] "Man and Object in the Theatre." In *A Prague School Reader on Esthetics, Literary Structure, and Style*, edited by Paul Garvin. Washington: Georgetown University Press.
1983 "Puppetry and Acting." *Semiotica* 47, 1–4:69–122.

Venu, G.
1990 *Tolpava Koothu: Shadow Puppets of Kerala*. New Delhi: Sangeet Natak Akademi.

Very, Francis George
1957 *Historia de los titeres en España*. Madrid: Revista de Occidente.

Vidal, Teodoro
1983 *Las Caretas de Carton del Carnaval de Ponce*. San Juan: Ediciones Alba.

Wegner, Manfred, ed.
1989 *Die Spiele der Puppe: Beiträge zur Kunst- und Sozialgeschichte des Figurentheaters im 19. und 20. Jahrhundert*. Cologne: Prometh-Verlag.

Wilde, Oscar
1909 "The Truth of Masks." In *The Works of Oscar Wilde*, vol. 9, 193–238. New York: Lamb Publishing Company.

Wiles, David
1993 *The Masks of Menander*. Cambridge: Cambridge University Press.

Winnecott, D.W.
1971 "Transitional Objects and Transitional Phenomena." In *Playing and Reality*. London: Tavistock Publications.

Yeats, W.B.
1921 *Four Plays for Dancers*. New York: Macmillan.

Zguta, Russell
1978 *Russian Minstrels: A History of the Skomorokhi*. Philadelphia: University of Pennsylvania Press.

A Puppet Tree

A Model for the Field of Puppet Theatre

Stephen Kaplin

Over the past several decades, puppet theatre in America has experienced a period of extraordinary growth, cross-cultural miscegenation, and technological advancement. Within this relatively short time, puppetry has been transformed from a marginalized and overlooked genre of children's and folk performance to an integral part of contemporary theatre, film, and television. A whole generation of puppeteers has labored to synthesize stylistic influences from around the planet and to meld emerging technology with traditional forms.

Many factors have contributed to this transformation. But to no small extent it is the activities of the two greatest purveyors of late-20th-century American puppetry, Peter Schumann and Jim Henson, that have revolutionized the field. Their companies, The Bread and Puppet Theater and the Muppets, began about the same time in the early 1960s and have been rocketing off toward diametrically opposite aesthetic poles ever since. Both outfits have produced prodigious volumes of original work that are utterly distinct in style and content, yet both somehow remain faithful to the puppet theatre's populist, egalitarian roots.

Schumann has developed a style of socially and politically conscious visual poetry, rooted deeply in both old European pageantry and folk traditions and the exigencies of cold-war era, avantgarde agitprop performance. The B&P is the first modern puppet theatre in America to aim its work specifically at adult audiences and to open itself to direct community participation. Schumann insists on using the cheapest materials and simplest technical means available to create moving and disturbing performance pieces directly touching upon social issues of the day.

Henson and the Muppets, on the other hand, discovered an affinity between their warm and fuzzy creations and cool television cameras. Their puppets are tailored to reflect the images and concerns of the giant media networks who sponsored them, marketed their images globally, and helped make them into the most recognized puppet characters on the planet. With the vast resources of these corporate enterprises available to them, Henson and company were able to develop new materials and production technologies that have pushed the envelope in the field of puppet animation and special effects.

The widespread influence and popularity of B&P and the Muppets laid the groundwork for directors and auteurs such as Julie Taymor and Lee Breuer, who have in recent years given new impulses and critical exposure to the field. Indeed, Taymor's stage adaptation of Disney's *The Lion King* has proved to be an especially huge cross-over hit—garnering rave critical reviews and adulation

from audiences, some of whom who had never experienced large-scale adult puppet theatre before. Her work, Breuer's, and that of many other artists active in the field today, are a testament to a growing sophistication in the use of puppetry forms on the American stage.

And yet despite decades of popular success and technical advances, scholarly interest in the field has been scant. Repeated trips to the Drama Book Shop in New York City confirm the depressing fact that more books get published yearly on soap operas than on puppetry. There are few puppet scholars in this country and no puppet critics—no coterie of informed insiders to critique and champion new work; there are no regularly published journals in which to disseminate new work and ideas—except those put out by puppetry organizations themselves, such as the Puppeteers of America or UNIMA (the Union International de la Marionette). Nor have there been many attempts by non-puppet-minded theatre scholars to write about puppetry in a way that relates it to human theatre, dance, opera, vaudeville, or performance art.

Two notable exceptions are worth mentioning. Scott Cutler Shershow's *Puppets and "Popular" Culture* is a social history of the puppet as paradigm of popular "sub"-culture in Europe, using puppet performance as a "metaphor for the entwined processes of cultural definition and appropriation" (1995:2). Shershow uses puppet theatre to examine issues of conflict between "high" and "low" and "popular" and "élite" culture, but not as a subject in its own right. Similarly, Harold Segel's *Pinocchio's Progeny* (1995) is a survey of modern dramatic literature seeking evidence of puppetry as a recurring leitmotif. His interest in puppet theatre is primarily as a literary trope exploited by artists in the 20th century to advance the avantgarde. While these books regale us with juicy tidbits of historical research, both approach puppet theatre from without, stressing the distance separating puppets from the mainstream of Western theatre. For insiders, this approach is unsatisfying. Whatever historical conditions contributed to puppetry's isolation in the past have been swept away by a new set of realities.

It is imperative to delineate these realities. What is the puppet's nature? Clearly, it is a signifying figure for the stage, as is an actor. But unlike actors, puppets are objects, defined by Frank Proschan as "material images of humans, animals or spirits that are created, displayed, or manipulated." These material images reflect an "iconicity [...] between a material object (sign vehicle) and the animate being for which it stands" (1983:4). But while actors animate a sign vehicle from the inside out, using their own feelings, bodies, and voices, puppet performers must learn to inhabit the sign vehicle from the outside in. Henryk Jurkowski points to this in his comprehensive definition of puppet theatre as an art in which "the speaking and performing object makes temporal use of physical sources for its vocal and driving powers, which are present beyond the object" (1983:31). The complexities of this relationship and its "constant pulsation" define puppet performance.

By focusing on the dynamic of the puppet/performer relationship instead of fixating on the puppet as an expressive object, Jurkowski points the way. If one focuses on puppets as objects or artifacts, then the best that can be done is to build a system of classification according to means of articulation, materials of construction, place of origin, etc. Edward Gordon Craig did precisely this in 1918 in the pages of his journal, *The Marionette*:

1. Round puppets
 a. Marionettes suspended from above
 b. Guignols or Burattini [hand puppets]
2. Flat puppets
 a. shadow figures (1918:170)

A Key to the Diagram
of Interrelated Performing Object Forms

The following are descriptions of the individual components of the diagram. (Computer imaging by Najma Harisiades)

1. "Kermit the Frog"—star of Jim Henson's Muppets and arguably the most widely recognized puppet character on the planet.

2. "The God Face"—by Peter Schumann. The arrival and setting up of this 25" tall rod puppet marks the beginning of Bread and Puppet's annual *Domestic Resurrection Circus* Pageant performance. It requires eight performers to operate. These two figures represent the two most influential purveyors of late-20th-century American puppet theatre. (Photo by Ron Simon)

3. A Kayon Shadow figure from Indonesian wayang kulit represents the Tree of Life. It is used to indicate act divisions and the start and end of performances. It is also used to represent scenic elements, such as mountains, forests, or palaces. The Kayon is the cosmic ground on which the shadow play is enacted, hence its use here as the body of the "Puppet Tree." (Photo by John Koopman)

4. A Malaysian *dalang*, or puppet master, singlehandedly operates all the characters from the complex narratives, drawn from classical Hindu sources such as the *Mahabharata* and the *Ramayana*. (Photo by Leonard Bezzola)

5. "Mother Earth"—another giant rod figure mounted on a wheeled carriage, from the Bread and Puppet Pageant. This figure engulfs the entire cast of hundreds of performers at the end of the performance, lights the fire that consumes the representation of evil, and then exits the field with everybody in its skirts and arms. Figures 4 and 5 represent the extremes of the dimension of Ratio of performer to object. (Photo by Ron Simon)

6. Sergei Obratzov's love duet strips down the hand puppet to its most essential elements. (Photo courtesy of Stephen Kaplin)

7. A Japanese bunraku puppet and performer, from the highly refined tradition of puppetry. (Photo by Harri Peccinotti)

8. Antique Czech marionettes from *Faust*, from the collection of Vit Horej and "Hurvinek," the famed costar of Josef Skupa's marionette theatre in Prague. (Photo by David Schmidlapp)

9. Stop-action "claymation" figures from the Aardman Studios (makers of Wallace and Grommit) are manipulated in the temporal space between blinks of the film camera's eye. (Photo by Richard Lang)

10. Stop-action dinosaur armature built by Jim Danforth for the movie *Caveman* (1981). Puppet figures such as these had been staples of movie special effects until they were superseded by computer animation figures. (Photo by Jim Danforth)

11. Two mechanical dinosaurs from the movie *Jurassic Park* (1993). The T-Rex operated via a 1/4-scale Waldo, which encoded the movements into a computer that then translated them into motion for the full-scale puppet. The whole rig could be operated by four puppeteers.

12. Virtual puppetry requires new ways of interfacing with the computer-generated environment. These motion-sensor gloves, on the hands of their inventor, James Kramer, allow the wearer to perceive the shape and firmness of virtual objects. (Photo by Thomas Heinser)

13. "Manny Calavera," the star of LucasArts computer adventure game, Grim Fandango, represents the digitalized future of the performing object. (Image by LucasArts)

14. NASA's Martian Sojourner represents the furthest extreme of remote-control manipulation possible with today's technology. (Image by Don Foley)

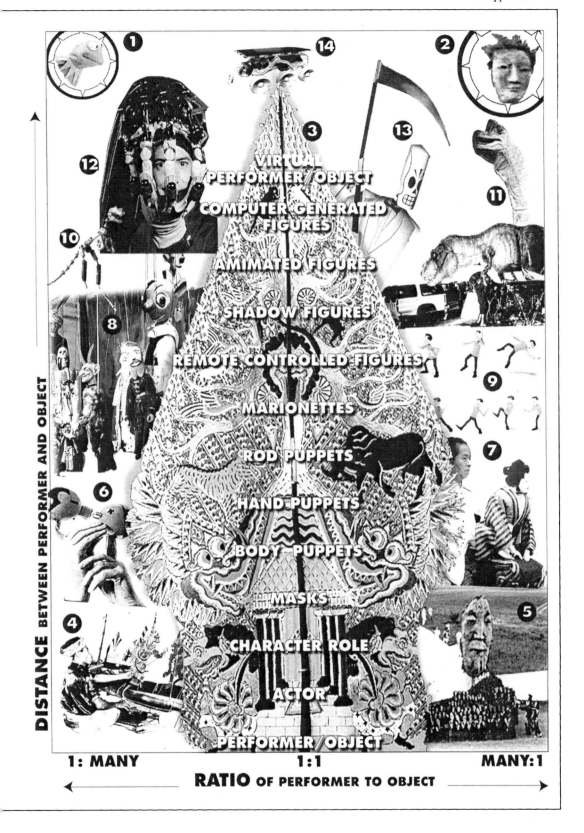

VIRTUAL
PERFORMER/OBJECT

COMPUTER GENERATED
FIGURES

AMIMATED FIGURES

SHADOW FIGURES

REMOTE CONTROLLED FIGURES

MARIONETTES

ROD PUPPETS

HAND PUPPETS

BODY PUPPETS

MASKS

CHARACTER ROLE

ACTOR

PERFORMER/OBJECT

DISTANCE BETWEEN PERFORMER AND OBJECT

1: MANY 1:1 MANY:1

RATIO OF PERFORMER TO OBJECT

Craig further classified puppets according to the "materials from which [they are] made," "costume" and the "country of origin." Issues of taxonomic clarity aside, such systems hardly do justice to today's plethora of new technologies and hybrid styles of puppet theatre. It may be good to distinguish between a Chinese shadow puppet and a Sicilian marionette, but much more remains to be said.

But if the puppet/performer dynamic is taken as the starting point, then a useful new kind of classification system can be constructed. Two quantifiable aspects of this dynamic are distance and ratio. By "distance" I mean the level of separation and contact between the performer and the object being manipulated—beginning at the point of absolute contact (where performer and object are one) and running through psychic, body, remote, and temporal degrees of contact. "Ratio" refers to the number of performing objects in comparison to the numbers of performers. Thus a "1:1" ratio indicates a direct transfer of energy from a single performer to a single performing object. A "1:many" ratio means that one object is the focus of the energies of diverse manipulators, as with Bread and Puppet's giant Mother Earth Puppet, or a Macy's Thanksgiving Day Parade balloon. "Many:1" indicates a single performer manipulating many separate objects, as a Javanese *dalang* does during the course of a *wayang kulit* performance.

I shall use these two aspects of distance as the X and Y axes for plotting the various permutations of the object/performer relationship. The map itself takes the shape of a tree, or more exactly, a *kayon*—the fan-shaped shadow figure of Indonesian wayang kulit performances, made from delicately punctured and carved buffalo hide, that represents the universe in the form of the Cosmic Tree. The kayon is used before and after the performance to frame the play; it also functions as an act curtain and a set unit during the show. The central spine of the kayon is superimposed on the Y axis, representing the degree of distance, beginning at the point of absolute contact and extending upward to the most tenuous degree of remote contact. The X axis measures the ratio—with the left side of the diagram representing many:1 and the right side representing 1:many.

At the point of intersection of the two axes—a zone of absolute contact— no displacement between performer and performed exists at all. But once actors begin to represent themselves onstage (as do Spalding Gray or Annie Sprinkle) a gap begins to open up between the performer and what is being performed—their stage personae. Even if these personae recreate their offstage personalities precisely, it is still a highly edited, crafted, and shaped self that is being savored by the audience. It is this presence of others, the audience, which compels the first split in the unity between performer and performed. At first the displacement is merely a shift in mental calibration to "performance mode." But the psychic distance widens as the performer's role becomes more distinct from the performer. A character role in a play has an objective existence distinct from the actor. Hamlet or Medea is the "object" that becomes embodied in a set of gestures, moves, and utterances enacted by the actor. The role is or becomes autonomous. In some instances, character roles can be flexible, shaping themselves to the impulses and whims of the performers. But in some genres of traditional performance, such as in Chinese opera, roles are tightly defined, with every gesture and expression choreographed, and every detail of facial makeup and costume codified.

At some point, the increasing distance from the performing object means that the actor's own body can no longer physically accommodate the role. Makeup and costume, prosthetic devices, wigs, and body extensions help to a degree, but eventually the performing object reaches the limits of the human body's anatomy and must begin to emerge with a physical presence of its own. This first happens with the mask. A mask is an object totally external to

the performer, a sculptural expression imposed from without. To be effective onstage, it must appear to be articulated from within by the actor's own impulses. It doesn't alter the actor's center of gravity, but it re-contours her surface, while remaining in intimate contact with the flesh beneath its shell.

As long as the mask's features correspond more or less with the actor's own face, the character's center of gravity remains united firmly to the performer's. But a mask doesn't need to be limited to or confined by human physiognomy. It can be oversized, so that the actor peers through the mouth or nostrils (as can be seen in *vejigantes,* the horned demon masks of Puerto Rico, or traditional European Carnival "fathead" characters); or it can be shifted away from the face entirely, to the top of the head, for example (like the lion mask/ headdresses in *The Lion King,* which are modeled on African antecedents). At this point, a new threshold is crossed and the performing object has become detached from the actor's body, developing its own center of gravity, its own structure, its own presence.

It is at this point, where the center of gravity of the performing object and the performer are distinct from each other, that the term "puppet" can be used. But like all the different zones of contact I outline here, the divisions are not sharp. There is a liminal zone where the actor in an oversized mask and the puppeteer in an all-encompassing bodysuit overlap (as in sports team mascots or theme park stroll-about characters). But once the performing object wriggles free from constraints of human anatomy and proportion, there is nothing, beyond the practicalities of engineering, to stop it from drastically morphing in form or scale. It could telescope upward to two or three times human size and be supported from below by a backpack or other frame device, as with Trinidad Carnival *mas*; or it might shrink to less than a foot tall, its center of gravity migrating to a useful human appendage, such as with hand puppets. Once the object is liberated from the body, it no longer needs to have a one-to-one correlation with its power source. A puppeteer can operate two hand puppets simultaneously, while a giant Bread and Puppet–style rod puppet or an elaborate Japanese *bunraku* puppet needs several performers to be properly manipulated.

As the physical distance between the performer and the object widens, the amount of technology needed to bridge the gap increases. Moving the puppet's center of gravity outside the body of the puppeteer requires more and more sophisticated linking systems. Rod puppets use a direct, mechanical linkage to support, lift, torque, and lever the spines and limbs of the puppet figure. One of the simplest rod puppet is the Indonesian *wayang golek*, with a center rod that runs through a T-shaped shoulder block and attaches to the neck of the solid, carved, wooden head, and two thinner rods attached loosely with knotted string to each hand. The puppeteer operates it from below using both hands; if necessary, the arm rods can be held in the same hand as the body rod. One of the most mechanically complex styles of rod puppets is the bunraku puppet, a type that has become more popular in the West in recent years. It is operated from behind, with parts of the body manipulated by several puppeteers. The main operator controls the head through a control grip in the puppet's chest, which is also the locus of separate lever controls for articulating such features as eyes, brows, and mouth. The shoulder block is suspended from cords attached to this center rod to give the puppet maximum articulation of the neck. The same puppeteer controls the right arm with a short rod that is hinged onto the lower arm, or attached solidly to the elbow. Often wrists and even fingers are articulated for greater gestural expressiveness. A second puppeteer controls the left arm, and a third manipulates the feet. If more precise manipulation is required, the operators can slip their fingers into loops in the palms of the puppet's hands to handle and pick up props

directly. Bunraku puppets are notoriously difficult to master, in part because of their complex construction and in part because of the difficulty of melding together the energies of three operators. Even the simple act of walking takes great effort and study to be convincing.

Marionettes use a more tenuous mechanical linkage; they are suspended from above via strings (or in some cases, wires), which means that control of the puppet's limbs is maintained through a precise play of gravity against the shortening and lengthening of the strings in relation to each other. A simple head turn, for example, requires the operation of four strings: two shoulder strings are pulled up slightly to take the weight of the puppet body off the head and free it to drop forward; then two head strings are altered in length by tilting the main control, which pulls one ear or the other upwards and causes the puppet's face to turn in that direction. Every articulation of the body requires additional strings to control. The simplest marionette from Rajastan requires only two: a loop from the top of the puppet's heavy wooden head up to the hand of the performer and then down to the middle of the back, and then another from one puppet hand to the other. A European-style marionette requires 10 or 11, and a Chinese string puppet often has 30 or more.

No matter how attenuated and subtle the control linkages become, rod and marionette puppets still give the operator a linear, mechanical path into the puppet. But as distance between the performing object and its manipulator increases, operating with a direct line of sight becomes untenable. It is possible for puppets to be controlled remotely with hydraulic or radio devices, operating systems that are quite commonly used for film and television special effects. Puppets like the dinosaur heads used in close-up shots in *Jurassic Park* (1993) may be articulated by dozens of separate servo-motors, which can be operated by a team of puppeteers live on the set, or more distantly via computer. As the level of available technology climbs, so does the ability to operate objects at greater and greater removes. And conversely, the greater the distance between object and performer, the greater the level of technology needed to span the gap. In early 1998 television viewers saw an extreme of such long-distance manipulatory feats when they watched a little sand buggy roving around the rocky surface of Mars, beaming back three-dimensional pictures and nibbling at boulders while its crew of operators sat millions of miles away in Houston.

Physical proximity between performing object and performer is only one dimension of the term "distance." There can also be a separation between an object and its image. You can notice this separation if you pull a shadow puppet away from the screen and back toward its light source. When the puppet touches the screen, the silhouetted image cast on the focal plane corresponds exactly to the outlines of the object. But as it pulls away from the screen, the shadow image starts to increase in size and become blurrier. The object performing before the audience's gaze in this case is no longer the puppet held in the puppeteer's hand, but the image of that puppet seen on the focal plane of the shadow screen. If the image is captured by a camera lens instead of a sheet of fabric, then a further distancing is possible: whereas a lamp can illuminate only a few square yards of cloth, the video camera passes the image to millions upon millions of screens simultaneously. The camera also allows a further bifurcation, a temporal schism between object and image that can be exploited by using the techniques of stop-motion animation. These techniques—objects or poseable models manipulated by hand as the camera is advanced frame by frame, giving the illusion of motion to the object—are almost as old as cinema itself. An obvious difficulty is that the animator may spend weeks or months posing and reposing objects to make a moving image that is only a few minutes long. This technique does not encourage spontaneity.

But more recent technical developments in the field of digital imaging and computer-generated imagery (already a staple of film special effects, as evidenced by the dinosaur herds of *Jurassic Park*, the spiffy buff surfaces of *Toy Story* [1997], and the teaming arthropodal swarms of *Antz* [1998]) have made real-time puppet animation quite practical. By using motion capture suits and data-glove interfaces to stream digitized movement data directly into the computer, fantastically realistic motion can be given to virtual objects, or objects scanned digitally from real hard copy. The computer-generated avatar becomes a sort of virtual body mask or diving suit, which allows the actor to inhabit the digital environment. With the motion capture suit, the performer can again achieve a kind of direct contact with the object, performing as though from inside the object. But unfortunately, at this level of technology, the complexity of the systems themselves creates impediments; although the cyber-puppeteer is capable of wondrous feats of real-time animation, a small army of technicians and programmers is required to run the system before he or she can take the first step in a motion-capture suit. And once the digitized actors record their object's movements, a whole other team of specialists must step in to take that data and further massage and render it before it can be finally duplicated in some format that can be shared with others. No wonder at the present time such technology is incredibly expensive, out of reach for anyone lacking access to deep corporate pockets. However, probably in the not-too-distant future such technology will become cheap enough and easy enough to use to be accessible to individuals and smaller production companies. Already something like digital avatars exist for virtual immersion arcade games and for players on video game networks. It is only a matter of time before some enterprising puppeteer converts one for use in a theatrical performance.

References

Craig, Edward Gordon
1918 "The History of Puppets." *The Marionette* 1:171–74.

Jurkowski, Henryk
1983 "Transcodification of the Sign Systems of Puppets." *Semiotica* 47, 1/4:123–46.

Proschan, Frank
1983 "The Semiotic Study of Puppets, Masks and Performing Objects." *Semiotica* 47, 1/4:3–44.

Segel, Harold B.
1995 *Pinocchio's Progeny*. Baltimore, MD: Johns Hopkins University Press.

Shershow, Scott Cutler
1995 *Puppets and "Popular" Culture*. Ithaca, NY: Cornell University Press.

Julie Taymor

From Jacques Lecoq to *The Lion King*

an interview by Richard Schechner

On 19 March 1998 I interviewed Julie Taymor in her studio in Manhattan. At that time, Taymor's production of *The Lion King* was (and still is) enormously successful on Broadway. Taymor's career has spanned continents, venues, and media from Indonesia to off-off-Broadway, from Japan to the New York Shakespeare Festival, from stage to television to film. In fact, when we met, she was busy planning her film of Shakespeare's *Titus Andronicus*. The idea for the film grew out of her 1994 stage version. Shot in Rome and Croatia in 1998 and 1999, the film features Anthony Hopkins as Titus and Jessica Lange as Tamora. It opened in 1999. In the interview, Taymor discussed the whole range of her career—with a focus on her work with masks, puppets, and performing objects.

SCHECHNER: What connection is there between your earlier work—the stuff with Herbert Blau, the years you spent in Indonesia—and work like *The Lion King*, *The Green Bird*, *Fool's Fire*, *Oedipus*, and *Titus Andronicus*? Some people just leave their early work behind.

TAYMOR: No, no, not at all. Quite the opposite. The things that I learned when I was in Lecoq's mime school in Paris at age 16 which had to do with mask work, and then the ideographing work with Herbert Blau have stayed with me. I wasn't interested in being a mime—but I was very intrigued with the use of masks and how the body became a mask. The work at Lecoq's was about getting disciplined with the body. It wasn't just mime. It was work with the neutral mask, character masks, abstract masks.

SCHECHNER: When you say you got connected to your body—I want to explore that because one of the absolutely extraordinary things about *The Lion King*, and about your mask work in general, is the dialogue that takes place between the mask carrier and the mask itself.

TAYMOR: Really what Lecoq is about is that the body is a complete resource you can use to express anything, including emotions—which we're used to doing as actors. But it's not about "acting" sad. What is it about "sad" that makes the body hard or soft? What rhythm does "sadness" have? So your body becomes a tool. Your body's like paintbrushes. It's completely non-characterological at first. You start with the neutral mask. But then there were other ones that I found really inspiring and interesting. How and when can we be a fat person or a thin person? How do we get rid of what we ordinarily

are? What is it about a thin person, what is it about angularity, what is it that makes someone *feel* thin? You should be able to transform your body. That part of Lecoq's work was amazing to me.

Then there was a woman, Madame Citron [Renée Citron, a teacher at Ecole Jacques Lecoq in the early '70s], who introduced me to puppetry, which was also very great because I wasn't really interested in puppets as an art form then. I had played with them as a kid like any kid, but that was it. Madame Citron animated objects, so it was really about mime, about understanding shape, form, and substance. What is air? What is it to *be* air? What is it to be lead, to be heavy? Ice? What *happens* to a thing when something acts upon it? I might want to use a concrete image like a dripping faucet. [Taymor's voice imitates the pace and pitch of a dripping faucet:] To [pause] be [pause] a [pause] drip [pause] ing [pause] fau [pause] cet. What does that make you *feel*?

When Madame Citron would use a broom, you'd think about the shape of a broom and what it *does*, and you'd make it come alive. So we'd have dialogues between bottles and brooms and balloons. It was wonderful. You'd start to really see—to anthropomorphize these things.

SCHECHNER: Yeah. I'm smiling because you say "broom" and I'm immediately thrown back to—

TAYMOR: To Disney!

SCHECHNER and TAYMOR: *Fantasia*! "The Sorcerer's Apprentice!"

1. *Julie Taymor as Tamsen Donner in* The Donner Party *(1974). (Photo courtesy of Julie Taymor)*

TAYMOR: Well, what is animation? It's that you can really put life into inanimate objects. And that's the magic of puppetry. You *know* it's dead and therefore you're giving it a soul, a life.

SCHECHNER: But how can you say that's not characterological?

TAYMOR: It's anthropomorphic. But the stuff with the masks that were abstract wasn't about playing human characters.

SCHECHNER: But what about playing an emotion?

TAYMOR: First, it was just those abstract masks that were rounded, say. Then it was about having the body—purely abstractly—create the same sense of roundness. And when you do that, you feel a certain way. When you put a costume on a person, it makes them *feel* a certain way. So this is pushing that further. Forcing a person to get into a concrete exterior form helps them get out of themselves. That's one of the things about masks.

Another thing we did with Lecoq *before* the masks—remember, I was only 16 at the time—was acting out concepts. Let's say you wanted to act out a landscape with your body. We would create a concept of the landscape. This I've taken with me up till today. That's the way I explore a piece. When I did *Titus Andronicus*, for the first four or five days I didn't have the actors work on characters. I say, "Okay, let's really look at the themes of the piece, and whether it's violence, racism, blah, blah, blah." And then in an extremely abstract way, I have the actors create ideographs. What I find from those things,

Chronology of Works

1974/75 *Way of Snow*, written, directed, and designed by Taymor. Java and Bali. New version, Ark Theatre, New York, and International Puppet Festival, 1980.

1978/79 *Tirai*, written, directed, and designed by Taymor. Java, Sumatra, and Bali. New version, La MaMa E.T.C., New York, 1981.

1980–82 *The Haggadah*, conceived, composed, and directed by Elizabeth Swados. Sets, costumes, masks, and puppetry by Taymor. New York Shakespeare Festival.

1981 *Black Elk Lives*, by Christopher Sergel, based on the novel *Black Elk Speaks*. Directed by Tom Brennan. Sets, masks, and puppetry by Taymor. Entermedia Theatre, New York.

1982 *Savages* by Christopher Hampton. Directed by Jackson Phippin. Masks and puppetry by Taymor. Center Stage, Baltimore, MD.

1984 *The King Stag* by Carlo Gozzi. Directed by Andrei Serban. Costumes, masks, puppetry, and choreography by Taymor. American Repertory Theatre, Cambridge, MA.

1984 *The Transposed Heads*, the play. Adapted by Sidney Goldfarb and Taymor from the novel by Thomas Mann. Direction, puppetry, and masks by Taymor. The Ark Theatre, New York.

1985 *Liberty's Taken*, book by David Suehsdorf and Taymor, music by Elliot Goldenthal. Direction, puppetry, and masks by Taymor. Castle Hill Festival, Ipswich, MA.

1986 *The Transposed Heads*, the musical. Book by Sidney Goldfarb, music by Elliot Goldenthal. Direction, puppetry, and masks by Taymor. American Music Theatre Festival, Philadelphia, and Lincoln Center, New York.

1986 *The Tempest* by Shakespeare. Direction, puppetry, and masks by Taymor. Theatre for a New Audience at Classic Stage Company, New York; Shakespeare Festival Theatre, Stratford, CT, 1987; PBS Television *Behind the Scenes*, 1993/94.

1988 *The Taming of the Shrew* by Shakespeare. Directed by Taymor. Theatre for a New Audience, New York, and Beverly, MA.

1988 *Juan Darién: A Carnival Mass*, by Taymor and Elliot Goldenthal based on a short story by Horacio Quiroga. Music by Elliot Goldenthal. Directed by Taymor. Costumes and sets by G.W. Mercier and Taymor. Puppetry and masks by Taymor. St. Clemens Church, New York. Revived 1990; performed at festivals in Edinburgh, Lille, Montreal, Jerusalem, and San Francisco, 1990/91; performed at Lincoln Center Theater in Association with Music Theater Group, New York, 1996/97.

whether it's for them or for me, is a visual style for the show that I can use and work in. It also helps them understand. And, it brings the actors together without too much competition: who's the star, who's this, who's that? Instead, all of a sudden we're all saying, "Why are we doing this piece?" In *Titus* it got out some pretty *intense* concepts.

SCHECHNER: What exactly do you mean by "ideograph"?

TAYMOR: An ideograph is an essence, an abstraction. It's boiling it right down to the most essential two, three brush strokes.

SCHECHNER: Can you give me an example from one of your pieces?

TAYMOR: The best example I can give is from *The Transposed Heads,* which is a piece about friendship. The actors came up with the most spectacular ideograph that I've ever seen. I use it all the time because it's the one that people can get. It takes two people, it's not just a static image. It has a beginning, middle, and end. They came forward and stood with their feet next to each other. Let's do it together because I can't really explain it as well as I can do it.

So, we stand next to each other like this, and then the arms are held up.

1992　　　　*Fool's Fire*, screenplay by Taymor based on the short story "Hop-Frog" by Edgar Allan Poe. Direction, puppets, and costumes by Taymor. American Playhouse and Rebo Studio. Premiere at Sundance Film Festival, UT. Aired on PBS, 1992.

1992　　　　*Oedipus Rex* by Sophocles. Opera composed by Igor Stravinsky, libretto by Jean Cocteau. Directed by Taymor. Conducted by Seiji Ozawa. Masks and sculptures by Taymor. Saito Kinen Festival, Japan. Film produced by Peter Gelb and Pat Jaffe, premiere at Sundance Film Festival, UT, 1993. Aired on PBS, 1993.

1993　　　　*The Magic Flute* by Mozart, conducted by Zubin Mehta. Directed by Taymor. Masks and puppetry by Taymor and Michael Curry. Costumes by Taymor. Maggio Music Festival, Florence, and Turin, Italy, 1994.

1994　　　　*Titus Andronicus* by Shakespeare. Music by Elliot Goldenthal. Directed by Taymor. Theatre for a New Audience, New York.

1995　　　　*The Flying Dutchman*. Directed by Taymor. The Los Angeles Opera; remounted in a coproduction with the Houston Grand Opera, 1998.

1995　　　　*Salomé* based on the libretto by Oscar Wilde. Directed by Taymor. Choreography by Taymor and Andreas Liyepa. Conducted by Valery Gergiev. Passionstheater, Oberammergau, Germany, and at the Kirov Opera's Mariinsky Theater, St. Petersberg, Russia. Subsequently toured by the Kirov Opera at the Mikkeli Festival, Finland, 1996, and The New Israel Opera, Tel Aviv, 1998.

1996　　　　*The Green Bird* by Carlo Gozzi. Direction, mask, and puppet designs by Taymor. Music by Elliot Goldenthal. Theater for a New Audience, The New Victory Theater, and La Jolla Playhouse.

1997–present　*The Lion King*. Book by Roger Allers and Irene Mecchi. Music by Elton John. Lyrics by Tim Rice. Direction and costume design by Taymor. Masks and puppets codesigned by Taymor and Michael Curry. Additional music and lyrics by Lebo M, Mark Mancina, Jay Rifkin, Taymor, and Hans Zimmer. Produced by Walt Disney Theatrical at The Orpheum Theatre, MN, and The New Amsterdam Theater, New York City.

1999　　　　*TITUS* by Shakespeare. Film adaptation and direction by Taymor. Executive Producers: Clear Blue Sky Productions, Urania Pictures, and Overseas Film Group. Produced by Conchita Airoldi and Taymor.

Put your feet next to mine. And they did this very well. And then you go back until you are totally balanced, like this. Now they worked this out—you can let go now—they went like, "Hi, Joe!" "Hi, Bob!" They came in and did a kind of handshake, and then they went into this thing. And what the audience sees is what? They see a *heart*, number one. So this ideograph was a triangle or a heart, depending on how you shape it. But it's also a handshake, it's got that "real" gesture, too. And it's also about balance. If I think, "Fuck you," and give one little push, you're gonna tip over! So in one beautiful, little, sculptural, kinetic move … It's not *just* naturalism, which we don't need in the theatre, but it's familiar enough to an audience that they'll believe it. It can operate in a naturalistic world, but heighten that naturalism to the point where it adds another layer. Now I was blown away when I saw the actors do it. You know, this was not my idea; this was the *actors'* idea. As a director I file it—knowing that this is going to be a motif. Every time Nanda and Shridaman meet, that's their concept. An ideograph is like a musical motif. And it's the actors' own unique, characterological relationship or thing. So that's one example of an ideograph, very simply, and how it operates both on an abstract and a characterological level.

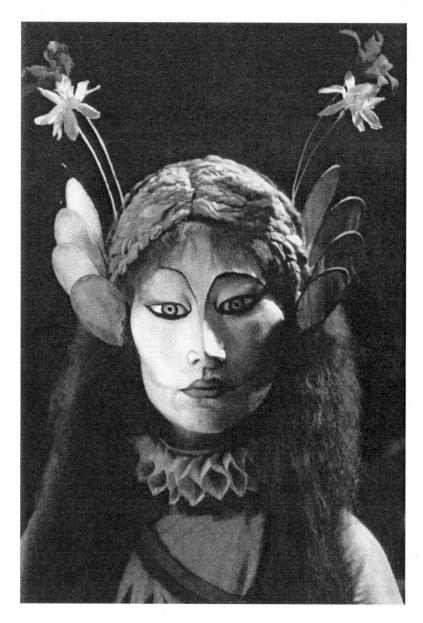

2. Angela (Diane D'Aquila), the love of King Deramo, designed by Taymor for her production of The King Stag *(1984). (Photo by Kenneth Van Sickle)*

SCHECHNER: Now this is totally different. You said you were studying at Lecoq's when you were 16? Was it summer? Were you taken out of school? Were you living in Paris?

TAYMOR: I graduated high school early and I'd been in a theatre workshop in Boston with Barbara Linden and Julie Portman. I grew up in the 1960s doing Living Theatre kind of stuff, creating theatre from scratch, from ideas—and I didn't feel I had any training. I knew at that time I was good in movement, I knew I wanted some physical discipline. I was too young for Lecoq's but I got enough out of it. I mean, he usually didn't take people that young. I was there for a year. If I were older I probably would have done the two-year course, but I went to college instead after one year, to Oberlin.

SCHECHNER: Where you met Herbert Blau. What was the connection between the Lecoq work and what you did with Blau?

TAYMOR: Well, the connection is that Blau, working in the way of Grotowski and Peter Brook, was really also interested in abstraction. In getting to this kind of—*he* might have called them ideographs—that probably came from Blau. What I loved about working with Blau was he was *so* heady. And I was so physical and visual. In Paris I was in mime school, I didn't have to talk. I hardly spoke French, I was very quiet. Then all of a sudden with Blau, I had to do two hours of solo verbal improvisation! So he really got that out of us—me, Bill Irwin, Mike O'Connor. First year we were about 15, then it went down, for *The Donner Party*, to seven. And I was the physical, visual person in that company. I designed, I came up with the square dance for *The Donnor Party*.

SCHECHNER: That was your idea? A great idea. I still remember that dancing after all these years.

TAYMOR: Blau was extremely good at pulling us into places where we weren't used to going.

SCHECHNER: Now let's shift venue—to Indonesia. Did you study *wayang kulit*?

TAYMOR: You know, I studied it before I went, in Seattle at the American Society for Eastern Arts, but I didn't go to Indonesia to study traditional arts. I went to observe. This happened a little bit due to Peter Schumann. He said I should just watch and don't assign myself to a mentor. You know I worked with Bread and Puppet one summer at Goddard. Peter saw I could sculpt. So at night I would go into the barn and sculpt, and he'd come over and give me some guidance. And then I said, "Well, I'm gonna do this. What do you suggest? Who should I be with?" And he said, "Don't do, just watch." I think he sensed there were a lot of Bread and Puppet look-a-likes and he didn't think that was so hot.

Peter felt if you had your own vision it should show. Don't hook on. Don't go study *bunraku* and then do bunraku. He told me that if I had the opportunity to travel, I should just travel, take my time, and just watch. "Just watch." That stuck with me. I studied Japanese shadow puppetry a teeny bit here and there, but I had planned to go to Indonesia only for three months. I ended up staying a long time, but that was because I started to create my own work there.

SCHECHNER: Teatr Loh, right?

TAYMOR: Yeah, but that didn't happen right away.

SCHECHNER: And you had the car accident, came back to the USA, and went back again to Indonesia, right?

TAYMOR: I had a couple of accidents. And I was there for four years, from around 1974 to 1978—I can't remember the exact years.

SCHECHNER: All in Java, or—?

TAYMOR: The first two years in Java and the second two years in Bali. But I didn't start Teatr Loh until I'd been there two years. I'm sure the ideograph stuff was in there at that time. It's with me always.

I'll give you another example from *The Lion King*. As the director I hadn't hired the designer yet, but I had to come up with the concept. My deal with Disney had three parts, the first being conceptual. If we all agreed on the concept I'd go to the next part. That suited me just fine because the last thing I wanted was to be enmeshed in something that I couldn't stand behind. Disney felt the same way.

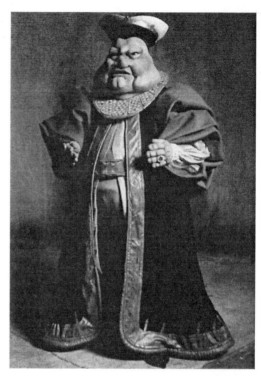

3–6. Based on the short story "Hop-Frog" by Edgar Allan Poe, Taymor designed the puppets, masks, and costumes for her 1992 film, Fool's Fire. *Plates 3 and 4 are the drawing and realization of Hop-Frog, the king. Plates 4 and 5 show a lady of the court. (Drawings by Julie Taymor. Photos courtesy of Julie Taymor)*

The ideograph for *The Lion King* was the circle. The circle of life. This symbol is the actual, most simple way of talking about *The Lion King*. It's the biggest song. It's obvious. So before Richard Hudson was hired [as set designer], I already was thinking about wheels and circles. And how whatever Pride Rock was I would never do the jutting Pride Rock from the movie. I knew it had to be abstract. You had the sun, then you had the first puppet I conceived, the Gazelle Wheel. The Gazelle Wheel represents the entire concept. You know what I'm talking about? The wheels with the gazelles that leap? With one person moving across the stage you get eight or nine leaping gazelles. Which is a miniature, too. So you get the long-shot and the close-up. I brought the miniature to Michael Eisner [of Disney] and I said, okay, in traditional puppet theatre, there is a black-masking or something that hides the wheels, and you see these little gazelles going like that. The puppeteer is hidden. But let's just get rid of the masking. Because when you get rid of the masking, then even though the mechanics are apparent, the whole effect is more magical. And this is where theatre has a power over film and television. This is absolutely where its magic works. It's not because it's an illusion and we don't know how it's done. It's because we know *exactly* how it's done. On top of that, this little Gazelle Wheel is the circle of life. So then over and over again, with the audience conscious or not, I'm reinforcing this idea of the wheel.

SCHECHNER: Did Eisner immediately go for it?

TAYMOR: Completely. He said, "Got it!" I knew then that I could do the masks on the heads. I could show the process. There are places where the mechanics are hidden, but they're not very important places. You don't see the machinery under the floor for Pride Rock, but pretty much everything else is visible.

SCHECHNER: One of the things I like very much in *The Lion King* is the tension between what you see, what you imagine, and what you know. I've forgotten the name of the actor, but you know, the guy who plays Zazu—

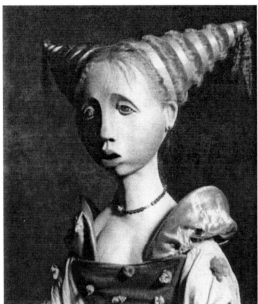

TAYMOR: Geoff Hoyle.

SCHECHNER: He's very special. When I first saw him, I said to myself, OK, I'm going to watch him and not his puppet. But that was impossible. I kept slipping into watching the puppet.

TAYMOR: It's because he puts his energy into the puppet.

SCHECHNER: It was like the bunraku master puppeteer who is so good he doesn't have to wear a black cloth over his face. A double magic: you see the puppet and the puppeteer together. In that universe, God is visible.

TAYMOR: I've been calling that the "double event" of *The Lion King*. It's not just the story that's being told. It's *how* it's being told.

SCHECHNER: But you did that earlier, didn't you?

TAYMOR: I first did it in *The Green Bird* where, even though the actor was all in black, I didn't put a mask on his face. I didn't want to hide his facial expression because of the story—a prince *transformed* into a bird. So he wore black, but his costume was the costume of a prince. And he is the *shadow* of the bird. So the personality, the yearning to be a prince again, was always there. I explored the dialectic between the puppet and the human character. So finally the bird flies away and the prince comes down; it's the same silhouette, only now he's got his human face and his green coat.

In *Juan Darién* there's no speaking. There's no speaking in bunraku either; the speaking all comes from the side. *The Green Bird* is the first time where I had the puppeteer both visible and speaking, rather than the neutral puppeteer.

SCHECHNER: The tension in *The Lion King* for me was in the danger that the performance might fail, that the dialectic would not hold. What makes it thrilling for a grown-up, is to see if they can all pull it off.

TAYMOR: Right. Michael Eisner and the other producers, Tom Schumacher and Peter Schneider, were very concerned in 1996 when I did my first prototypes with four characters. Michael Ovitz and the whole shebang of

Disney people were there. Things weren't working like they were supposed to work. The main problem was we were working in daylight, we were ten feet away. The actors weren't secure enough to not upstage the puppets. Some of the actors were so nervous in front of this crowd that the puppets were dead. Dead. So everybody said, "Uh, you can't do it for the principal characters." And I said, "But you saw the Hyena and Pumbaa work." "Well we're frightened about it because you don't know where to look. The actor is more interesting than the puppet." So I said, "Well I agree with you. This didn't work." I knew that.

But I also knew *why* it didn't work and I knew where it could go. See, a good thing about Disney is that they have money to do the next workshop. So I said, "Look, I hate puppets. I'm sick of them. I'm happy to do this with actors, with makeup, Peking opera–style, *kabuki*. I don't give a shit. I've got nothing to prove. If that's the best way to tell the story, let's do it that way. But I don't think that's why you wanted to work with me." And they answered, "Well, you can do it for the chorus animals, but not the principals." So I said, "All right, what I'm gonna do—and this is as much for me as you, because this is the first opportunity I've had to spend the amount of money it takes to do this experiment—I'm gonna do two or three versions of each character. I'll do full makeup and wig for Scar. And for Geoff Hoyle—we'd hired Geoff by then—I'll do it first with the bird and then without the bird. But we have to do it in the New Amsterdam, in a black environment, with all the lights, all the makeup, and full costumes. And you have to be 30 feet away."

And that's what I did. A true experiment. And it worked. Michael Eisner said, "Let's do *all* the puppet stuff. Because it is definitely more risky, but the payoff is bigger." So that was it. And there were no more worries about it.

SCHECHNER: Working with Disney gave you the freedom, the money, to really experiment?

TAYMOR: Yeah.

SCHECHNER: And once Eisner made the decision, did Disney stay out of it?

TAYMOR: They stayed out of it.

SCHECHNER: They didn't play producer?

TAYMOR: Tom Schumacher *was* the producer. He was the one who asked me to do it. He was the head of the Olympic Arts Festival in L.A. before he went to Disney. Tom is really one of the best theatre producers I've ever worked with, if not *the* best. He knows theatre from all over the world, so he would sit there and he'd say, "Why don't you try an Awaji puppet?" Because of the Olympic Arts Festival, he's been all over the world. This is a guy who knew exactly one technique from another. And even though he's in California, he was here in New York enough to say, "Do it Taymor style." What he meant by that was, "You don't need all that. Get it simpler." I was interested—because we had the budget—in exploring high technologies. But what happened was that I came back to my beginnings. The most successful stuff is the stuff I've done my whole life, which didn't cost anything. Like the tears coming out of the eyes. Or the silk going into the water hole. Or the shadow puppets of the fish. Or the little mouse.

You have that incredibly big, opening scene and the next thing you have is a little circle of light—just a hand-held light and a teeny little mouse that moves along the screen.

SCHECHNER: And the birds, too. The flying birds.

TAYMOR: Oh yeah, yeah. You mean the kites in act 2?

SCHECHNER: Right.

TAYMOR: Those are the things that I've done since I had no budgets. They have the power. In fact *more* power because they are so transparent, so simple. It is so pleasing to me to hear people say, "My child went home and picked up some fabric and a stick." Do you know what that's like for me? To see a child go home and run around with fabric and a stick instead of creating a bird on a computer where they're given the bluebird head and the bluebird wing, and they get the color. And that means that they haven't really understood air. They haven't understood that silk is gonna work better than velvet, you know? I think it's just shocking what's gonna happen.

SCHECHNER: People say the computer is a liberator, but it's all painting-by-the-numbers, programmed.

TAYMOR: And it's a very pathetic physical experience. The idea of sitting in front of a little box, minimizing life experience rather than making it greater. Why play on the internet when you can go outside and ride a bicycle? It doesn't have any air. I can't imagine having a child and having to fight over being outside or working on the computer.

When I was at a tech/design conference two weeks ago, I insulted everyone. I started by saying, "Look at this stage. Look how ugly it is." It was filled with wires and computers. "Don't you guys even think about aesthetics? How unbearable this is?" Now I'm talking to a bunch of Microsoft guys. I mean these were the people who invented all this stuff.

SCHECHNER: Right, there's something whacko about it. It's like the love-affair with the automobile. Everyone thought it was so great—you can go anywhere! But where the fuck do people go? To the mall, to the supermarket? The car didn't bring utopia, and neither will the microchip.

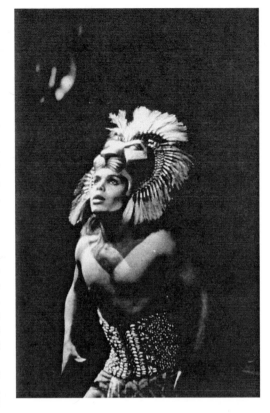

7. *Jason Raize as Simba in* The Lion King, *on Broadway (1997). (Photo by Joan Marcus)*

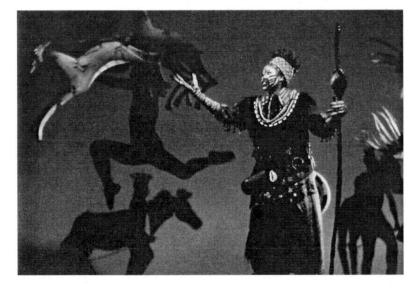

8. *Tsidii Le Loka and company in* The Lion King. *(Photo by Joan Marcus)*

I want to talk now about *Oedipus* and *Titus Andronicus*. They seem to be different from a lot of your other work in the sense that these are heavy, bloody tragedies.

TAYMOR: *Titus* is meant to touch you, and to be emotional.

SCHECHNER: Had you earlier done anything as heavy as this?

TAYMOR: I did *The Tempest*.

SCHECHNER: But *The Tempest* is a magic show.

TAYMOR: Yes, but it's got such beautiful, deep themes in it. But you're right, it's nothing like *Titus*. *Juan Darién* is pretty dark in certain places.

SCHECHNER: Yes, *Juan Darién*. But the way you did it was both dark and not. I mean, the very idea that the village was this—the scale was such that a person could literally embrace the village.

TAYMOR: Right. I'm just saying that it goes to a point where the child is tortured to death and burned alive. I did *Titus* because Jeffrey Horowitz asked me to read it and I was shocked. I'd never been shocked by something I read before. And I thought, "Whoa! If I'm this shocked, how could someone have written this? And it's Shakespeare's first play—people think it's a bad play. I don't really know how I feel about this." People said, "Julie, you know you've done so many things with violence in them." I had. But I'd always stylized the violence. So this was one where I had to say, "You can't stylize this violence because then it becomes too pretty, too aesthetic." I don't like violence. I'm like any other normal person. But I think that the thing that drew me to *Titus*, and that still draws me, is that I've never seen any dissertation on violence as complete as *Titus*. Think of *Braveheart* or all those violent Hollywood movies. Or *Richard III* or Jacobean plays. What is it about *Titus*? You don't think about the violence in *Richard III*. It just happens and it goes. There's something else in *Titus* that gets to people, I guess because the violence is so . . . gruesome. Cutting off hands, and tongues, and rape. It's not just smothering your wife with a pillow.

SCHECHNER: Yes, the violence in *Titus* is celebrated. In *Richard III* he kills the kids because they threaten his claim to the throne. In *Titus*, there's a delight in the torture.

TAYMOR: By some characters. Yes, Shakespeare chose that aspect. Violence as war. Condoned violence. Ritual sacrifice. Then it has father-to-son violence, which is the patriarch thing. Violence as an act of passion and anger, accepted because it was an irrational act of passion. Then violence as art, which is what Aaron does when he thinks about the art of violence. He's the one who's like the guy in *Clockwork Orange*—that kind of nihilistic violence, violence without meaning. And lust, and sex. Ultimately Titus killing his daughter, which is . . . Bosnia. Or whatever the latest outrage is. You can't live anymore. You've been raped by the enemy. Your life is over, you are disgraced, you are condemned—so why live?

SCHECHNER: Why did you want to do it?

TAYMOR: I did it as a play because I found it just so compelling. I am so sick of stories like *Pulp Fiction* where you have a bunch of low-lifes being violent in a stereotypical low-life way. No real story. What I love about *Titus* is that you have a good man, a powerful man, your chief of state. You want him to be your president. But he behaves exactly the same as the worst of the worst.

SCHECHNER: And as a movie. How will you translate it, both conceptually and physically into film?

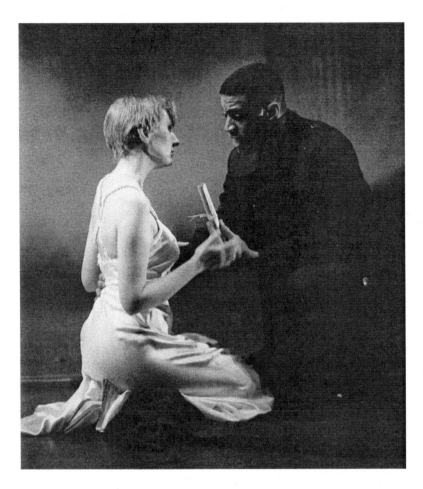

9. *In Taymor's 1994 stage production of* Titus Andronicus, *Tamora (Melinda Mullins) and her lover Aaron the Moor (Harry Lennix) plot to kill Bassianus, the emperor's brother. (Photo by Kenneth Van Sickle)*

TAYMOR: In the theatre, my set designer Derek McLane and I took ancient Roman ruins and made photographic blow-ups on plastic and then we scratched it. So what you had was something grand, chintzy, and contemporary. I played with the Etruscan right up to the present. Costume is character, not period. I thought of Lavinia more as Grace Kelly, with the little gloves, a 1950s character. But Tamora is more like Visconti's 1930s film, *The Damned.* She's androgynous. And Titus, he starts in black and he moves through grays to white, with a chef's hat. White, where the blood really shows. But, at a certain point when he's been completely reduced to being a pathetic old man, he's like *Father Knows Best.* This was Robert Stattel's idea. He said, "I feel like wearing a cardigan. You know, a frumpy cardigan sweater." Clothing became so much an emblem of status in society and what you think about yourself. I'm doing exactly the same thing in the film.

SCHECHNER: You're mixing time periods?

TAYMOR: Oh yeah. It's in two time periods—or maybe I should say we're creating our own time period. I can say I've never seen anything like it in film except maybe *Road Warriors* and *Blade Runner.* We're going to shoot in Rome using both the ancient Roman ruins—they have elements of modernity to them—and then we're going to use Mussolini's government center, which was modeled after the ancients. And we'll take these modern places, which have an incredible kind of minimalist power, and we'll put Roman cobble-

stones down. And what we'll try to do, if we go into an ancient catacomb where they buried their dead, there might be—like in Mexico—a little photo of the character next to something that reminds you of him.

In the theatre production I used the gold frame and red curtain which is symbolic of revenge dramas. I had the concept of "Penny Arcade Nightmares," all in gold and the red. In the film, the Colosseum has become the symbol. It's more cinematic. Everybody in the world knows that the Colosseum is the original theatre of violence and cruelty. The film starts in a kitchen that could be in Sarajevo or Brooklyn. A child is watching TV. As the child's innocent play with his toy soldiers escalates into a palpably thunderous explosion of bombs, the boy falls through an *Alice in Wonderland* time warp, with the intervention of a Shakespearean clown, right into the Colosseum. Magically, his toy Roman soldiers have become armored flesh and blood, covered in layers of earth—Titus and his armies are returning from war with a triumphant march into the arena. The boy takes his part as Young Lucius, Titus's grandson, and it's through his eyes that the audience will witness this tale of revenge and compassion.

SCHECHNER: And you're using Shakespeare's text?

TAYMOR: Completely.

SCHECHNER: Nothing added to it?

TAYMOR: No.

SCHECHNER: And who's playing what? Do you know yet?

TAYMOR: Anthony Hopkins is Titus.

SCHECHNER: Wow. Who's producing it? Disney?

TAYMOR: No studio! We're raising the money independently. If we can do it for 12 or 14 million, it will be a miracle—

SCHECHNER: You mean you can have Hopkins in a film for that kind of budget?

TAYMOR: He's not doing it for the money.

10. Julie Taymor and Anthony Hopkins (Titus) confer between takes of the crossroads scene in Titus, *the 1999 film version of Taymor's* Titus Andronicus. *(Photo by Alessia Bulgari; courtesy Clear Blue Sky Productions)*

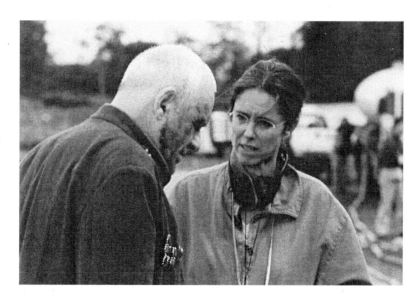

SCHECHNER: To get back to *The Lion King*. It was all miked, right?

TAYMOR: Body-miked?

SCHECHNER: Yeah.

TAYMOR: Of course, but it's the best sound designer in New York. With a full orchestra, you have to mike.

SCHECHNER: Ethyl Merman didn't mike.

TAYMOR: In those days nobody did. But that's why she came right down to the front of the stage. The New Amsterdam was a vaudeville house and we learned that the sound is only really good at the front of the stage.

SCHECHNER: This interview is going into a *TDR* book on puppets and performing objects. I wonder if you feel an affinity to American traditions of performing objects—stuff like the Macy's parade, the Disney and other theme parks. You talked about Asian arts. What about American popular arts?

TAYMOR: I never liked those things. Not even as a kid. I think I always felt that that kind of thing was just goofy, literally. The roundness of everything—the aesthetic of it—never appealed to me. When I was given marionettes as a child they were more like Czech marionettes. They weren't that four-fingered, big-eyed—I never liked the big-eyed types of things.

Bread and Puppet was one of the first things I saw that really grabbed me, during the Vietnam War. It was *that* power of parade. I've never seen the Macy's parade.

SCHECHNER: Over the last 10 years or so, you've been making movies. Are you changing over from live performance to film?

TAYMOR: Not really. I did two nonfeature films, which I enjoyed, *Oedipus* and *Fool's Fire*. And now *Titus*.

SCHECHNER: Do you have any theatre projects coming up?

TAYMOR: Elliot [Goldenthal] and I are still working on *Grendel*, that's opera. If Nigel Redden [the producer] can pull it off we'll do it in 2000. There's nothing more ridiculous than the amount of time we'll have spent to work on what will amount to a noncommercial eight performances. It's ridiculous! We started this in 1988, so it'll be 12 years. And I want *The Green Bird* to come back to Broadway. I'm really gonna try hard to have an open Broadway run. After New York, we did it in La Jolla. We made cast changes and cut 20 minutes. It was very good. [Theatre for a New Audience's production of *Green Bird* directed and codesigned by Taymor was presented on Broadway by Gregory Mosher and Bill Haber in the spring of 2000.]

SCHECHNER: But with the fabulous success of *The Lion King*, aren't producers running after you?

TAYMOR: Not a lot of theatre producers.

SCHECHNER: Why not, do you think?

TAYMOR: I never had theatre producers run after me. Some people want to make more Broadway shows out of movies. But Elliot and I aren't going to do *Batman: The Musical*.

SCHECHNER: It's interesting—plays from movies. Until recently it was the other way 'round. Now they think they already have name recognition and a proven box office.

11. A bound Aaron (Harry J. Lennix) arrives at the Goth camp with his infant son slung on his back in Titus *(1999). (Photo by Mario Tursi; courtesy of Clear Blue Sky Productions)*

TAYMOR: And they own it.

SCHECHNER: Right. They own it.

TAYMOR: Name recognition definitely works. If *The Lion King* hadn't been a movie, there would be nothing like this. You've got children who *know* it. It's like the *Mahabharata* for our culture. These kids have it memorized. And they love it, and they say, "Mommy"—I get these stories all the time—they say, "Don't worry, Mommy. Simba's going to be okay."

You know what I love about *The Lion King*? It's really theatre operating in its original sense, which is about family and society. It's doing exactly what theatre was born for—to reaffirm where we are as human beings in our environment. It's precisely to reestablish your connection with your family, to know what your hierarchy is. And to watch families come and go through that with their children is a very moving experience for me.

SCHECHNER: Greek theatre was that—

TAYMOR: And Shakespeare—

SCHECHNER: Great popular theatre was always something like that. A ritual celebration, rather than "what's-going-to-happen-next?"

TAYMOR: When I worked on the story of *The Lion King* I ultimately knew that this is a classic story. It doesn't have to be so absolutely amazing. What needs to be amazing is the *telling* of the story. The meaning comes in the telling, not in the story itself. It's how you tell it. And everybody always talks about this crying. The most common statement is, "The giraffes came on and I burst into tears." From adults. You know, children don't say that. And you ask, "Why is that?" I remember having a disagreement with Richard Hudson over how to do the sunrise. I won because I'm the director. He wanted to use projected light, which of course you can do. But I said, "Then you might as well use a movie because a film clip can do it even realler." Then I said, "It's the beginning of the show. I can't do that. I've gotta establish the rules of the game at the beginning. I just want it to be flat, and I want it to be clearly pieces of silk, on the floor. So that when the audience looks at it, they go, 'Oh—it's just pieces of silk on flats going up and down.'" And the giraffes were the second thing I designed. I said, "Sure, I could hide those people in a costume with stilts." But then no one would feel anything. The fact that as a spectator you're very aware of the human being with the things strapped on, and you see the straps linking the actor to the stilts, that there's no attempt to mask the stilts and make them animal-like shapes—*that's* why people cry.

SCHECHNER: Earlier in your work, you were your own designer, weren't you?

12. The emperor, Saturninus (Alan Cumming), sits on his throne beneath a giant sculpture of the wolf, the emblem of Rome, in Taymor's film, Titus *(1999). (Photo by Enrico Appetito; courtesy of Clear Blue Sky Productions)*

**Julie Taymor, Playing with
Fire: Theater, Opera, Film.**
By Eileen Blumenthal and Julie
Taymor. New York: Harry N.
Abrams, 1995; 208 pp.;
illustrations. $49.50 cloth.

Julie Taymor's work is highly visual, lush even, saturated with color, pulsing with rhythmic movement. This large-format book shows Taymor as a visual theatre artist. Fifteen performances, from *Way of Snow* (1974) through *Titus Andronicus* (1994), are presented in photographs, drawings—often enough Taymor's working sketches—and brief processual and descriptive texts in which Taymor explains the why and how of each work. Preceding this chronological march through Taymor's oeuvre is a 46-page biographical and analytic essay by Eileen Blumenthal. What the material reveals is the consistency of Taymor's vision. Some artists, like Picasso, change their styles and modes of presentation radically as they move through life; others, like Richard Foreman, remain very fixed. Taymor falls between these extremes. She varies her texts, media, and place in the production hierarchy—sometimes working as director-designer-adapter, sometimes just being in charge of the visuals, and often serving as both director and designer. She constructs her puppets, masks, and performing objects. But for all the changes, her basic style remains recognizably her own throughout.

Blumenthal points out that Taymor's work:

is not so much eclectic as it is cross-bred. She draws on an enormous pool of forms, genres, traditions. [...] Usually she assimilates disparate elements rather than leaving them in native dress. Only historians of European theater might notice how closely the stage arrangement in Taymor's design for a Passover *Haggadah* pageant resembles that of medieval Christian Passion plays. Only viewers familiar with Chinese the-

TAYMOR: You mean sets? Not always.

SCHECHNER: Well, like in *Juan Darién*, who designed the village?

TAYMOR: We codesigned the set, Skip [G.W. Mercier] and me. The actual look of the village is Skip's. My concept, his realization.

SCHECHNER: And in *The Lion King*, you had a costumer?

TAYMOR: No, I designed the costumes. The puppets and the masks are codesigned by Michael Curry and myself. I am the aesthetics director. I sculpted everything, I drew everything. He did the mechanics. Sometimes he did the visuals, but our balance together is really technical and aesthetic. Richard Hudson did the sets. I gave him some basic concepts like the circles. I said to him, "You're a minimalist, that's perfect, because the puppets are gonna be so rich. I need a minimal background." He's a white guy from England born in Africa, spent his first 17 years there.

ater would be likely to realize that the show's Red Sea of billowing cloth derives from a Peking Opera convention. Taymor's *Juan Darién* incorporates techniques from Japan, Indonesia, Czechoslovakia, and Western fairgrounds [...]. (7–8)

Taymor is a theatre artist who emerges from a rigorous academic and adventurous intercultural background. As a teenager she trained in mime with Jacques Lecoq; as a college student at Oberlin she joined Herbert Blau's experimental group, Kraken. I saw Kraken perform *The Donner Party* at the Performing Garage in the early 1970s. Taymor played various roles, human and animal, with a great physical intensity drawing fully on her mime training. But Blau's work was not only artistic. He demanded from his actors intellectual commitment. Taymor was well-prepared for her experiences in Indonesia later in the 1970s. Half a world away from the USA she learned first-hand how to form a theatre company; she experimented deeply with masks and puppets.

Because of her great gifts as a costume designer and mask and puppet maker, Taymor found herself slotted as a "visual artist" in the theatre. But her ambitions were much broader. As success in one area opened up opportunities in others, Taymor was able to direct more often and to work across genres in theatre, television, opera, and film. Blumenthal's introduction follows Taymor's progression. There is not much deep analysis or attempt to locate Taymor within the whole spectrum of modern American theatre. Taymor's enormous success in *The Lion King* takes place a few years after this book was published. But the seeds of that success are well noted. Taymor's own writing in the book sticks fairly close to the various grounds she stands on—narratively, theatrically, technically. Taymor is not given to theorizing or comparing herself to others. To some degree Taymor is unique. Peter Schumann has kept strictly to his origins in the counter-culture. The Muppets are popular puppetry par excellence. Taymor has emerged from the avantgarde into the mainstream. What this excellent book shows most clearly is how Taymor has happily realized her ambition to be a director: the person who conceives and executes what happens onstage, whatever the medium.

—Richard Schechner

Which brings me to the only other thing that I want to say about *The Lion King,* something particularly important to me. The production is very interesting when you think about race in America. For white people, *The Lion King* has nothing to do with race. It's beyond race. It transcends race. For black people, it's the opposite. It's all about race.

SCHECHNER: How's that?

TAYMOR: First of all, when you see the movie of *The Lion King,* unless you're an adult you have no idea that the voice of Mufasa [James Earl Jones] is an African American. In my production you see the actors in flesh and blood. Technically, the entire chorus is nonwhite—some of them look white, but they are of mixed race. You have a nonwhite cast onstage for the most part. And for a black child—black papers have written about this—the response from the black audience has been rewarding and moving. In American mainstream theatre, a black king is nowhere to be found.

SCHECHNER: Right.

TAYMOR: *Never!* To have Mufasa played by a black actor. In the movie, Matthew Broderick was Simba's voice. Okay, so we had a black father and a white son. *Why* didn't they cast a black actor to do the voice of Simba? I didn't intentionally have two light-skinned people playing those parts; they were the best actors for the roles. Our other Simba who's playing it now is *very* black. The black audience sees race onstage. Now I know my work isn't African, but Lebo's music [Lebo M] is African.

The Lion King isn't about racism the way, say, *Ragtime* or so many other plays with black performers are. In this regard, *The Lion King* is totally refreshing—a kind of glimpse of the future. My friend Reg E. Kathay said, "This is like the next century." But no one in the white press ever talks about the race issue in *The Lion King*. I think one article in L.A. brought that up.

SCHECHNER: But the black press talked about it?

TAYMOR: Oh, yeah.

SCHECHNER: Is the story itself an African story?

TAYMOR: No. African tales are much more outrageous than this. This is a Western story. What is very African about *The Lion King* is Lebo's music. The visuals, too, the textiles. And Garth Fagan's choreography. I picked Garth because I wanted something real cross-cultural, very European and African, or American-European and African. I liked that Garth is a contemporary choreographer from Jamaica. He has the roots and he knows African idioms, but he's doing his own modern stuff.

SCHECHNER: Anything else?

TAYMOR: You know what, I'd love to make a film of my *The Lion King*.

SCHECHNER: A film of a play based on a film?

TAYMOR: It's different! First of all, the movie only had five songs. And the faces of the people are very compelling. We're not talking animation.

SCHECHNER: But would Disney do that?

TAYMOR: Not right now. They don't want to ruin the box office. And

13. Giraffes (Timothy Hunter and Ashi K. Smythe) cross the stage in Taymor's The Lion King *on Broadway. (Photo by Joan Marcus)*

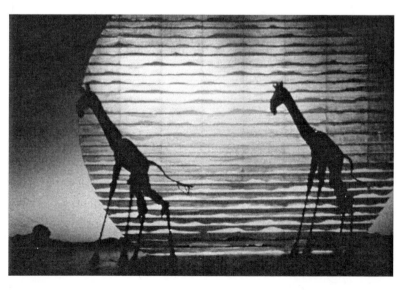

then I thought, maybe we could shoot it in Africa. But what I can't quite figure out is this: the whole reason to stylize is because you're not in a real setting. So how do you do the Serengeti in the Serengeti? It would be fantastic to have the Serengeti, and then out of the ground, the land starts rising up, and there are the people. Or take a real cave and literally paint the cave with slashes like we did onstage. So that you stylize the natural. I mean, you literally treat the land and maybe you color the grass. We could film from helicopters, you know, or any angle. It could be amazing to try and figure this out. I don't even know what it would look like to have real giraffes moving by fake giraffes. I know it's completely the opposite of what it's supposed to be, and what its success is in the theatre, but there's something very compelling and interesting to me about having the real, and then having the stylized. It's a musical. I mean, it's not like you're pretending to be really real.

What, At the End of This Century, Is the Situation of Puppets and Performing Objects?

Peter Schumann

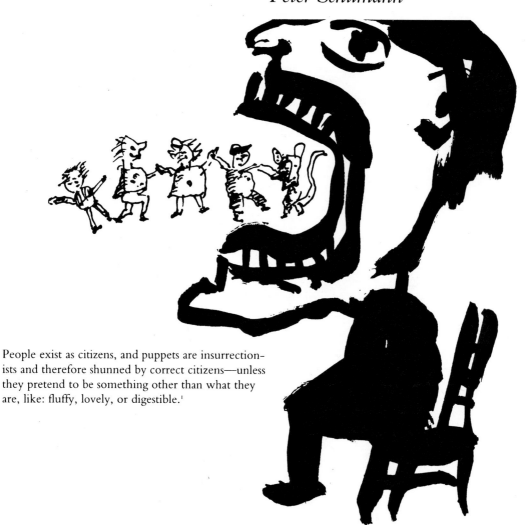

People exist as citizens, and puppets are insurrection-ists and therefore shunned by correct citizens—unless they pretend to be something other than what they are, like: fluffy, lovely, or digestible.[1]

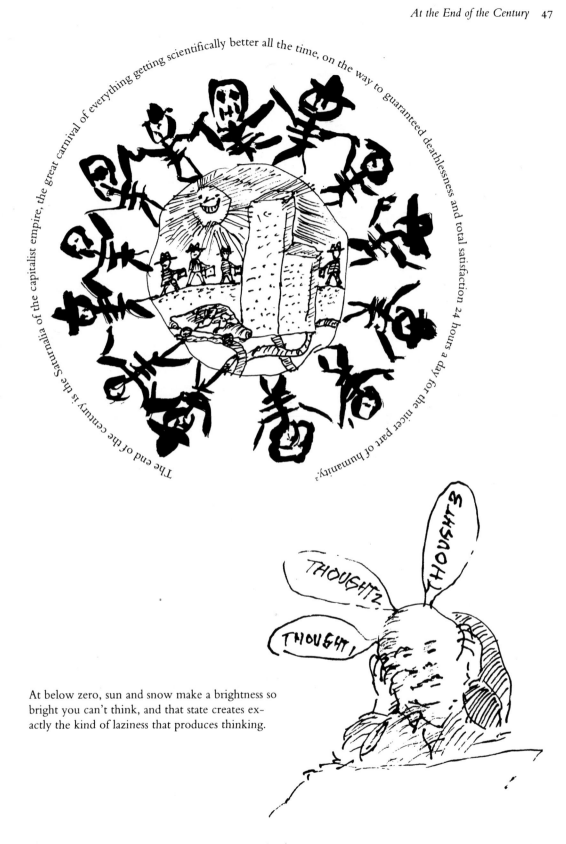

The end of the century is the Saturnalia of the capitalist empire, the great carnival of everything getting scientifically better all the time, on the way to guaranteed deathlessness and total satisfaction 24 hours a day for the nicer part of humanity?

At below zero, sun and snow make a brightness so bright you can't think, and that state creates exactly the kind of laziness that produces thinking.

SLOW DOWN!

HOW FAR?

The snow makes for slow-
motion. The slow-motion helps
doing the chores: banking the house
with snow, liberating the roof from snow,
dragging wood through the snow, tossing hay on
the snow for the sheep and donkey, ending joyfully
with the old practice of cigar smoking and piling up slow-
motion thoughts which are influenced by snow.

We who think of ourselves as subjects don't even know donkeys well
enough, not to speak of fence posts and rocks, to which we assign the
job of object, because we haven't discovered their individuality yet. As a
donkeyman—which means: related to donkeys and therefore also to fence
posts and rocks—I shy away from that particular definition: object. Object
exists only because we are deceived into being subject, and as subjects we
are subjects of a republic in which the prisons grow faster than any part of
the growth factor.

When the snow is shallow enough I take my donkey to the top of the
sugarbush. I saw off the limbs of fallen maples, lash them to the
whiffletree and my donkey throws his weight into the load as if he was a
pony in a pulling contest, and alarmed by the clatter of branches behind
him, improves his pace to that of a pony.

OK.

Objects have been performing under the whip of subjects too long and are now disobedient and can't be counted on any longer. They avoid real contact and meaningful relationships and divorce themselves from the intentions of subjects. They used to be good and close to our hearts. They almost liked us and seemed to be grateful for our attention, but were deprived of their dignity by the throw-away philosophy, which resulted in the object's revenge: garbage.

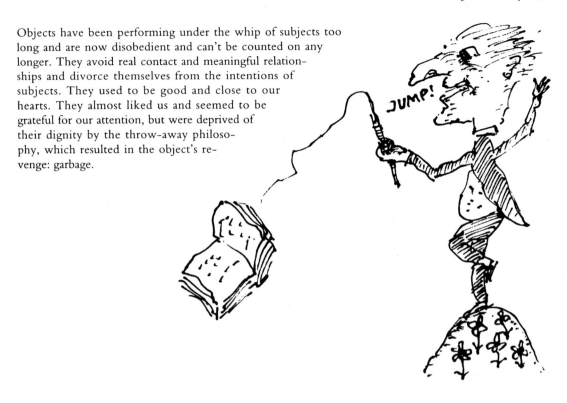

Why are puppets subversive? Because the meaning of everything is so ordained and in collaboration with the general sense of everything, and they, being only puppets, are not obliged to this sense and instead take delight in the opposite sense, which is the sense of donkeys confronting the existing transportation system.

Objects, which also proselytize as objectivity and objectification,

lack the soul of their brothers, the things with their big families, the somethings, everythings, and anythings.

Can things fly?

Yes. I have seen angels in the drafty streets of NYC who were actually tossed-away wrapping papers, but obviously joyful and superhuman in their ability to brighten up masses of dark stinky air stuck between high-rises.

Are things in league with puppets?

Yes. They too defy their subservience and the ungodly meaninglessness to which they are delegated by the habits of the republic; they too are infested by the sourdough of cultural insurrection.

Notes

1. Why are puppets insurrectionists? Because nobody but puppets could possibly be insurrectionists, because (1) insurrectionism as recommended by the Declaration of Independence is never right for the politics at hand, and (2) it's totally illegal, just ask the dead Black Panthers or the John Africa family of Philadelphia.

2. Canadian scientists figured out that the distribution of our first-world habits to the rest of the globe would need four planets with equally wonderful resources. We have one already, all we need is three more! Or is it more reasonable to assume that the master design isn't for more planets but for continuation and intensification of the existing slave-labor system that provides for these habits of ours?

The End of
Our Domestic Resurrection Circus

Bread and Puppet Theater and
Counterculture Performance in the 1990s

John Bell

The Bread and Puppet Theater's *Domestic Resurrection Circus* emerged in the context of the countercultural goals of the 1960s and '70s. How did the development of counterculture-as-commodity in the 1980s and '90s affect the end of this unique 27-year performance event? My intent is not to focus so much on the theatre of the *Circus*, but on the events surrounding it, and the nature of its presence in the spectacle economy of Vermont and the United States.

1970: Counterculture Puppet Theatre in Plainfield

Peter Schumann's Bread and Puppet Theater started in New York in the 1960s, when the city was seeing the creation of a new avantgarde in the midst of the Cold War and its then hot ancillary in Vietnam. In the fertile atmosphere of places like Judson Church, artistic borders were crossed or broken: musicians acted, painters sang, sculptors (like Schumann) danced, and poets wrote plays. Rent was relatively cheap, and there were men and women interested in making art, music, and theatre in ways that would connect new and old forms, in order to respond to and reflect what seemed to be going on around them. Bread and Puppet Theater grew in this atmosphere. Perhaps it did not flourish in the sense of becoming commercially *famous* (as Jim Henson's Muppets soon did), but it changed the way puppets were thought of in the United States. Schumann's moving sculptures created a visual focus, first in parades organized by Puerto Rican tenants' organizations on the Lower East Side, and then even more strikingly in parades in New York and Washington, DC, protesting the Vietnam War. Yet the greatest renown the theatre had achieved was not in New York at all but in Paris and other European cities, where Bread and Puppet's intense, often mute images were recognized both as part of the 20th-century avantgarde tradition and as an example of the development of 1960s American avantgarde performance.

In the late '60s Peter and his wife and partner Elka received an offer to be a theatre-in-residence at Goddard College in Plainfield, Vermont. Goddard was (and still is) an experimental school with a long tradition in progressive education. Schumann was happy to leave New York—the prospect of raising five children on an old farm in the countryside was very alluring.

So Bread and Puppet took up residence on Cate Farm, a large parcel of land with a big barn, outbuildings, fields, and a brick farmhouse set in a bend of the Onion River. Goddard College, owner of the farm, was undergoing an enormous boom as its interpretation of John Dewey's teaching philosophies attracted hundreds of students interested in alternative education. Goddard became a center of 1960s counterculture, a community of artisans, musicians, activists, performers, entrepreneurs, and communes who fed each other the vision of an alternative way of life at some distance from the economics and mass culture of American capitalism.

Plainfield boasted an active food co-op, the Plainfield Village Chorus specializing in Bach Cantatas and 16th-century masses, a Plainfield Village Gamelan, and The Word of Mouth Chorus. This chorus sang Balkan music, Early Music, and above all Sacred Harp music—the early American shape-note singing tradition which implied democracy in its community, nonchurch origins, and independence in the way it forsook traditional European harmonies for more raw "American" progressions and chord structures. In addition to traditional courses, the Goddard curriculum included courses on how to build houses, "social ecology," a radical history of Vermont taught by Kirpatrick Sale, nontraditional non-Western music taught by Dennis Murphy, and a theatre department, headed by Paul Vela, that incubated the early plays of Goddard student David Mamet and created off-campus groups like Two Penny Circus, and collaborations with Schumann's Bread and Puppet Theater.

But in a way, the most important aspect of Bread and Puppet's move to Vermont was how it dovetailed with the experience of Elka Schumann's grandfather, the radical economist Scott Nearing, 36 years earlier. In 1934, Nearing and his wife Helen had left New York City for southern Vermont, to live the "Good Life" by creatively combining subsistence farming with political and intellectual activity.[1] The Nearings held steadfast to their socialist ideals throughout the following decades, and by the late 1960s were seen as examples of how to lead an alternative political and social life. The Nearings had wanted to inspire city-bound factory workers of the Depression era, but the young people going "back to the land" in the '60s and '70s were mostly middle-class, and sooner or later developed hybrid ways of living that reconnected them to mainstream American society.

It was possible, especially in the bustling counterculture of Plainfield, to imagine alternatives; to consider the experience of the Nearings in southern Vermont as an example on which to build. I believe this in large part inspired the Schumanns' focus on what became *Our Domestic Resurrection Circus*. Above all, the Nearings' experiences farming, maple sugaring, teaching, writing, and distributing their books showed that it was possible to achieve radical goals in 20th-century America by doing it yourself and taking slow satisfaction in the accomplishment of limited success. Scott Nearing, after all, was famous for building a pond by excavating a few wheelbarrows of earth every day for decades.

In New York City, Bread and Puppet performance spaces were most often tiny storefronts and lofts, occasionally theatres, and very often streets and city parks. But Vermont opened up new possibilities. The Schumanns and their collaborators began making shows at the edge of the largest field in Cate Farm. They marked out a circular performance area with 18-foot tall flagpoles, set up a large old brown tent at its edge, and, using masks and larger-than-life-size puppets, created abstract political puppet skits played in the round to the music of a "junk orchestra," amateur brass band, and Sacred Harp singing. Schumann wrote of the first *Circus*:

> *Our Domestic Resurrection Circus* will be an effort to find a new way of doing circus that is more human, that is not merely a collection of superla-

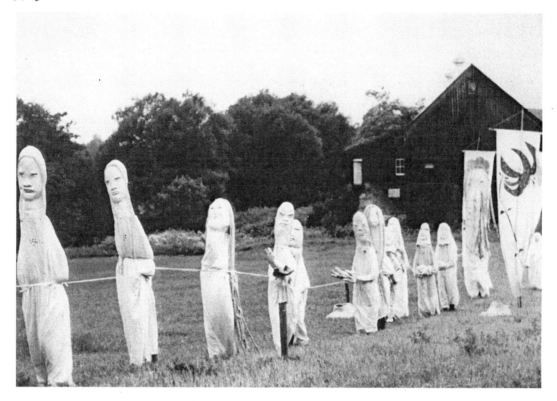

1. Vietnamese Lady puppets in the Pageant sequence of the 1972 Domestic Resurrection Circus at Cate Farm. (Photo by Ruth Barenbaum; courtesy of Bread and Puppet Theater)

tives, of extraordinary feats arbitrarily mixed together, but something that becomes a story of the world circus. [...] It has to do with just creating a big outside attraction for the people in the area. It's a piece that shouldn't be traveled, something we want to perform where we can integrate the landscape, that we can do with real time and real rivers and mountains and animals. It's something that is seen in the woods, up there in the hills, back here in the river. I guess it would be called an "environment!" (in Kourilsky 1974:107–08)

These events were the original *Domestic Resurrection Circuses*, and they artfully employed the energies of the Plainfield performing community.[2] When Françoise Kourilsky wrote about the *Circus* in 1974, she noted its connections to Happenings, John Cage, Yvonne Rainer, bauhaus, dada, and Kurt Schwitters. But, of course, to call an event a "circus" is to embrace a central form of popular culture, and *Our Domestic Resurrection Circus* did exactly this, not only seeking connections to American and European circus traditions, but to American historical pageants, carnivals, and county fairs (Kourilsky 1974).[3]

"The first version of *Our Domestic Resurrection Circus*," Kourilsky wrote, "was like a history of America, ending with the war in Vietnam" (1974:108). Like most Bread and Puppet Theater productions, it was both more and less than a history: more in that it constantly sought to make bigger sense of events by using the automatically evocative abstract symbolism of puppets and masks; and less, in that it always had room for silly jokes, pratfalls, and sheer nonsense. This openness marked the development of the *Circus* throughout its long life, and influenced the form it took until its end in 1998: a presentation of simultaneous Sideshows, followed by a Puppet Circus performed in a ring, followed by a traveling Passion Play, a Pageant during sunset, and then evening shows lasting until 10:00 or 11:00 P.M.[4] Schumann distributed his sourdough rye

bread in a "Free Bread Store," and no admission was ever charged, although donations were vigorously solicited.

Moving to Glover

The Bread and Puppet residency at Goddard College ended in 1974. The theatre moved north to an ex–dairy farm in Glover, about 20 miles south of the Canadian border in a somewhat remote region called the Northeast Kingdom. When I drove up to Glover the first summer I worked with Bread and Puppet, I sat in the back of a 1956 Chevrolet panel truck driven by Schumann, and looking through the windshield I quite clearly felt the difference from the busy community in Plainfield. The further north we headed, the sparser the houses and farms became, the longer the unbroken stretches of pine-covered hills and forest. When we finally reached the new Bread and Puppet farm, it seemed to sit quite alone on the slope of a gentle valley.

Elka Schumann's father, John Scott (Scott Nearing's son), was a writer for *Time* magazine.[5] After buying the Glover farm from Daisy and Jim Dopp, Scott sold off tons of gravel at the south end of the largest hayfield to a construction company then building Interstate 91 nearby—a highway that would make it easier for tourists to reach the Northeast Kingdom. The road builders took a large bite out of the hillside field, leaving a steep-sided horseshoe-shaped bank curving around its west end. When the question of smoothing over this new gravel pit came up, Schumann urged his father-in-law to leave it the way it was, realizing he could use its new topography as an outdoor amphitheatre.

The first *Domestic Resurrection Circus* in Glover took place in the summer of 1975. The Dopps' barn had been transformed into the Bread and Puppet Museum, where Schumann's growing output of puppets and masks was displayed. We set up a ring in the Glover amphitheatre, with flagpoles around the top of the audience area, and played an epic series of shorter and longer pieces out in front of the brown tent. The event began with a small banner story, *Hallelujah*, progressed through a series of circus acts both silly and pointed, and then

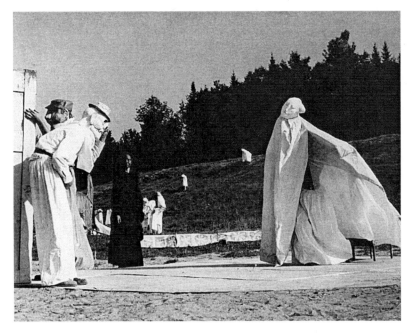

2. The White Horse Butcher *in the amphitheatre at the first Glover, Vermont,* Circus. *Margo Lee Sherman in black, John Bell as Death, and Peter Schumann as the White Lady. (Photo by Ruth Barenbaum; courtesy of Bread and Puppet Theater)*

shifted into the performance of *The White Horse Butcher,* a death-and-resurrection show pitting black-clad butchers against a white horse and an angel on stilts (Schumann himself). About 700 people watched.

Bread and Puppet and the Spectacle Economy of the Northeast Kingdom

From 1975 through 1998 the *Circus* grew in scope, in numbers of performers, and numbers of spectators, but its aesthetic focus remained basically fixed.[6] The spectacle economy of the Northeast Kingdom in the 1970s was quite rich, despite the area's distance from large cities. Annual performance events created by local communities included the Orleans County Fair in neighboring Barton (as well as other county fairs nearby), village Fourth of July parades, festivals, talent shows, and a surprising number of small-scale, Florida-based traveling tent circuses. In addition, there were newer, tourist-oriented events, such as the Craftsbury Fiddlers' Contest, the Hardwick Banjo Contest, and occasional attempts at Woodstock-style music festivals. During the first year of the Glover *Circus,* for example, an outdoor, two-day rock-and-roll festival was held just down the road from Bread and Puppet, on fields belonging to Doug Conley, the son of a prominent Glover landowner and sawmill operator. Conley's festival, although held only that one year, was a prescient counterpart to the Bread and Puppet festival. *Our Domestic Resurrection Circus* was a complex mix of avantgarde forms, political ideals, populist aspirations, and a definite desire to present an alternative to mass-media, capitalist culture. Conley's rock-and-roll festival, while sharing the same interests in outdoor, popular, and locally produced performance, focused more straightforwardly on entertainment and pleasure (for example, in the guiltless use of alcohol and drugs), and displayed a pronounced lack of interest in politics. The different emphases marked two contrasting visions of performance and alternative culture, a contrast which a decade later began to contribute to the eventual and perhaps inevitable demise of the *Circus.*

A Countercultural Spectacle Flourishes

By 1998, Vermont had changed, as had the cultural economy of avantgarde performance in the U.S. Vermont newcomers (or "flatlanders") Ben Cohen and Jerry Greenfield had turned the alternative ice cream parlor they had

3. Meredith Holch in a Sideshow in the Pine Forest, Our Domestic Resurrection Circus, *1992. (Photo by Ron Simon; courtesy of Bread and Puppet Theater)*

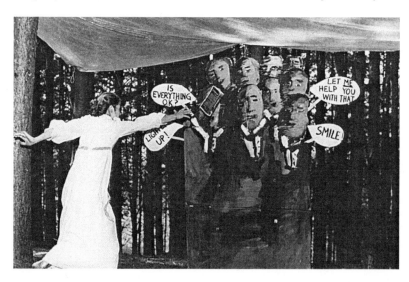

started in 1978 at an old gas station in Burlington into a nationwide, socially conscious corporation. Bernie Sanders, who used to campaign on Montpelier street corners as a third-party candidate for state office, now represented Vermont as the only socialist in the U.S. Congress. The Barton *Chronicle*, which had been created by back-to-the-land Northeast Kingdom newcomers in the early '70s, was now the paper of record for Orleans County, and respected throughout the state as a model of local journalism. Bread and Puppet *Circus* volunteers, who had emigrated to Vermont in the 1960s and '70s, were now respected members of their communities. The Bread and Puppet Museum was noted in red letters on the Vermont Official State Map, and tourism was supplanting dairy farms at an alarming rate. Doug Conley and his neighbor Ronald Perron were annually making thousands of dollars renting out their fields to the out-of-state campers now flocking to the Bread and Puppet *Circus*.

The summer *Circus* had become the central event in Bread and Puppet's year. During the late 1970s and early 1980s Bread and Puppet tours in the United States and abroad had supported the finances of the *Circus*. But gradually, as audience numbers for the summer event grew, the amounts of their donations rose, and by the mid-1980s the *Circus* was not only paying for itself, but had become the largest single annual source of income for the theatre. The *Circus* was the event for which new puppets were built and new themes, music, texts, and movements were invented, and determined the theatre's performances for the following year.

Early audiences for the *Circus* were largely a mixture of the local "new" population of the Northeast Kingdom, central Vermonters who had known Bread and Puppet in Plainfield, and a contingent of New York City fans who had known the theatre in the '60s. Most local residents in Glover, Barton, and the rest of the Northeast Kingdom were far more likely to see Bread and Puppet in Fourth of July parades or smaller town hall, church, or school shows. Some native Vermonters came to see the *Circus*, liked it, and attended it in increasing numbers over the years, but the event certainly had the taint of hippie licentiousness and leftist politics that marked a cultural divide.

Scott Stroot's 1998 depiction of the *Circus* gives an idea of the manner in which the event evolved, both as part of the Northeast Kingdom's summer cultural season, and as a regional or national counterculture spectacle:

> *Our Domestic Resurrection Circus* has become a counter-culture institution (only in America could such a beast evolve!) involving 200 or more volunteer participants, and attracting an audience of nearly 40,000 people of all ages and persuasions to the area around the tiny town of Glover. A little bit Grateful Dead concert (with some un-Deadlike rules: no drugs, no dogs, no alcohol), a little bit Rainbow gathering, a little bit religious celebration, and a little bit political be-in, each year's event has a theme (usually sociopolitical in nature) and more or less follows the same format: afternoon *Sideshows* featuring a variety of simultaneously performed small skits and stories, followed by a more focused, larger-scaled puppet *Circus* featuring a succession of longer, more interconnected narratives in the early evening, and finally, as the sun sets, the *Pageant*, featuring a procession of multi-operator giant puppets, usually culminating with the immolation and resurrection of one preeminent giant puppet figure. (Stroot 1998:15)

The apparent oxymoron of "countercultural tradition" (much like, say, the concept of an "avantgarde institution") characterizes not only the *Circus*, but the situation of post-1960s Vermont, and, by extension, the cultural quality of the post-'60s United States. In fact, by the '90s, the strict separation implied by culture/counterculture was no longer in effect (if in fact it had ever really

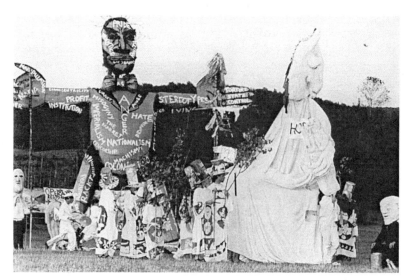

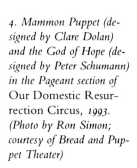

4. Mammon Puppet (designed by Clare Dolan) and the God of Hope (designed by Peter Schumann) in the Pageant section of Our Domestic Resurrection Circus, *1993. (Photo by Ron Simon; courtesy of Bread and Puppet Theater)*

been). In Vermont, distinctions between young flatlanders living in communes and native Vermonters working family farms had lessened and in many cases completely disappeared. The newcomers had become absorbed into the cultural, political, and economic life of Vermont, and in fact their energies and enthusiasm were central to the life of the state. Many of the people who annually created the *Circus* had become selectmen, librarians, state officials, judges, and prominent members of Vermont's other professions.

The situation of community in the Northeast Kingdom became complicated in interesting ways. The same independent political philosophy that helped foster the Plainfield community also pertained farther north. Robert Kinsey, for example, was a West Glover farmer who also served in the State House of Representatives as Republican Majority Leader. Kinsey espoused the strong liberal philosophy of Vermont Republicanism, a kind of live-and-let-live attitude which, over the years, led him to pronounce liberal opinions about the Vietnam War, homosexuality, drugs, and other controversial cultural issues, and to carry giant puppets with Bread and Puppet in the Barton Fourth of July parade. The same voters who sent Kinsey to the State House also sent Bernard Sanders, a Jewish radical originally from Brooklyn, to Washington. Of course, a handful of Northeast Kingdom residents continued to express their antipathy to Bread and Puppet's political positions over the years in the "Letters to the Editor" columns in the *Chronicle*, and others swore they would never come to see the *Circus*. But the generally flexible, open, and friendly attitude of northeastern Vermont supported the *Circus*.

Dealing with Problems

The *Circus* audience changed from the '70s to the '90s. As its numbers steadily grew (every year another thousand or so), its makeup shifted. While a core group of Bread and Puppet fans continued to come, some initial audience members began to drift away.

In order to deal with the extra-theatrical aspects of the *Circus*, a logistics committee was formed from among those who worked annually on the event. Many members of the committee were residents with close ties to the community, including Ellen Braithwaite, a founder of the *Chronicle*; Everett Kinsey (son of Robert Kinsey), a dairy farmer/carpenter; Chip Troiano, a

Staten Island native and Vietnam veteran who, because of his work in the St. Johnsbury public defender's office, had close connections with Northeast Kingdom law enforcement agencies; Lee Viets, who had served as a state legislator; and Allen Hark, whose lobbying for low-income Vermonters made him familiar with state politics.

The organizational structure within the Bread and Puppet Theater developed in response to the requirements of the *Circus*—organically (as it were) in an anarchistic fashion, which is to say, in response to situations as they developed, with individual members of various committees taking on responsibilities as they saw fit. All met regularly with the Schumanns and other puppeteers. This organizational democracy was quite different from the artistic leadership of Bread and Puppet, which remained clearly the purview of Peter Schumann.

When we planned the earlier Glover *Circuses*, the logistics of food, parking, and camping were not of major import. Many, if not most, of the audience members lived close by. More a community of friends than a far-flung network of fans, the audience either went home after the *Circus*, or camped informally on the Bread and Puppet fields. But as the crowds grew, attendant facilities did also. We soon figured out our own garbage recycling system, which, with the cooperation of the audience, was quite successful: the *Circus* grounds were never littered with trash. In the late '70s parked cars began to crowd public roads, and we asked neighbors near the farm to allow their fields to become temporary parking lots. At first as a favor to us, and then as an increasingly lucrative income windfall, Glover residents, particularly Conley and Perron, took on the job of providing parking and later campsites for *Circus*-goers.

Food was another question. Peter Schumann baked and distributed his trademark sourdough rye bread in ever increasing amounts, finally building a ten-foot-long oven right next to his bread house on the *Circus* grounds in the early '80s. But this, of course, could not feed all the audience. Many audience members brought their own picnics, but in the late '70s we attempted to feed everyone at the *Circus* with a free corn and potato roast, asking audience members to contribute the fruits of their gardens. This enterprise eventually proved to be too much of an undertaking for us to handle in addition to the theatre we were creating. Finally we invited food vendors onto the grounds, and their numbers grew, until in the early '80s we realized that, like the camp-

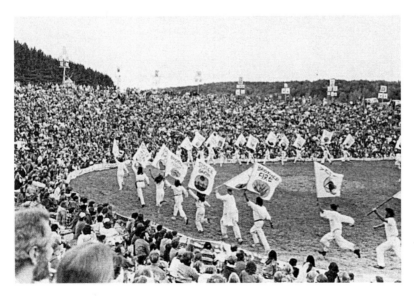

5. *The opening act of the Puppet Circus from the 1984* Domestic Resurrection Circus. *(Photo by John Fago; courtesy of Bread and Puppet Theater)*

ers, they were encroaching on the available performing space. When we asked the vendors to move off the *Circus* fields, they began to set up on Route 122, the state road leading to the Bread and Puppet farm. But the growing number of food stands slowed down traffic, creating a nuisance for our neighbors who did not attend the *Circus*. In 1993 we resolved this problem by arranging for the vendors to set up on the campgrounds.

We also dealt with more sensitive issues: dogs, alcohol, and drugs. Many *Circus*-goers brought dogs, resulting in a large free-ranging animal population, and alcohol and drugs became more and more widespread. We began to get letters from parents worried that *Our Domestic Resurrection Circus* was the place where their children were first offered marijuana, LSD, and other hallucinogens.[7] While the dog problem was relatively straightforward, the situation of alcohol and drug use and dealing was more complex. To regulate individual behavior seemed authoritarian, alien to the open spirit of the event. When we discussed these issues in Bread and Puppet meetings, it was argued that drug use was an inevitable aspect of American culture at large, and its presence at the *Circus* was in fact a reflection of that culture, not a cause of it. But we concluded by deciding, in the summer of 1997, to ask the *Circus* audience to refrain from bringing drugs and alcohol onto the *Circus* grounds, explaining this effort in letters to *Circus*-goers, press releases, and an insert in the *Circus* programs.[8]

What is striking about these efforts is that they were all basically successful. The *Circus* audience responded immediately, and at the 1997 *Circus* there were in fact no more beer coolers, hardly any dogs, and little open drug taking or dealing on the *Circus* grounds. But of course, the problem simply moved to the campgrounds where dogs, drink, and drugs were rampant and where we were not in a position to control the situation as we had our own land. I think we felt that if we offered an example on the *Circus* grounds, the campground owners might try parallel measures. This was not to be.

Variations on the "Bread and Puppet Idea"

At the *Circus* there was an often vague perception of the "Bread and Puppet idea" which in various forms was considered to define and pervade all aspects of the event. One *Circus*-goer spoke of it this way:

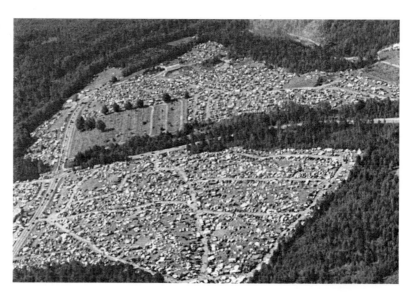

6. Aerial view of the Glover campgrounds during Our Domestic Resurrection Circus, *1998. Conley's campground is on the upper half of the photo, Perron's is on the lower half. Route 122 separates them. (Photo by Theresa Perron)*

I think it's just the Bread and Puppet idea—you know, you don't sit on seats, you sit on the grass hill to watch the show, and it's political, so we're all in a sense brought together because it's the hierarchy of what we live under. [...] And the fact that they let you come into the pageant and hold puppets that they've made, and be part of it, or they let you make the bread they give you—the festival's for free, as well, you don't feel like you have to pay or you have to show I.D., it's a donation. [...] Also, giving out the bread—that's something that's sort of religious in a way, for community. (in Finegar 1996:33)

This sense of the "Bread and Puppet idea" also extended to all that surrounded the *Circus*: the campgrounds and the vendors—legal and illicit. The two largest campgrounds, owned by Conley and Perron, lay on opposite sides of Route 122 down the hill from the Bread and Puppet Farm. Conley's property had become known as the "party campground," in keeping with the somewhat rowdy image that Conley had fostered since his 1975 rock festival. The Perron campground was somewhat less active, but bigger. A footpath ran between it and the Bread and Puppet–owned fields where the *Circus* took place. In 1993 the Town of Greensboro, ten miles south of Glover, bought the piece of land holding the footpath, and began to operate it both as a third large campground and as a place where vendors could sell food, clothing, and other items. Soon the path to the *Circus* became a large temporary bazaar of stalls offering everything from pizza, falafel, and burritos, to cappuccino, bell-bottom jeans, hemp clothing, and tie-dyed T-shirts. It was also a place where dealers gathered to sell drugs. This aspect of the greater *Circus* event had no financial or organizational connections to Bread and Puppet, but the separation of activities was not often clear to *Circus*-goers, especially the newer, younger audiences who began to attend in the mid-1980s. The Bread and Puppet productions on the theatre's grounds, the campgrounds, and the mall—the whole experience became "Bread and Puppet."[9]

Remi Glettsos, a Bread and Puppet audience member interviewed by Janet Finegar in 1996, talked about the atmosphere of the campgrounds as a positive extension of the "Bread and Puppet idea":

[T]here's like campfires and drum circles, you know, a real communal kind of thing, you just walk up to someone's campfire and you introduce yourself, and um, you know, if someone walks up and you hand them a beer, the next day they're gonna come back with some chicken or something. It's just, you know, friendly. It's really nice. You don't really get that kind of feeling anywhere else. (1996:46)

But Zachary Krol, an audience member who had worked with Bread and Puppet, described the campgrounds as "this whole other scene," a "side culture" with significant differences from the theatre's ethos (in Finegar 1996:50). Krol felt that the *Circus* audience had become too big, that "the crowds destroy what is beautiful about Vermont." He told Finegar that while he felt the environment at Bread and Puppet "ask[ed] you to be quiet and contemplative," the "whole scene" at the campgrounds was:

anything but thoughtful... all the things that are worst about progressive politics and environmentalism these days... everyone drives up in their cars, leaves garbage all over the place and do lots of drugs [...T]here's nothing wrong with a party but it just seems as if it's mashed into the wrong place. Seems too mindless for a scene that individually everyone would say is about political/environmental awareness, things that are not

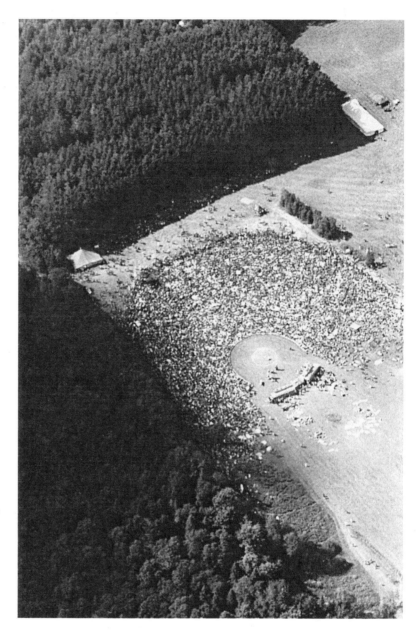

7. *Thirty thousand spectators watch the Puppet Circus in the amphitheatre at Our Domestic Resurrection Circus, 1998. The Pine Forest is at the upper edge of the photo, and the path downhill to the campgrounds starts near the tent at the left. (Photo by Theresa Perron; courtesy of* The Chronicle*)*

the system, the city, all the sort of vague evils that everybody in these crowds seems to talk about. (53)

By the mid-1990s, the "Bread and Puppet idea" of an alternative to American capitalist culture become inextricably mixed with a different, more "mainstream" vision of counterculture, often at odds with what we intended with our performances. This different vision had become, at worst, a devolution into "alternative" consumer choices, and, at best, a vague sentiment of iconoclasm allied to phenomena such as the summer Lollapalooza festivals, Grateful Dead tours, and the gigantic Phish concerts.[10] We began to hear, amid the occasional reports of rambunctious goings-on in the campgrounds, rumors that some *Circus*-goers—or many—never came to the Bread and Puppet shows, simply staying all the time at the campgrounds.

The Last Circus

When I look at my notes for the 1998 *Circus* and read the transcripts of the daily meetings we had to plan the event, I see they are almost totally focused on the productions we were creating: circus acts about current political stories, vaguely or directly connected to Bertolt Brecht; sideshows similarly dealing with Brecht and with contemporary political issues; *The New York City Community Gardens Passion Play*; a pageant incorporating Brecht's *Hitler-Choräle*, set to the music of Bach; an indoor giant puppet show based on the diaries of anarchist Alexander Berkman and Emma Goldman; a rough version of the Brecht/Weill *Threepenny Opera*; and, for the Great Small Works company, of which I am a member, a toy theatre show about Brecht's work in the United States. We met with the campground owners and with local Glover groups who provided important services to the *Circus*: the Glover ambulance squad, the security guards we hired to help us direct traffic, and the Glover Parent-Teachers' Organization. But the larger performance that the *Circus* had become, including the campgrounds and vending areas, was somewhat of necessity outside our focus of concentration. Creating the *Circus* itself was such an intense, multifocused job of coordinating construction, rehearsals, publicity, food, and shelter for our crew of 40 to 100 volunteers that there was no time to attend to events clearly out of our purview. In July, we were aware that a local Glover resident had falsely advertised on the internet that this would be the last *Circus*, so we made our own internet announcement to the contrary. For years we had been concerned about keeping audience numbers down, and except for local advertising, did nothing to publicize the show. However, it became clear as the 8 and 9 August *Circus* dates approached that news of the event was spreading by word of mouth, the internet, and national publications such as *High Times* (1998). There would probably be 40 to 60 thousand people attending.

At an early morning swim at nearby Shadow Lake the week before the *Circus*, I met some *Circus*-goers who had camped out there overnight on the public beach. They were a friendly group of five from western Massachusetts, quite ob-

8. The Mother Earth puppet with paper cranes has 200 operators and is watched by a giant head at the 1995 Domestic Resurrection Circus. (Photo by Ron Simon; courtesy of Bread and Puppet Theater)

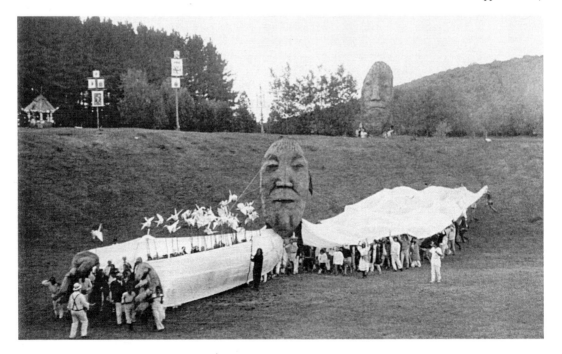

viously enjoying the opportunity of getting away from the city. As I left, one of the women said to me "Happy Bread and Puppet!" and I realized this was, in fact, a common greeting for the approaching weekend. It did not simply mean "enjoy the puppet shows," but "enjoy the whole event!": The entire participatory spectacle of camping, hanging out, experiencing the vendors' mall, partying, being in the Northeast Kingdom, as well as, but perhaps not even necessarily including, the actual Bread and Puppet shows. The Wednesday before the *Circus*, the sound of drum circles began to pulse up from the campgrounds, continuing unabated until Sunday. It formed a constant aural background for our myriad dress rehearsals and other preparations. We were still gearing up for the weekend shows, but the *Circus* had already started without us.

Michael Sarazin, a 41-year-old logger from Post Mills, Vermont, about 45 miles south of Glover, worked with a tree service company. A regular *Circus*-goer, Sarazin had heard the rumors about 1998 being "the last circus," and had told his business partner "I got to go up, because it's the last it's going to be." Sarazin came to Conley's campground the Friday before the *Circus*. At 4:00 A.M. on Saturday morning he was involved in an altercation with a Vermonter from nearby Morrisville nicknamed Junebug. During an evening that seemed to involve nothing more than "sitting around drinking beer," a fight broke out, an eyewitness said, as the result of "'something to do with a hot dog.'" Junebug struck Sarazin and a short while later Sarazin died from a brain hemorrhage (Wheeler 1998).

The *Circus* performances on the Bread and Puppet grounds that followed over the next two days were, from a theatrical, logistical, and experiential point of view, a great success, especially, in my opinion, the Pageant. At the end of the Saturday Puppet Circus, as I paraded around the ring as part of the brass band, I was struck by the preponderance of young audience members who obviously had never seen anything like this before. How wonderful, I thought, that this fresh crowd was watching exciting puppet theatre about landscape, Brecht, and contemporary politics. And yet throughout the weekend we were all thinking about Sarazin's death, and what it portended.

Near midnight Saturday, after our performances were done, I walked down the hill with friends to check out the campgrounds. It was an active, wildly enthusiastic scene, with a spirit something between a vast tailgate picnic, the vendors' area at a Grateful Dead concert, and the vaguely raunchy midway of the Orleans County Fair. Which is to say, not really unpleasant, but somewhat off-balance, especially in the light of Sarazin's death. Everywhere in the semi-darkness hundreds of cars and tents filled the fields, campfires cooked up a dense haze of wood smoke, and competing boomboxes played from different encampments, some done up like college dorm living rooms, with chairs, TVs, and bongs for an evening's entertainment. There were also elaborate outdoor performances: a disco complete with a portable dance floor, deejay, and light show; a loud rock band in matching Bermuda shorts playing perfect '60s surf instrumentals; and, supposedly, a rave, which I looked for but never found. All of this was at once magical and scary: a huge, night-long party with all the intensity of a small city. And yet, after all, we were in the middle of a hayfield in the otherwise dark night of northern Vermont. At one of the booths on the mall, I met a middle-aged vendor of hippie paraphernalia smoking hashish from one of the blown-glass pipes he was selling. He said he used to sell at Grateful Dead shows, and had only recently begun to work the Bread and Puppet weekend; he liked the atmosphere. Tired, and mindful of the next day's 10-hour performance schedule, I walked through the mall back to the Bread and Puppet fields.

After the 1998 *Circus* ended, Peter Schumann decided it indeed would be the last. Our traditional post-*Circus* exhaustion was tinged with sadness at

Michael Sarazin's death, so Schumann's decision was not a surprise. He paid for an ad in the *Chronicle*, set in a box on the page usually assigned to community notices. Schumann wrote:

Note of Thanks

I want to thank all our friends and neighbors for years of help and very rewarding collaborations, and announce publicly that this was our last Domestic Resurrection Circus. It was our twenty-seventh circus: three on Cate Farm in Plainfield, one in Aubervilliers, France, and twenty-three here in Glover. As we learned how to do these big spectacles and got better at it, the spectator crowd grew and finally outgrew our capacities.

The culmination of troubles was the death of Michael Sarazin on August 8, which makes the continuation of the event impossible. To our neighbors who know the Circus only from the traffic jams on the extended weekends, we apologize for the inconvenience. To our friends and guests we want to say: We are not going away, we will do other smaller forms of theatre during the summer months here on the Bread and Puppet Farm.

Thank you all

Peter Schumann (1998a)

After Schumann's announcement there were letters to the editor in the *Chronicle*, articles in other local Vermont papers, intense internet exchanges on an unofficial Bread and Puppet webpage, and letters to the theatre itself. A few weeks later, I noticed that a *Circus* volunteer named Moon, who had shown up at the Bread and Puppet farm three weeks before the *Circus*—with green hair, tattoos, and a star-studded jumpsuit—and had ended up joining us for the whole event, had written an impassioned, frustrated contribution to the web page (original spelling retained):

9. A map of the Circus *grounds by Amy Trompetter printed in the 1998* Domestic Resurrection Circus *program. (Courtesy of Bread and Puppet Theater)*

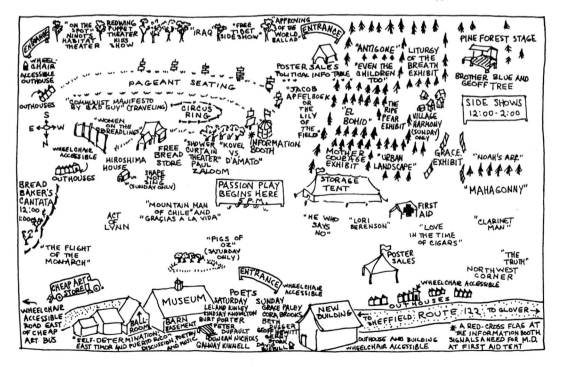

Subject: BREAD AND PUPPET IS DEAD

Name: I AM MOON

Time/Date: 22:50:56 9/13/98

Message: Bread and puppet is dead and you, the unconcience spectator, have killed it. You did not need to come to glover to get all wacked out of your gourd and hang out in the campgrounds all day oblivious of a circus going on. If you didn't know there was a concience raising event going on that weekend you and you chums came to glover vermont, to have a blowout weekend. What you thought was innocent fun was in fact an ignorant paradox. This is not what it's all about. You obviously haven't a clue as to what was the purpose of the weekend. Get involved and attempt to understand what it is all about. Not what you think, you haven't the capacity for constructive thought, these things are put here to accomplish. I was in the circus this year and it was the best moments of my life this year, I learned more than I had ever exspected and it has given me a far better perspective to approach life from. But all this is over. Thank you, ignorant campers [...]. (Moon 1998)

In the postings before and after Moon's contribution, ravers, drummers, and Phishheads critiqued the scenes they had each created at Bread and Puppet. But on another thread of the online discussion, some long-time fans and younger audience members eloquently and movingly mourned the end of the *Circus*.

Death and Resurrection

Since June 1998 Schumann and his company had been performing a weekly Friday evening *Insurrection Mass*, a "Funeral Mass for Rotten Ideas" in Bread and Puppet's post-and-beam indoor theatre, then filled with Schumann's giant paintings based on Marx's *Communist Manifesto*. The *Insurrection Mass* used the structure and nature of the Roman Catholic mass to present a ritual featuring Schumann's "fiddle lectures," individual puppeteers' performances, newly minted "household gods," and the ritual burial of a cardboard sign bearing the name of the week's "rotten idea" (for example, "Hills of Guilt," "Progress," and "Perfection"). On Friday, 21 August, the *Mass* was performed in memory of Michael Sarazin. Sarazin's former wife, two daughters, and friends came to the event, and at its close puppeteers buried a sign reading "Typical Modern Emptiness," a rotten idea which for Schumann reflected the senseless nature of Sarazin's death.

Two weeks later, Schumann ruminated on the last *Circus*, and how its own clear intentions had slipped away from much of the press coverage of the event. "Did you read any of the press commenting in retrospect how nice we were?" he wrote. Paraphrasing Marx's *Communist Manifesto*, he continued: "Did you read them quot[ing] Marx, Brecht, Marcuse, etc., 'all fixed fast frozen relations with their train of ancient venerable prejudices are swept away'?" Schumann was right. Over the years, except for coverage in the *Chronicle*, the spectacle of the *Circus* was largely presented as a '60s nostalgia weekend, especially in the larger state newspapers such as the *Burlington Free Press*. This studied avoidance of the *substance* of the theatre's work ignored the real content of the Bread and Puppet productions. This was not unlike the manner in which, two decades previously, the work of Scott and Helen Nearing had become the harbinger of back-to-the-land lifestyles, rather than a sustained, independent socialist critique of capitalist society. "There must be some very attractive quality goods for sale in these papers to omit so blatantly

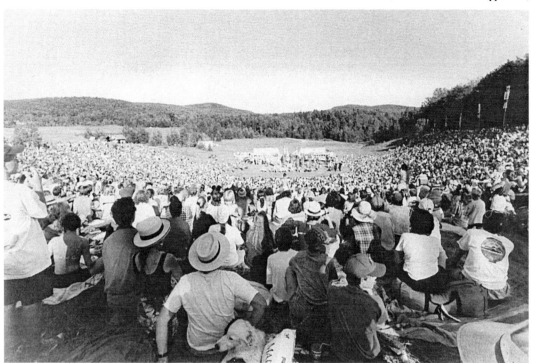

10. The finale of the Puppet Circus section of Our Domestic Resurrection Circus, 1994. (Photo by Randy Williams; courtesy of Bread and Puppet Theater)

what we are about," Schumann continued pointedly, asking, "How did we get suspected [of providing] such good home entertainment?" (1998b).

Schumann's analysis points out the difficulties facing political and social critique in turn-of-the-millennium America. The *Burlington Free Press* (owned by the Gannett corporation) would not analyze what *Our Domestic Resurrection Circus* was actually about. To do so would mean taking the event seriously, using such words as "capitalism" and "Marx" in earnest. It was far easier, and totally in keeping with the way such mass-media organs present events, for the paper to see the *Circus* and the 40–60,000 people who attended as seekers of entertainment and 1960s nostalgia.

What I saw in the *Circus* of 1998 was the exchange we puppeteers were able to have with exactly those in the audience who had come to be entertained, those who probably generally avoided live theatre, but who now found themselves involved in interchanges about someone named Brecht, a chorale by Bach, the foundations of the Spanish-American War, a nonsense text by Kurt Schwitters, or the reasons why anarchists thrived in New York in the 1880s. All this was counterbalanced by the sensory pleasure of dancing stilters, silly walks, brass band music, slapstick humor, and an open spirit of friendliness among thousands.

I think it was always clear to the puppeteers that despite the end of the *Circus* we probably would still be making puppet shows in Vermont the following summer. In January 1999 Schumann proposed just that—a new event, or actually a series of events which, like the *Insurrection Masses* the previous year, would take place every week, thus decentralizing the massive *Circus* weekend into a series of smaller-scale performances. The skills Bread and Puppet learned in creating outdoor spectacles over almost three decades went into the making of Sunday afternoon performances in Glover in the summers of 1999 and 2000. These weekly circuses, which combine the various performance elements developed at the *Circuses* have already begun to develop a consistent audience.

Notes

1. See Nearing (1970). For Peter Schumann's sense of Scott Nearing, see Bell (1994).
2. On the beginnings of the *Circus*, see Stefan Brecht (1988, vol. 2, chapt. 5).
3. Kourilsky also notes connections to traditional puppet theatres, specifically *bunraku* and Sicilian marionettes.
4. To avoid confusion, I shall use the term Puppet Circus to refer to the show taking place in the circus ring after the Sideshows. *Circus* refers to *Our Domestic Resurrection Circus*, the entire day-long event. For images of the 1974 Cate Farm *Circus* see DeeDee Halleck and George Griffin's film *The Meadows Green* (1975).
5. The son had a falling out with his father so serious that he dropped his last name, Nearing, and became John Scott. In the 1930s Scott trained as an electrical engineer so he could assist the development of Soviet society in Russia. In the eastern Siberian city of Magnitogorsk, where Scott helped build power plants, he met and married Elka's mother, Maria. His later frustrations in trying to return to the U.S. with her and his increasing dissatisfaction with Soviet organization led him in the 1940s and '50s to join such efforts as the anti-Communist Liberty Lobby. Scott's account of Magnitogorsk, *Behind the Urals* (1973) is a valuable history of prewar Russia.
6. Beginning in Glover, each year's *Domestic Resurrection Circus* focused on a particular theme:

 1975: Ishi
 1976: The United States Bicentennial
 1977: Masaniello (collaboration with Pupi e Fresedde)
 1978: Oswald von Wolkenstein (collaboration with Music for a While)
 1979: Washerwomen
 1980: L'Histoire du pain (transplanted summer festival at Théâtre National Populaire, Lyon, France)
 1981: The Fight against the End of the World
 1982: St. Francis
 1983: Domestic Insurrection
 1984: Central America and Liberation Theology
 1985: Bach and Nicaragua
 1986: The Hunger of the Hungry and the Hunger of the Overfed
 1987: Bicentennial: The U.S. Constitution and *Kaianerekowa* (the Iroquois constitution)
 1988: The Principle of Hope and the Banality of Evil (Ernst Bloch)
 1989: State of the Planet (including *Passion Play of Chico Mendes*)
 1990: Theatrum Mundi
 1991: The Triumph of Capitalism (including *Mr. Budhoo's Letter of Resignation from the IMF*)
 1992: The Green Man
 1993: Convention of the Gods
 1994: Frogs and Luddites
 1995: Birds
 1996: Cultural Insurrection (special focus on the Zapatista uprising)
 1997: Maximum Security Democracy
 1998: Unite! (Anniversaries of Brecht, Hildegard von Bingen, and the *Communist Manifesto*)

 For images of the Cate Farm *Circus* see Halleck and Griffin's film *The Meadows Green* (1974); for a documentary on the 1998 *Circus* see Halleck and Schumann's *Ah! The Hopeful Pageantry of Bread and Puppet* (1999).

7. See, for example, the "High Vibes" article on Bread and Puppet Theater in the December 1993 issue of the marijuana-oriented magazine *High Times*.
8. After many meetings, we decided on the following text (Bread and Puppet 1997), mostly written by Peter Schumann, which gives an idea of the way we tried to communicate with our audience, Schumann's attitude towards drugs, and our efforts to make the distinction between Bread and Puppet performances and the campground activities clear:

 Dear Circus Audience:

 We are getting an increasing number of complaints about drugs and alcohol at the Circus. The Circus is a family event and drugs and alcohol seriously

jeopardize its continuation. Please bear in mind—we are a modest little puppet theatre and all we want is to change the world and save it from going down the drain. Support our efforts: NO DRUGS OR ALCOHOL AT THE CIRCUS.

And please, no dogs. They make a lot of problems for us—dog shit, dog fights, dog-disruption-of-shows, and dog bites. Last year several kids were bitten by dogs. Naturally, not your dog, but still, leave it at home.

Please also note: the vending, parking, and camping operations surrounding the Circus field are not Bread and Puppet Theater's but our neighbors' businesses. We are grateful for the services they provide, although we receive no profit from them. Please respect the property and privacy of our neighbors.

Thank you!!

We appreciate your cooperation and support.

Bread and Puppet Theater

9. For example, an adventurous 18-year-old Colorado high school student named Jarvis Fosdick spent the summer of 1997 traveling on the east coast, and his impressions of the *Circus* reveal no distinction between the Bread and Puppet Theater events and those performance elements created by others:

> Well, in Vermont we went to the Bread and Puppet Festival. It was in a farm in the really beautiful part of Vermont. There was a puppet show, a drum circle, and a huge fire. There was also a circus there, with fire-twirling belly dancer people. There was a big rave, and there were always bands playing. I think there were about 20,000 people. It was probably the best thing that happened [on my vacation]. (Stock 1997)

10. Many long-time creators of *Our Domestic Resurrection Circus* also helped design and create elements of the large-scale Phish spectacles of 1996, 1997, and 1998, which were held in decommissioned Air Force bases in northern New York state and Maine. This was especially so with the performance elements of the temporary "villages" built in the campground areas of the concert sites. These spectacles at the Phish concerts were different from the Glover events in many ways. Most importantly, audience members paid an admission price, and Phish provided and controlled every aspect of the event, including vending and camping.

References

Bell, John
1994 "Uprising of the Beast: An Interview with Peter Schumann." *Theatre* 25, 1 (Spring/Summer):41–42.

Bread and Puppet Theatre
1997 Insert for *Our Domestic Resurrection Circus* program. 3 August.

Brecht, Stefan
1988 *Peter Schumann's Bread and Puppet Theater*. 2 vols. New York: Routledge.

Finegar, Janet
1996 "Research on the Folkloric Aspects of the Bread and Puppet *Circus*." Unpublished manuscript.

Halleck, DeeDee, and George Griffin
1975 *The Meadows Green*. 16 mm film.

Halleck, DeeDee, and Peter Schumann
1999 *Ah! The Hopeful Pageantry of Bread and Puppet*. 90 min. Viewing Habits/Bread and Puppet Theater.

High Times
1993 "High Vibes: Bread and Puppet Theater." *High Times* 220 (December).
1998 "Summer Festival Guide." *High Times* 276 (August).

Kourilsky, Françoise
1974 "Dada and Circus." *TDR* 18, 1 (T61):104–09.

Lisberg, Adam
1996 "Tension Brews around Phish Fans." *The Burlington Free Press*, 21 August:1.

Moon (Albert J. Danas III)
1998 Posting on Bread and Puppet forum. <http://207.136.230.200/dcforum97n/
 BreadandPuppet/24.html#0>.

Nearing, Helen, and Scott Nearing
1970 *Living the Good Life: How to Live Sanely and Simply in a Troubled World*. New
 York: Schocken Books.

Scott, John
1973 *Behind the Urals: An American Worker in Russia's City of Steel*. Bloomington:
 Indiana University Press.

Schumann, Peter
1986 "Puppetry and Politics." *American Theatre*, November:32–33.
1998a "Note of Thanks." *The Chronicle*, 19 August:5.
1998b Letter to "Friends and Puppeteers." 5 September.

Stock, Alisha
1997 "Jenny's Kids: Jarvis Fosdick." *The Insight* (Loveland [Colorado] High School
 newspaper), n.d.

Stroot, Scott
1998 "Radical Beauty in the Northeast Kingdom: The Bread and Puppet Theater
 and Museum." *Art New England* October/November:15.

Wheeler, Scott
1998 "Morrisville Man Charged with Manslaughter." *The Chronicle* 19 August:26.

Performing the Intelligent Machine

Deception and Enchantment in the Life of the Automaton Chess Player

Mark Sussman

*We feel it is epical when man with one wild arrow strikes a distant bird.
Is it not also epical when man with one wild engine strikes a distant sta-
tion? Chaos is dull; because in chaos the train might indeed go any-
where, to Baker Street, or to Baghdad. But man is a magician, and his
whole magic is in this, that he does say Victoria, and lo! it is Victoria.
No, take your books of mere poetry and prose, let me read a time-table
with tears of pride.*

<div align="right">

—G.K. Chesterton, The Man Who Was Thursday:
A Nightmare *([1908] 1986:12–13)*

</div>

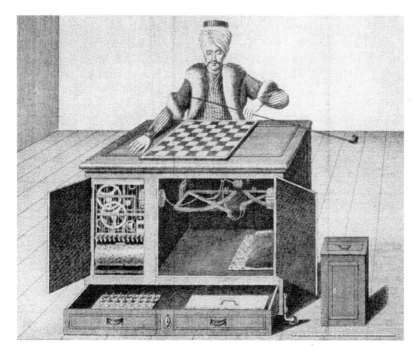

*1. The first stage of the
"reveal." (Copper-plate
illustration in de Windisch
1784)*

Chesterton's hero, Gabriel Syme, is a disguised policeman, member of a squad of metaphysical cops in a secret war against the all-too-real forces of anarchy. Syme begins this nightmare novel sworn to protect a world ordered by trains, automobiles, communication lines, common sense, law and order (Chesterton [1908] 1986). He ends the adventure, in which a crew of anarchists are unmasked as fellow cops, by recognizing a profoundly irrational prime moving force behind his reasonable sense of the real. Chesterton, finally, leaves his uncertain hero staring at faith as the boundary between chaos and order. The sense of chaos, that *anything* might happen when the train arrives or the telephone rings, is held in check by faith in, among other things, the modern magic of machines, their extension and repeatable mimicry of human capacities and actions.

Electricity and magnetism were prominently figured as a technical form of magic in the scientific imagination of the 18th-century, modernity's dream life prior to its technological awakening in the electrical inventions of the 19th century. Christoph Asendorf describes a key shift between the 18th and 19th centuries: in the 18th, man is understood as an *homme-machine*; in the 19th, the machine itself is assigned human characteristics, frequently figured as female or exotic other:

> In comparison with the eighteenth century, a shift in perspective has taken place. The body as a mechanical object has been replaced by the machine as a bodily object. If in the *homme-machine* the image of the machine was identical with that of the human body, then the consequences of this objectification become manifest in the image of the living machine: the separation of the body from the subject. [...] The rationality of the machine world is transformed into a mythology. (Asendorf 1993:4–5)

Following Marx's insight into the fetishism of commodity relations and mapping Hegel's notion of master-slave relations onto the relation between worker and machine, Asendorf discerns the operations through which subjectivity itself is reified—separated from human beings and displaced onto modern machines. How did electricity participate as mythology in this displacement? Electrical and magnetic sources of power first appeared to conjure up the invisible and to embody the tension between animate and inanimate realms, giving life to this newly reified machine with a human soul. This invisibility demonstrated for the spectator of 18th-century scientific entertainments impossible feats of distant control and the mimetic subjectivity of the inanimate world. Certain *pre*-technological performances, then, can give us some insight into the tense metaphoric operations and interconnections of faith and skepticism, or belief and disbelief, in the staging of new technologies in the image of *l'homme machine*, to use Julien Offray de La Mettrie's famous phrase for the marriage of intelligence and clockwork operations of the human body ([1748] 1912).

The display of invisible forces associated with electrical and magnetic experiments called upon the 19th-century observer to believe in a force that could not be seen beyond its effects. The history of seeing the effects of electrical and magnetic forces crosses with the Enlightenment tradition of rational and mathematical entertainment in the 18th-century dramaturgy of popular scientific lecture-demonstrations in which Leyden jars and automata were the featured performers. Here lies what Barbara Maria Stafford, in her study of Enlightenment forms of "rational recreation," has called "the tension between quackery and pedagogy lurking in instrumentalized or empirical performance" (1993:22–30; see also Stafford 1994 and Altick 1978:64–69, 350–57). The legends surrounding Wolfgang de Kempelen's Automaton Chess Player—a mechanical puppet built in 1769 and costumed as a Turkish sorcerer seated at a chess board, awaiting the challenges of living oppo-

nents—illustrate the belief-inducing theatrical conventions of this genre, "empirical performance." The life-sized figure was dressed in a fur-trimmed cloak and turban and held a long pipe in its right hand, its left arm resting on a pillow. The figure was seated at a large mahogany chest about a meter wide, 80 cm high and 60 cm deep, with two swinging doors and one long drawer in its front. With the assistance of its exhibitor, it would publicly compete with volunteer players, using its mechanical arm to lift each chess piece and drop it into its new position (Hooper and Whyld 1984:363). With its downcast eyes and mustache, the figure suggested the Orientalist fantasy of a sorcerer or fortune-teller.

How and when did the early 19th-century spectator come to believe in technology? How did the operations of theatre participate in the reification of the inventions of science at a moment when technologies were new, even magical in their appearance? My interest is in the faith-inducing dramaturgy of technology thrown into relief by the trick performance. The Chess Player, a landmark in the history of automata, showed mechanism without itself being mechanical, and provoked evaluation of the secret workings of the machine, beyond the spectacle of its effect. Disguised *as* "technology" it presented the impossible, asking the viewer to suspend a certain disbelief. The double negative of this formulation—the suspension of disbelief—points to something more tense, and intentional, than simple belief. This double operation—first, of disbelieving; and, second, of setting aside that initial response in favor of a willing entry into the image, the spectacle, or the conjuring trick—was first named by Coleridge with respect to the faith exercised by the reader of the poetic image (Coleridge [1817] 1907, II:5–6).[1] In this light, the 18th- and 19th-century texts associated with the Automaton Chess Player may be read as descriptive of an early modern form of *technological* faith, depending on a post-Enlightenment skepticism in the face of a new kind of magic.

De Kempelen's Automaton Chess Player was a technological *mysterium*, a secret to be uncovered, and a riddle to be solved, whether it won its game or lost to its volunteer opponent. To Chesterton's list of cultural miracles—the arrow striking its mark and the locomotive striking its distant station—we could add an ancestor from the prior century: the mechanical puppet, costumed as a Turkish sorcerer, moving a chess piece from one square to another, conscious (or so it appeared) of the rules of the game. One contemporary writer, Karl Gottlieb de Windisch, writing from Pressburg, then capital of Hungary, in 1783, titled his series of letters concerning the machine *Inanimate Reason*. "'Tis a *deception*! granted," he writes in a series of letters, enthralled by the machine and its inventor, "but such a one as does honor to human nature; a deception more beautiful, more surprising, more astonishing, than any to be met with, in the different accounts of mathematical recreations" (1784:13).[2]

The preface to these letters refers to de Windisch as "the respectable author of the history and geography of the kingdom of Hungary, and the intimate friend and countryman of [the inventor] M. de Kempelen" and calls the Chess Player "beyond contradiction, the most astonishing Automaton that ever existed." The machine unites:

> the *vis motrix*, to the *vis-directrix*, or, to speak clearer, [demonstrates] the power of moving itself in different directions, as circumstances unforeseen, and depending on the will of any person present, might require.
> (de Windisch 1784:vi)

The power of motion was combined with the willpower to direct that motion in unforeseen directions, cloaked in the figure of a chess-playing Turk; further, this power would be shown as "real" in a series of public perfor-

mances spanning nearly a century in which both the automaton's working action and its inner mechanism were revealed.

The Reveal

Exhibition of the Automaton began with the revelation of its inner mechanism, a set of moves intended to convince the spectator that intelligent machinery was on display (see plate 1). Robert Willis, a Cambridge undergraduate who later became the university's Jacksonian Professor of Applied Mechanics and an archaeologist of England's medieval cathedrals, soberly defines, in an 1821 pamphlet, three categories of automata: the simple, the compound, and the spurious—or, those depending on mechanism alone, those moved by machinery but also in communication with a human agent, and those controlled *solely* by a human agent "under the semblance only of mechanism" (1821: 9–10).[3] Willis sets out to prove that de Kempelen's Automaton belongs to the second category: a hybrid machine aided by a human operator. The problem, for critics of the machine from de Windisch in 1783 to Edgar Allen Poe 50 years later, was to discover the exact location of human agency in the performance. Willis writes:

> [I]t will be evident to any person, even slightly acquainted with mechanics, that the execution of these movements, so extensive, so complicated, and so variable, would be attended with difficulties almost insurmountable; but we will suppose for a moment that these obstacles are overcome; [...] What then? The main object will still be unattained! Where is the intelligence and the "promethean heat" that can animate the Automaton and direct its operations? Not only must an intellectual agent be provided, but between such an agent and his deputy, the Automaton, a direct communication must be formed and preserved, liable to no interruption, and yet so secret that the penetrating eye of the most inquisitive observer may not be able to detect it. (1821:12–13)

The exhibitor addressed the observer's "penetrating eye" in an elaborate mise-en-scène of disclosure framing each performance. He would roll the chest into place on casters to show the lack of any connection with the floor. As a magician reveals "nothing up my sleeve" and "nothing in the box," so de Kempelen (and his successor Johann Maelzel) would open the cabinet, show its back side, part the curtains, open the locked doors, and show the internal wires, rods, gears, and flywheels. Lighted candles would illuminate every internal crevice where a human operator might be concealed. The routine of the "reveal" was elaborate.[4] According to Willis:

> The exhibitor, in order to shew the mechanism, as he informs the spectators, unlocks the door (A, fig. 1) of the chest, which exposes to view a small cupboard, lined with black or dark coloured

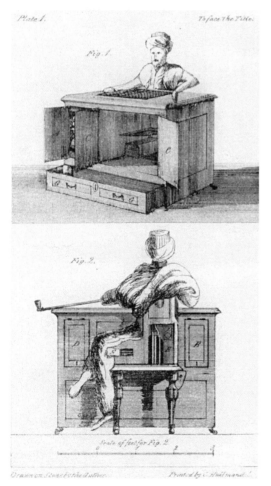

2. Front and rear views of de Kempelen's Automaton Chess Player. (Willis 1821)

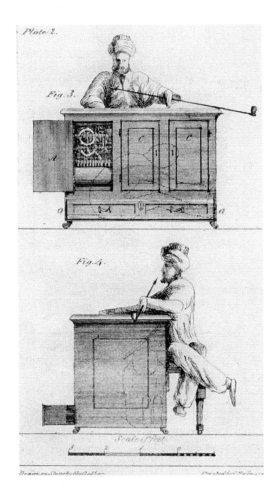

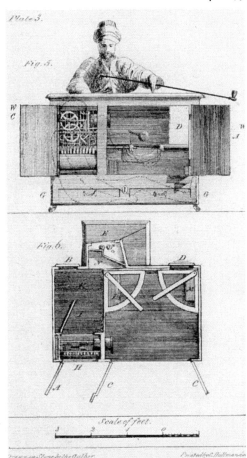

3 & 4. Robert Willis's drawings show the interior organization of the Chess Player's mechanical parts and, in faint pencil outline, the hidden operator of the Chess Player. (1821)

cloth, and containing different pieces of machinery, which seem to occupy the whole space. He next opens the door (B, fig. 2) at the back of the same cupboard, and, holding a lighted candle at the opening, still further exposes the machinery within. (1821:6–7; see plate 2)

Every door is opened in succession. Even the Turk's garments are lifted to show the absence of a human performer. "In all these operations," comments David Brewster, the 19th-century historian of mathematical, scientific, and magical curiosities, "the spectator flatters himself that he has seen in succession every part of the chest, while in reality some parts have been wholly concealed from his view, and others but imperfectly shown [...]" (1832:278). Edgar Allen Poe, describing Maelzel's American exhibition of the Chess Player in Richmond in summer 1834, wrote of this moment of disclosure:

> The interior of the figure, as seen through these apertures, appears to be crowded with machinery. In general, every spectator is now thoroughly satisfied of having beheld and completely scrutinized, at one and the same time, every individual portion of the Automaton, and the idea of any person being concealed in the interior, during so complete an exhibition of that interior, if ever entertained, is immediately dismissed as preposterous in the extreme. (1938:426)

Willis wonders why the machinery is revealed prior to the operation of the Automaton and concealed when it is in motion. Why is the moment of disclosure isolated from the performance itself? And how might this isolation "flatter" the observer? There's the trick:

> The glaring contradiction between eager display on the one hand, and studied concealment on the other, can only be reconciled by considering the exhibition of the mechanism as a mere stratagem, calculated to distract the attention, and mislead the judgment, of the spectators. (1821:18–19; see plates 3 and 4)

Willis concludes that "more is intended by the disclosure than is permitted to meet the eye," an extraordinary statement, considered along with Poe's perception of the automaton's interior, "crowded with machinery," that says something about the performance genre considered here: the spectacle of early technology as an illusion of cause and effect. Both Brewster and Willis acknowledge that de Kempelen never denied that the image of the intelligent machine was an illusion. Brewster's account quotes de Kempelen himself:

> The chess-playing machine, as thus described, was exhibited after its completion in Pressburg, Vienna, and Paris, to thousands, and in 1783 and 1784 it was exhibited in London and different parts of England, without the secret of its movements having been discovered. Its ingenious inventor, who was a gentleman and a man of education, never pretended that the automaton itself really played the game. On the contrary, he distinctly stated, "that the machine was a *bagatelle*, which was not without merit in point of mechanism, but that the effect of it appeared so marvelous only from the boldness of the conception, and the fortunate choice of the methods adopted for promoting the illusion." (1832:272)

De Kempelen never pretended to show magic on the stage. The popularity of the performance of an inanimate object giving the *effect* of the rational and scientific application of mechanical principles to a particular mimetic challenge, the imitation of human reasoning and thought, raises a question: Which conventions of stage magic actually made it appear technological? The Automaton Chess Player enacted a fantasy of mechanical power: that clockwork gears, levers, invisible wires, or magnets could somehow perform enough discrete operations to add up to the faculty of thought, symbolized by chess, a game combining the calculations of reason with the mechanisms of the chess pieces moving on the board.

The author of an 1819 pamphlet, *Observations on the Automaton Chess Player*, identifies himself only as "An Oxford Graduate." In the introduction to his careful explication of the phenomenon of the Chess Player, the Oxford Graduate reminds the reader of the historical moment in which a thinking machine is possible:

> [I]t was reserved to modern times, to witness the invention of those exquisite and grand combinations of mechanism, which are displayed in the numerous kinds of watch and clock work, and in the higher order of wind instruments, in their several varieties. [...] Notwithstanding, however, the superior ingenuity of modern artists, in mechanics, which these scientific inventions discover, it seems to be a thing absolutely impossible, that any piece of mechanism should be invented, which, possessing

perfect mechanical motion, should appear to exert the intelligence of a
reasoning agent. This seeming impossibility is surmounted in the con-
struction of the Automaton Chess Player. (1819:7)

The image is further complicated by its surface. The puppet of the Turk as
the figure of a magician representing a pretechnological order is one of many
representations of the Orient as a site of thaumaturgy.[5] This is the dialectical
tension illustrated in Walter Benjamin's wish-image in the "Theses on the
Philosophy of History" ([1950] 1969)—the dream of a future technology, a
performing machine, costumed in the garb of a mythic time and place, in this
case a past in which magic could provide the "Promethean heat," to recall
Willis's phrase, to drive the inanimate mechanism as though it were alive. In
the case of the Chess Player, the liveness of the machine was theorized as the
power of linear, sequential decision-making, the performance of the art of
chess, in which *thought* itself is performed: a scientific form of enchantment
and the most rational of entertainments.

A Good Deception

It began in 1769 with a challenge, or perhaps a boast, made by the Hungar-
ian engineer and mechanician Farkas de Kempelen, born in 1734, in response
to the arrival of a French inventor named Pelletier at the court of the Empress
Maria Theresa of Austria. Pelletier's exhibition of "certain experiments of
magnetism" prompted de Kempelen to suggest that he could produce "a piece
of mechanism, which should produce effects far more surprising and unac-
countable than those which she then witnessed" (Oxford Graduate 1819:12).[6]
Six months later he appeared before the Empress with the Automaton Chess
Player, also known simply as the Turk.

Little is known of de Kempelen. The anonymous Oxford Graduate, in a
scholarly assessment of the Chess Player published in London in 1819, identi-
fies him most fully as Wolfgang de Kempelen, a Hungarian gentleman, Aulic
Counselor to the Royal Chamber of the domains of the Emperor in Hungary
(1819:11). Charles Michael Carroll suggests that his invention of the moving
arm of the Chess Player contributed to the development of the mechanisms of
artificial limbs. De Kempelen invented a method of printing embossed books
for the blind, a hydraulic system for the fountains at the Schönbrunn Palace, a
machine for producing mechanical speech, and a canal system to link
Budapest with the Adriatic. It is virtually certain that de Kempelen never ex-
pected the Chess Player to have a performing life of 85 years, 50 years beyond
the year of his death in 1804 (Carroll 1975:1–3).

From de Kempelen's death until his own in 1838, Johann Nepomuk
Maelzel was the machine's second exhibitor, arriving in the United States in
1826. Like de Kempelen, he was a Hungarian engineer employed at the court
of Vienna, where he acquired the automaton from de Kempelen's estate.
Much more a showman than his predecessor, Maelzel surrounded the Chess
Player with a touring assortment of mechanical curiosities that included an
Automaton Trumpeter, Automaton Slack-Rope Dancers, and a moving pan-
orama of the Conflagration of Moscow, all exhibits of his own creation (Odell
1970:427, 595).[7] Maelzel performed for extended runs in New York, Boston,
and Philadelphia, where the Chess Player was finally destroyed in the 1854
fire that consumed Peale's Museum.

Both Maelzel and de Kempelen were interested in the mechanical reproduc-
tion of sound and the problem of mechanical speech. On its first tour to Lon-
don in 1783, the Chess Player was exhibited alongside a Speaking Figure, a doll

that faintly, though audibly, answered questions posed to it.[8] In the winter of 1817/18, Maelzel rebuilt the Chess Player to give it the ability to "roll its eyes, move its hands, turn its head, and say in French, *échec et mat*" (Arrington 1960:61). The Chess Player, then, can be seen as part of a large collection of machines imitating the various isolated functions of l'homme machine.

Automata of the late 18th and early 19th centuries could play music, imitate human and animal movements, answer a limited set of questions, and otherwise dazzle audiences with clockwork *tableaux vivants* depicting pastoral scenes populated by articulated animals, angels, cupids, and views inside miniature proscenium theatres. Automata trace their history to the mechanical statues of antiquity—the articulated figures of ancient Egypt and the animated oracles of Greece and Rome. Hero of Alexandria describes machines that demonstrated physical principles, such as mechanical theatres, showing a variety of scenes and driven by water and systems of counterweights. Automaton historians Alfred Chapuis and Edmond Droz date the earliest applications of clockworks to automata to the beginning of the 14th century. The clock tower at Soleure, for instance, dates from 1452 and depicts a warrior beating his chest on the quarter-hours, while a skeleton clutching an arrow turns his head to the soldier on the first stroke of each hour. A 16th-century automaton from Brittany depicts a mechanical crucifixion scene. Automated scenes were similarly depicted in miniature in table- and pocket-clocks from the 16th century on. These clocks often had musical components, including the singing cuckoo, invented about 1730 (Chapuis and Droz 1958:120–21).

In the 18th century, German and Swiss clock makers began to connect clockwork movement with the detailed articulation of figures: rustic porcelain peasants ate potatoes, cobblers stitched tiny shoes, and military bands played their instruments. Chapuis and Droz reproduced an engraving of a large tabletop clock, called simply "the Microcosm," built in 1718 by Henry Bridges at Waltham Abbey in England. Exhibited in 1756 in Philadelphia, the "world in miniature" was described by the *New York Mercury* with the following scenes:

> 1. All the celestial phenomena are shown. 2. The nine Muses, giving a concert. 3. Orpheus in the forest. 4. A carpenter's shop. 5. A delightful grove. 6. A beautiful landscape with a distant view of the sea. 7. Lastly, all the machinery of the piece, including 1,200 wheels and pinions in motion. (in Chapuis and Droz 1958:129)

The final scene, a peek into the backstage workings of the machine, sets the stage upon which the Chess Player must have seemed both a plausible imitation of thought and an extraordinary leap into an impossible mimetic realm.

Engineers, nobility, chess enthusiasts, artists, and mechanics came to Vienna from all over Europe as the word spread that a "modern Prometheus," de Kempelen, had built a machine that could beat a human opponent at the game of chess. It seems that the instant popularity of the automaton caught its engineer quite unprepared for the role of showman. In 1773, roughly three years after the initial exhibition, de Kempelen retired the Chess Player, packing it away in crates in the hope of returning to his more serious work.

The visit to Vienna in 1781 of Grand Duke Paul, future czar of Russia, provided Maria Theresa's successor, her son the Emperor Joseph II, with an incentive to create an entertainment worthy of a distinguished guest, and one that would compete with entertainments planned for the Duke's tour of the capitals of Europe. The Chess Player's revival was ordered. De Kempelen's triumphant performance was rewarded with the Emperor's offer of a leave from his duties for two years for a tour of Europe (Carroll 1975:15).

The touring life of de Kempelen and the Automaton Chess Player began with a visit to Paris, chess capital of Europe, in the spring of 1783. De Kempelen challenged Philidor, chess champion of Paris, to a game played before the Académie des Sciences. The Automaton lost, but not without exhausting the master (Carroll 1975:18). De Kempelen remained in Paris from April through July 1783. By October, he had set up in rooms in London and remained there through 1784, the date of Philip Thicknesse's article, one of the earliest in a long series of analytical writings on, exposés of, and diatribes against the Automaton and its handler:

> When I see a Foreigner come among us, and call a Toy-Shop Doll, a *Speaking Figure*, and demand HALF A CROWN apiece admittance to hear it, and find within an hundred yards another Foreigner, who imposes double that sum to see what he calls an Automaton *Chess-player:*— When I see such men, I say, collecting an immense sum of money in this Kingdom, to carry into some other, by mere tricks, my indignation rises at the folly of my own countrymen, and the arrogance of the imposing strangers. (1784:2–3)

"Mere" tricks. Thicknesse doesn't specify where the trick is located, or even whether he objects to the false spectacle of a machine or the spectacle of an honest chess match with a mechanical Turk. Here is the problem, the source of fascination, and the subject of every published study of the machine: Was it a mechanism? Was it a trick? Or somehow both? The Automaton raised the question: Where does human agency end and mechanical agency begin? De Kempelen never denied that the machine was an "illusion." And yet, the spectacle of a human antagonist setting his powers of logic against a mechanical doll dressed in Turkish costume spoke to the imagination of its spectators, raising the idea that an automaton could not only move and perform *like clockwork*, but that it could mimic human logic and complex thought.

Clockwork automata and mechanical spectacles had been exhibited for decades prior to the Chess Player's arrival in London. The French inventor Jacques de Vaucanson, born in Grenôble in 1709, exhibited a flute player, a tabor and pipe player, and the infamous mechanical duck in the Opera House at Haymarket, London, four times daily in 1742 (Altick 1978:64–65). The duck was renowned for its ability to eat, digest, and excrete its food. Jean Eugène Robert-Houdin, a conjurer of mythic stature, an award-winning inventor, and builder of clockwork automata, saw the duck, which was later to be exhibited after its inventor's death at the Palais Royal in 1844, alongside Robert-Houdin's own automaton. In his memoir, he reveals the duck's secret:

> Of course I was one of the first to visit it, and was much struck by its skillful and learned formation. Some time after, one of its wings having been injured, the duck was sent to me to repair, and I was initiated into the famous mystery of digestion. [...] The trick was as simple as it was interesting. A vase, containing seed steeped in water, was placed before the bird. The motion of the bill in dabbling crushed the food, and facilitated its introduction into a pipe placed beneath the lower bill. The water and seed thus swallowed fell into a box placed under the bird's stomach, which was emptied every three or four days. The other part of the operation was thus effected: Bread–crumb, colored green, was expelled by a forcing pump, and carefully caught on a silver salver as the result of artificial digestion. This was handed round to be admired, while the ingenious trickster laughed in his sleeve at the credulity of the public. ([1859] 1944:146–47)

Both the mechanical duck and the Chess Player inhabit a hybrid realm, with respect to their status as performing objects. Machines *and* spectacles of mechanism, both were ingeniously assisted by an invisible hand.

Robert-Houdin tells a largely fictitious story of the Chess Player in his memoir, with the dramatic flair of a showman. It enters into the folklore of the automaton as the most fanciful and factually suspect account of the machine's secret, beginning as it does, not with a narrative of mechanical invention, but with the life of the first man to operate the Player from within, a certain Worousky, a Polish officer in a half-Russian, half-Polish regiment stationed at Riga in 1796. The leader of a group of rebel soldiers, Worousky is wounded in battle with the reinforcements from St. Petersburg. A benevolent doctor conceals him and, after the onset of gangrene, his life is saved only by the amputation of the lower half of his body ([1859] 1944:148–49).

"M. de Kempelen, a celebrated Viennese mechanician" encounters Worousky on his travels dedicated to the study of foreign languages and their mechanisms. The Automaton Chess Player enters as a prop in a rescue scheme: a hiding place in which to smuggle the body of Worousky out of the doctor's care and across the Russian border. Worousky, in his convalescence, had become, it seems, a formidable chess player.

In Robert-Houdin's breathless telling of the tale, Worousky and de Kempelen escape Russia only by duping chess players at exhibitions in Toula, Kalouga, Smolensk, Vitebsk, and finally before the Empress Catherine herself, who offers to buy the curiosity. Robert-Houdin narrates the genealogy of the Chess Player in the hyperbolic style of a conjurer, as a short melodrama. Robert-Houdin was an innovator in the staging of trickery, in determining how to trick the eye with a variety of electrical, magnetic, mechanical, and purely visual means. Robert-Houdin's tale of how he came to see the "precious relic" is included as an entry in a memoir of stage deceptions that belonged to a form of nonmagical magic, the 19th century's answer to the alchemist's blending of artistry, mysticism, and science. His story, however, is a historical bit of conjuring; while he catches the spirit of the mythic force of the machine's reception, his facts are largely fanciful, as was the replica Chess Player that he built for the Paris stage in 1868, a theatrical copy of a scientific fake in a historical scene that never took place.

A Man within a Man

Philip Thicknesse begins with the premise that the machine is "UTTERLY IMPOSSIBLE" (1784:5). The demystifying and debunking literature surrounding the Turk in its travels from London to Philadelphia (even the revelation in print of its secret by one of the operator's confederates in Paris in 1834) did not diminish the Automaton's steady popularity as an attraction and curiosity. Thicknesse concludes his 1784 pamphlet with a linguistic exposure: "[T]he Automaton Chess-Player is *a man 'within a man*; for whatever his outward form be composed of, he bears a living soul within" (1784:16; see plate 5).

Whether we consider it a conjuring show, a scientific demonstration, or a traveling curiosity, the case of the Chess Player was an anomaly. It appeared mechanical, demonstrating mechanism. If it seemed credible as a machine capable of the acrobatics of logic required to play an opponent at chess, then it could only be so by virtue of its staging, its framing narrative and commentary. The popular narratives of the Chess Player consisted of a series of stories, some more plausible than others, of its matches with famous figures of history (Catherine the Great in St. Petersburg; Napoleon in Vienna; Benjamin Franklin in Paris) and elaborate variations on the theory of the machine's secret: the method of

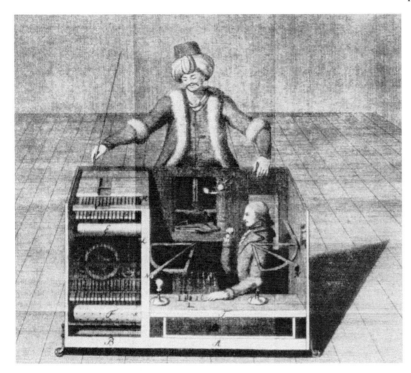

5. *De Windisch's illustration reveals a man within a man. (Copper-plate illustration in de Windisch 1784)*

concealment of an unseen, living player. Yet even Thicknesse, the most irate of the lot, seems to have no quarrel with the Automaton after his own righteous revelation of its workings. His demystification is respectful, admiring of the ingenuity of the performance, up to a point. "And I was one of the many who have paid fifteen shillings to show my family the figure of a Turk," he writes:

> which has a moveable arm, a thumb, two clumsy fingers, which, by pulling a string within the arm can embrace or leave a Chessman, just where *a living hand directs it.* Let the Exhibitor, therefore, call it a GOOD DE-CEPTION, and I will subscribe to the truth of it; but while he draws a large sum of money from us, under the *assurances of its being an Automaton* that moves by mechanic powers, he endeavours to deceive, and it is fair game to expose it, that the price at least may be reduced. For I confess it is a curiosity, and I believe as much money would be received at one shilling each, as is gained by demanding five. (1784:15)

A deception, but a good deception? Worth one shilling per view, but not five? What sort of exposure is this? Certainly not one hostile to the performance of the machine, only to its assumed claim to transparency, to technological truth. The image of the machine as it clicks, whirrs, creaks, and thumps, lifting the piece from the board, dropping it in its new position, eyes rolling and head turning, is separated from the intelligence that operates it by an invisible linear method of control. The variety of accounts of the machine and its secret belies the spectator's moment of uncertainty, in which disbelief that a machine can think is momentarily suspended. The normative relationship of authority between people and objects is briefly questioned, then set back into its rational, everyday hierarchy.

Belief and Unmasking

The Chess Player highlights the crucial role of the observer's simultaneous belief and skepticism in evaluating the object on display, presenting a limit-case in the development of a theatre of machines: part puppet show, part scientific demonstration, part conjuring trick. The Chess Player, which appeared driven by magnetic or possibly electrical forces, gave life for nearly a century to the ideal of an intelligent machine, an image that Walter Benjamin adapts from the "ur-history" of the 19th century.

Organizing his *Passagen-Werk* notes on historical progress into the "Theses on the Philosophy of History," Benjamin begins, employing the introductory language of the fairy tale, with an image of the Automaton Chess Player. "The story is told of an automaton," he begins, inside which, hidden by mirrors, sits a "little hunchback, who was an expert chess player," who guides the arm and hand of the false machine (see plate 6). Benjamin uses this model as an allegory for an ever-victorious, progress-driven "historical materialism" concealing within its armature a hidden figure whom Benjamin equates with "theology, which today, as we know, is wizened and has to keep out of sight" ([1950] 1969:253). Writing in 1940, Benjamin embeds the 18th-century Chess Player in high, modernist, philosophical allegory, figuring the dialectical relation between the outward appearance of linear, historical, secular time and the hidden influence and weak magnetic pull of messianic time, part revolutionary, part sacred. Benjamin's parable is a ghostly afterimage of early modernity, a final staging of the Automaton Chess Player as "wish-image."

In the Arcades Project files, Benjamin quotes Jules Michelet: "Every epoch dreams its successor." In his fragments for a critique of the notion of historical progress, Benjamin formulates the idea of the "wish-image," the mythic point at which past and future historical trajectories cross in the form of an image rescued by the Marxist historian from a temporal distance. Fanciful, early modern forms of architecture and technology could be perceived as such wish-images, provided they were considered through the shock of historical discontinuity. New technologies of the 19th century were clothed in the forms of ur-history, of the mythic past. "Just what forms, now lying concealed within machines," Benjamin writes, paraphrasing Marx, "will be determining for our epoch we are only beginning to surmise" (in Buck-Morss 1989:115; see also Benjamin 1983–84:1–40). Theology is revealed as the puppeteer. Benjamin's use of the term "theology" here is compelling, leading one to look beneath the surface appearance of technological phenomena for an element of object performance that is similarly kept out of sight. A "machine" is performed in the Chess Player's story; and yet, there is no machine and the

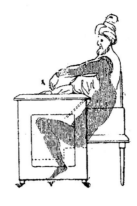

6. *A study of the postures required by the operator concealed within the Automaton Chess Player. (Illustration in Brewster 1832)*

reveal of the mechanics is a further concealment, a classic turn in the dramaturgy of the conjurer, who operates through the careful encouragement of distraction in the observer who willingly suspends disbelief in the machine.

The Chess Player was a dramaturgical hybrid of theatre, magic, and science, presented by an exhibitor—at once stage illusionist, conjurer and prestidigitator, sideshow talker, and mechanical engineer—and employing a choreography of momentary concealment and subsequent revelation, generating in the attentive observer alternate responses of skepticism at the impossible and belief that the secret of the trick, like the pea in the shell game, would be revealed. Like a traditional puppeteer, the exhibitor possessed a mix of verbal and manual dexterity, the reverence for objects and their capacity for enchantment.

In an essay on the magical practices of folk healers, the operations of skepticism and belief in everyday uses of magic, and the literature of enlightened explanation of the shaman's magic within Western cultural anthropology, Michael Taussig writes "another theory of magic" that proceeds from this proposition: "The real skill of the practitioner lies not in skilled concealment but in the skilled revelation of skilled concealment" (1998:222). In other words, partial acknowledgment of the trick *supports* the success of the performance. Though the essay refers to quite a different epistemological terrain, the linking element is the performing object, which stands in for, among other things, the disease to be extracted from the body of the patient. Again, the "trick" of the trick is that the spectator knows, and suspends disbelief in, the operation at work. Taussig offers a theory of how magic "works" given this paradox.

> Magic is efficacious not despite the trick but on account of its exposure. The mystery is heightened, not dissipated, by unmasking and in various ways, direct and oblique, ritual serves as a stage for so many unmaskings. Hence power flows not from masking but from unmasking which masks more than masking. (1998:222)

Unmasking as a form of further masking? This begins to account for the success of the pseudo-technological puppet show, the "enlightened Turk," along with its polite literature of respectful unmasking. Its dramaturgy took the form of an elaborate sequence of "reveals," the reveal being the basic gesture of the curiosity exhibition, a hybrid genre that always suggests fraud, sleight-of-hand, and artifice. The reveal that distracts and thereby conceals is the essence of the nothing-up-my-sleeve gesture of the conjurer.

The display of the machine raised the potential of fraud, the request for assessment, for exposure or the spectator's acceptance. Keeping in mind Taussig's "other" theory of magic, I would wonder whether the gesture of demystification

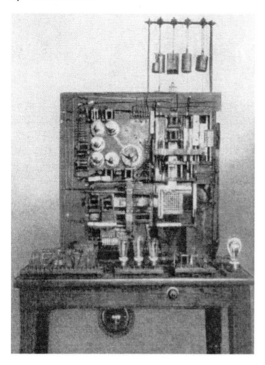

7. An early 20th-century chess-playing machine, built by Torrs y Quevedo, used electro-magnets and a gramophone record to utter "checkmate." (Photo courtesy of Mark Sussman)

wasn't bound up with the successful enchantment and wonder the Automaton must have provoked. For the Chess Player was both a popular success and a fraud. And, though it was not in itself an electrical or magnetic apparatus, it could only perform plausibly within the new conventions of scientific display of electrical and magnetic phenomena. The automatic thinking machine that concealed, in reality, a human person, can be seen as a model for how a spectator might reify, and deify, the hidden power at work in a new form of intelligent machinery, from the primitive forms of the Leyden jar or the electrical dynamo to IBM's RS/6000 SP supercomputer, nicknamed Deep Blue, which defeated world chess champion Garry Kasparov in a six-game match lasting ten days in May 1997 (Weber 1997:A1; see plate 7). In the Automaton Chess Player, electric power was enacted as the inner life of the machine, pulling its strings with invisible wires, smartly winning the game. The visual proof was, first, the demonstration of control at a distance; and, second, the transmission of human intelligence into the inanimate body of the object: the performing object that animates both demystification and reenchantment.

Notes

1. S.T. Coleridge, in his literary biography, discusses the relation of verisimilitude and the poetic imagination: "[T]he two cardinal points of poetry, the power of exciting the sympathy of the reader by a faithful adherence to the truth of nature, and the power of giving the interest of novelty by the modifying colors of the imagination." A balance of these elements produces "a human interest and a semblance of truth sufficient to procure for these shadows of imagination that willing suspension of disbelief for the moment, which constitutes poetic faith" (1907 [1817]:5–6).

2. French editions of the de Windisch letters were published in Paris and Basel, and a German edition appeared in Pressburg, all in 1783, the year the letters are dated. It appeared in Dutch in Amsterdam in 1785. Charles Carroll speculates that de Windisch acted in collaboration with de Kempelen as an advance man, publishing these letters in the vernacular of cities where the Automaton was exhibited "to titillate the prospective viewer" (Carroll 1975:18; see also Chapuis and Droz 1958:364).

3. Like de Kempelen, Willis was also the builder of a mechanical speaking machine (see Chapuis and Droz 1958:322; Altick 1978:352).

4. The term "reveal" bears a particular meaning in contemporary theatre practice, specifically in the field of industrial theatre—corporate events staged to reveal new products, from the next model of automobile to the latest antidepressant drug—to an audience of industry insiders (see Bell 1987:36–57).

5. Thomas Frost, for instance, describes the 1805 exibition in London of an automaton "in Turkish costume, that performed conjuring tricks with cards," by an Italian entertainer named Bologna (1876:167).

6. Brewster refers to "some magnetic performances, which one Pelletier, a Frenchman, was to exhibit before the late Empress" (1832:40). Asendorf shows an illustration from Hamburg (c. 1800) of a machine that subjected the willing victim, seeking a modern form of amusement, to an electric shock (1993:54).

7. Maelzel's program was exhibited at Tammany Hall in New York, May 1829. In later years, he would add a "Melodium" and a "Mechanical Theatre" to the bill.

8. Maelzel's Paris company built and distributed the earliest metronomes, a simpler adaptation of the mechanics of clockwork to music; his claim to the invention of the device was disputed by a rival Belgian inventor.

References

Altick, Richard D.
1978 *The Shows of London.* Cambridge and London: Belknap/Harvard University
 Press.

Arrington, Joseph Earl
1960 "John Maelzel, Master Showman of Automata and Panoramas." *Pennsylvania
 Magazine of History and Biography* 84, 1:56–92.

Asendorf, Christoph
1993 *Batteries of Life: On the History of Things and their Perception in Modernity.*
 Translated by Don Reneau. Berkeley: University of California Press.

Bell, John
1987 "Industrials: American Business Theatre in the '80s." *TDR* 31, 4 (T116):36–57.

Benjamin, Walter
1969 [1950] "Theses on the Philosophy of History." In *Illuminations,* translated by Harry
 Zohn, 253–64. New York: Schocken Books.
1983–84 "N[Theoretics of Knowledge, Theory of Progress]." Translated by Leigh
 Hafrey and Richard Sieburth. *The Philosophical Forum* 15, 1–2:1–40.

Brewster, David
1832 *Letters on Natural Magic Addressed to Sir Walter Scott.* London: John Murray.

Buck-Morss, Susan
1989 *The Dialectics of Seeing: Walter Benjamin and the Arcades Project.* Cambridge,
 MA: MIT Press.

Carroll, Charles Michael
1975 *The Great Chess Automaton.* New York: Dover.

Chapuis, Alfred, and Edmond Droz
1958 *Automata: A Historical and Technological Study.* Translated by Alec Reid.
 Neuchatel: Editions du Griffon.

Chesterton, G.K.
1986 [1908] *The Man Who Was Thursday: A Nightmare.* London: Penguin Books.

Coleridge, S.T.
1907 [1817] *Biographia Literaria, or Biographical Sketches of My Literary Life and Opinions,*
 vol. II. Edited by J. Shawcross. Oxford: Clarendon Press.

Frost, Thomas
1876 *The Lives of the Conjurers.* London: Tinsley Bros.

Hooper, David, and Kenneth Whyld, eds.
1984 *The Oxford Companion to Chess.* Oxford and New York: Oxford University
 Press.

La Mettrie, Julien Offray de
1912 [1748] *Man A Machine.* Translated by Gertrude Carman Bussey. LaSalle, IL: Open
 Court.

Odell, George C.
1970 *Annals of the New York Stage,* vol. 3. New York: AMS Press.

Oxford Graduate, An
1819 *Observations on the Automaton Chess Player, Now Exhibited in London at 4,
 Spring Gardens.* London: J. Hatchard.

Poe, Edgar Allen
1938 "Maelzel's Chess Player." In *The Complete Tales and Poems of Edgar Allen Poe,*
 421–39. New York: Modern Library.

Robert-Houdin, Jean Eugène
1944 [1859] *Memoirs of Robert-Houdin.* Translated by R. Shelton Mackenzie. Minneapolis:
 Carl W. Jones.

Stafford, Barbara Maria

1993 "Conjuring: How the Virtuoso Romantic Learned from the Enlightened Charlatan." *Art Journal* 52:22–30.

1994 *Artful Science: Enlightenment Education and the Eclipse of Visual Education*. Cambridge, MA: MIT Press.

Taussig, Michael

1998 "Viscerality, Faith and Skepticism: Another Theory of Magic." In *In Near Ruins: Cultural Theory at the End of the Century*, edited by Nicholas B. Dirks, 221–56. Minneapolis: University of Minnesota Press.

Thicknesse, Philip

1784 *The Speaking Figure and the Automaton Chess-Player Exposed and Detected*. London: John Stockdale.

Weber, Bruce

1997 "Swift and Slashing, Computer Topples Kasparov." *The New York Times*, 12 May:A1, B4.

Willis, Robert

1821 *An Attempt to Analyse the Automaton Chess Player of Mr. de Kempelen*. London: J. Booth.

Windisch, M. Karl Gottlieb de

1784 *Inanimate Reason; or a Circumstantial Account of that Astonishing Piece of Mechanism, M. de Kempelen's Chess-Player; now Exhibiting at No. 8, Savile-Row, Burlington Gardens*. Preface by Chrétien de Mechel. London: S. Bladon.

Czech Puppet Theatre
and Russian Folk Theatre

Pyotr Bogatyrev

Ed. note: We present this essay, translated for the first time from Russian (and Czech) into English, both for its insights into traditional Czech and Russian popular theatre and, perhaps even more importantly, as a pivotal document in the development of 20th-century theory of puppet theatre. In the early 1920s Pyotr Bogatyrev and Roman Jakobson began publishing texts of the Moscow Linguistic School as a means of applying the semiotic theories of Ferdinand de Saussure to the practical situation of contemporary culture. In Soviet Russia contemporary culture was affected both by the practical urgencies of industrial development and long-standing interests in folk culture going back to Russian symbolism at the turn of the century. The Moscow School saw the importance of Bogatyrev's essay in its attention to folk theatre as an area worthy of study, and particularly in its focus on the importance of the word structures in performance, at a moment when Russian theatrical experimentation had developed alternative languages of image and gesture. But, perhaps more importantly from our perspective, Bogatyrev's essay marks a moment where a recognition of the richness of the words used in puppet theatre began to open up a whole new body of semiotic studies: the development of performing object theories undertaken by the successor to the Moscow School, which Bogatyrev and Jakobson began in Prague in 1928. These structural theories of the Prague Linguistic Circle (or "Prague School") examined the function not only of words, but objects, and provided the foundation on which the performing object theories that followed are based. The essay was first published in 1923 as part of the Collections on the Theory of the Poetic Language. *We have had to make a number of cuts and these are indicated by "[...]."*

1. Czech Puppet Theatre

A strong case for puppet theatre is made by its admirers and followers. Among them we find such names as Plato, Aristotle, Horace, Marcus Aurelius, Apulius, Shakespeare, Cervantes, Molière, Swift, Fielding, Voltaire, Goethe, Byron, Beranger, and others. In recent years there has been a pull towards puppet theatre amongst many great men of the theatre. Bernard Shaw recommends that all actors "go to the puppet theatre." "Every school of drama," in his opinion, "should have its own puppet theatre." The famous English director Gordon Craig gives high praise to puppet theatre. The great Russian directors Yevreinov, Meyerhold, and Tairov give a great deal of consideration to

puppet theatre in their theoretical work and borrow from its technique for their own productions. Not long ago, at the state theatre in Berlin, there were stagings of Molière's comedies *George Dandin* and *The Doctor in Spite of Himself* in which the movement of the actors was stylized after that of puppets.

In this section I will offer information about puppet theatre in Czechoslovakia, a country where puppet theatre plays a prominent role in cultural life. I will not simply assert this but cite statistics: at present in Czechoslovakia there are 1,000 folk puppet theatres, 2,000 puppet theatres connected to schools and cultural organizations, and innumerable family puppet theatres which are not counted in any official tally. The numbers speak for themselves.

In Czechoslovakia the two most prevalent forms of puppet theatre are *loutkové divadlo*, in which the puppets are manipulated with the help of strings, and the so-called *bramborové divadlo* [literally "potato theatre"], in which puppets are worn on the hands and are moved by the fingers. Brabmorové divadlo is less prevalent in Czechoslovakia than loutkové divadlo and has been kept alive primarily by folk puppeteers.

At a fair in Prague I saw a pantomime done by folk puppeteers in the bramborové divadlo style. Kašpárek and the Jew appear on the stage. Kašpárek gets into a fight with the Jew, kills him, and hides him in the coffin. The Jew's wife arrives. She has come to mourn her husband. Kašpárek kills the widow too and hides her in the coffin. The Devil appears. He brings in a gallows and orders Kašpárek to put his head in the noose. Kašpárek asks the Devil to teach him how to do it. The Devil puts the noose over his own head, and Kašpárek pulls the noose and throws the Devil in the same coffin. At the end of the performance Kašpárek and his friend throw a live mouse (which throughout the performance has been sitting on the other side of the footlights) into the air and catch it in mid-flight. And with that, the simple performance comes to an end. The hostess of the bramborové divadlo circulates among the public and collects voluntary donations in a dish . . . And then the same performance begins all over again.

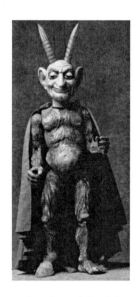

1. A traditional Devil, by Dušan Petráň (1991). (Photo by Orlando Marra; courtesy of Vít Hořejš of the Czechoslovak American Marionnette Theater)

The majority of theatres connected to schools and cultural institutions are essentially loutkové divadlo, theatres of puppets on strings.

We will now take a look at the practical aims of educational puppet theatre. Puppet theatre in Czechoslovakia is used as a pedagogical tool. More often than not children experience their first contact with native literature and folktales in schools by means of puppet theatre. The majority of contemporary puppet plays are adaptations of native folktales. In one Czech middle school *Elektra* and *Hamlet* were staged in the puppet theatre. For the production of *Elektra* an exact replica of a Greek stage was built. The performance was directed by one of Czechoslovakia's best scholars of classical theatre, University Professor [Josef] Král. The students themselves operated the puppets and spoke their lines. It is not uncommon for elementary school children to participate in puppet theatre productions. The teacher reads a story and the children each take a puppet and perform the story on their own. One teacher explained that in places where there is a mixed population of Czechs and Hungarians, Czech children rushed to Czech schools primarily because they have puppet theatres, while the Hungarian schools do not. In this way, puppets are used to defend national identity.

Currently there is an attempt in Czechoslovakia to use puppet theatre for the dissemination of medical propaganda. A Czech doctor wrote a medical play with the following characters: Infectious Bacteria, Fly, Shoemaker, and Kašpárek—a comic character who appears in almost all puppet theatre plays. The Shoemaker lives in a little room that he never airs out or cleans. Infectious Bacteria sneaks up on the Shoemaker. The Fly, Bacteria's assistant, tries to infect every corner of the domicile. Kašpárek sees trouble coming, and de-

spite the protests of the Shoemaker, flings the windows wide open, ventilating the room and embarking on a battle against the enemies of humanity.

Now let us look at artistic trends in Czech puppet theatre. The naturalistic trend comes from folk puppeteers. The main goal of the advocates of the naturalistic trend is to so master their materials that the public will forget they are watching wooden puppets instead of human beings. [...] I had the good fortune of being backstage at the largest puppet theatre in Czechoslovakia, located in Pilsen [*Loutkové divadlo ceskich ferialnick osad*]. The director and head of this theatre is the old folk puppeteer [Katel] Novák, who has been working with string puppets for nearly 50 years. You have to hear the passion with which he recites the lines of his wooden actors. The old nationalistic historic drama *The Death of Žižka* was playing. Žižka is fatally wounded in battle and on his deathbed learns of his troops' victory. Novák pronounced the dying words with such grand emotion that the old puppeteer himself nearly cried. As soon as Novák takes a puppet in his hands it comes to life. Every word is accompanied by a corresponding movement of arms, legs, head, and body. Such puppeteers bring their wooden actors to life so completely that not only do they convince their public that the puppets are "living people," but they half believe it themselves. One begins to understand the tales told about old Czech folk puppeteers. For example, a puppeteer was summoned to court and accused of launching political attacks from the stage of the puppet theatre. He appeared in court with Kašpárek in his hands, and announced that he was completely innocent because everything was Kašpárek's fault.

2. A 1920s photo of traditional Czech puppets made in the 19th century by an unknown carver in New York City's Czech-American community. From left: Game Warden, Woman, Devil, a Peasant dressed as a Robber, Peasant Woman, Turk, and two Bearded Men. (Photo by Sherril Schell; courtesy of Jan Hus Church and Neighborhood House)

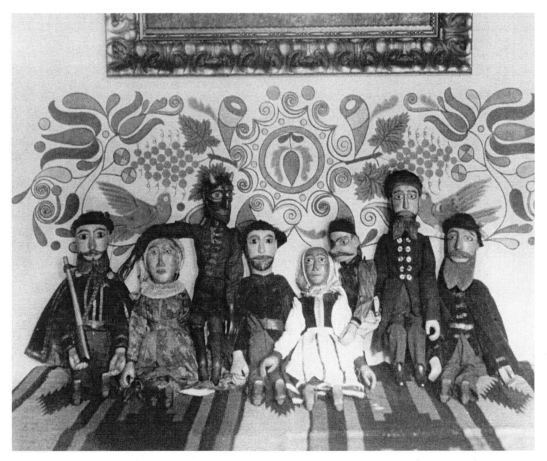

It is important to note that during the nationalist revival [of the 19th century] puppeteers played a large role in native-language propaganda by performing in Czech. When the authorities tried to force famous folk puppeteer [Matej] Kopecký to perform in German, Kopecký cunningly replied that although he could speak German, his puppets did not know that language. Notwithstanding the general tendency toward naturalism, there have been a number of nonnaturalistic conventions in folk puppet theatre that still fit within the naturalistic trend; for example, the conventional declamation style of various puppet characters. Some schools go even further, and use colloquial speech in their puppet shows instead of conventional declamation, thus taking the naturalistic tendency of folk puppeteers to the point of the absurd.

In opposition to the naturalistic trend and its efforts to imitate the theatre of living actors, a new trend has emerged among many puppet theatre directors in which the puppet faces and bodies are stylized. (One folk puppeteer remarked with contempt that these puppets look nothing like people.) The art of these puppets is to maintain rather than lose their puppet nature, so that with their awkward, stylized movement they will achieve the greatest expressiveness possible—which not even living actors have yet been able to attain. Obviously, this new trend has advantages over naturalism.

This, in brief, is the current state of Czech puppet theatre.

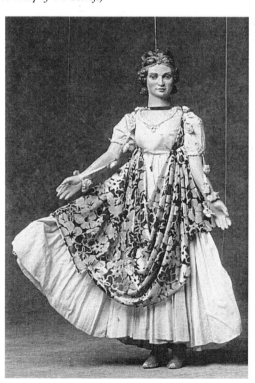

3. A Queen puppet, carved in the 1920s by a member of the Král family of Bohemia, and used by Matej Kopecký VI and his son Miroslav Kopecký. (Photo by Orlando Marra; courtesy of Vit Hořejš)

2. Russian Folk Theatre

Until recent years Russian folk theatre has remained aesthetically foreign and unacceptable to students of Russian literature. [...] Everything "beautiful" in folklore, everything aesthetically pleasing to the researcher, is projected by him into antiquity and considered an echo of the past.

Everything that from an aesthetic point of view is foreign is declared a recent degeneration, and considered the result of the recent corrupting influence of the city and factory. [...] The history of folklore according to researchers is considered a history of poetic degradation, gradual perversion, and oblivion. The works of oral tradition, in their present context and in the context of their gradual development over time, are of little interest to today's researchers. [...] The anthropological school regards folklore from the point of view of paleontological linguistics, in which it exists as a graveyard of primitive man's cultural experiences. The mythological school, which presents itself not from a historical perspective but as a part of the past itself, searches folklore for echoes of ancient beliefs in the form of myths. The theory of intertextuality does not value concrete evidence of a poetic work, nor the laws shaping it, but rather the existence of a particular "x" which becomes evident and remains present throughout all of the work's migrations. For the historical school the poetic work is valued first and foremost as a historical document, the evidence of historico-cultural facts. Clearly, only the initial form of the work of art will interest the proponent of this movement, or else only those later layers that are not caused by the laws of artistic evolution, but which directly reflect the phenomena of social life. Naturally, Russian folk theatre, whose recent literary origin is evident, and which lacks any form of

documentary material or evidence, did not attract the attention of researchers. [...]

We will digress slightly to explain the reasons why folk theatre is an important topic for research. Scholars coming from the romantic outlook perceived a sharp contrast between the oral tradition, which they saw as a product of collective creation, and literature, which they considered an individual creation. The very idea of a collective creativity was confusing enough to provoke a strong reaction among the practitioners of this newest of scholarly pursuits. Today the view that so-called "folk creation" in actuality is no different from "individual" creation is beginning to prevail. More and more attention is paid to the individuality of the storyteller, and to those alterations he makes in "his" performance. [...]

Another characteristic feature that distinguishes folk drama as an advantageous object of study [...] is its intelligibility due to the recent nature of many of its literary origins. [...] In folk theatre, we can make an almost direct comparison between the poetics of the original source and the poetics of an episode as it appears in its borrowed form. It has been shown repeatedly that the study of folk theatre could provide very interesting results and could in part clear up many questions about the people themselves. Once again let us stress that folk drama is not a fragment of the past, nor is it an artistic relic. [...] Folk drama lives and evolves together with the people, reflecting their own most pressing needs and everyday poetics. [...] In a stylistic analysis of the speech of characters from Czech puppet theatre I have presented numerous stylistic parallels from Russian folk theatre.

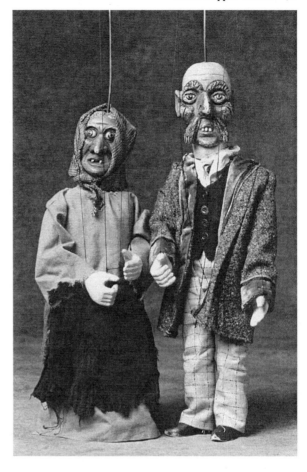

4. An Old Man and a Witch by two unknown Czech folk carvers, c. 1900. (Photo by Orlando Marra; courtesy of Vit Hořejš)

3. The Common Character of Stylistic Methods in Czech Puppet and Russian Folk Theatre

Now we will examine the style of speech of the comic characters in Czech puppet theatre (mainly the roles of Kašpárek and the peasants), and compare it to the speech style of the comic characters of Russian folk theatre. We will examine oxymoron, metathesis, play with synonyms and homonyms, repetition, and so on.

Oxymoron

By oxymoron we mean the combination of an attribute and a defined object in which the existing meaning of the attribute is the opposite of the existing meaning of the object. The attribute may be an adjective referring to a noun, a verb referring to a noun, and so forth. Here are some examples.

Adjective + Noun. In one Czech play, Kašpárek says: "Only I and the deaf-and-dumb Shouter somehow escaped." We come across similar constructions in Russian folk theatre. In *Tsar Maximillian*, the deacon says: "There stands a

rutabaga church, with carrot doors, and turnip locks." We come across an even more complex case in a Czech play. A list of nouns describing a conceptual whole is given, but the adjectives applied to the nouns as a group describe them as if they are only a part of the conceptual whole: "Men and women are the worst people in the world" (Vesely 1914–1916, 3:57).

Noun + Noun. In one Czech play we find: "Wait, who is called Zan around here? (About himself) Matvej? No, that's not it—I'm Matvej. Fedra? No, he's Fedra" (Vesely 1914–1916, 1).

Verb + Noun. In a Czech play the character Voříšek answers a student's declaration that a flute is missing a valve with the following: "That hole fell out" (Vesely 1914–1916, 1). We find the same thing in Russian folk theatre. In one play, a Priest says: "The deceased old kook! Died on Tuesday./ We've come to bury him./ He's looking out the window" (Ončukov 1911:134). [...]

Verb + Adjective. Kašpárek: "So I'll come a dead man" (Vesely 1914–1916:75).

We also count as oxymorons the combination of two or more phrases that speak of the same thing but have opposite meanings. For example, the puppeteer St. Karfiol always said, "Let me in front and I'll follow you" (Vesely 1914–1916, 1:3). In a Czech play a lamplighter declares: "Now I must reform myself: I can't drink beer for I forgot to light the lamps and for that I was beaten. Now I will drink vodka every quarter of an hour" (Vesely 1914–1916, 1:3). We find something similar in the speech of the deacon in *Tsar Maximillian*. At first the deacon declares that it is not possible to do anything easier, but then does something considerably more difficult. He says: "I see a stump/ And in the stump a hole!/ I stick my finger in the hole/ But it doesn't come out;/ I put a pole in/ But it doesn't pass through;/ I got angry and went in there myself" (Vinogradov 1914, version II:81). This type of oxymoron, constructed around the opposition of two or more phrases, often appears in Russian folk theatre. [...]

5. *Kašpárek, by an unknown Czech carver, c. 1900. (Photo by Orlando Marra; courtesy of Vit Hořejš)*

Metathesis

By metathesis we mean the transposition of separate parts of a word or parts of a phrase, one in the place of the other. The parts of a word are rearranged.

In one Czech play we find:

STUDENT: I am a stoor pudent [*studej chudent*].

VOŘÍŠEK: Who are you?

STUDENT: Pardon me, I meant to say I am a poor student [*chudej student*]. (Vesely 1914–1916, 1:92)

Individual words within a phrase are also transposed: "I pump the log full of firewood and chop the bucket full of water" (Vesely 1914–1916, 3:22). [...] In *Faust*, Wagner says to Kašpárek: "Let's go home and chop firewood and draw water." Kašpárek answers: "What are you saying? I must chop water and draw firewood." Some puppeteers

will reverse the parts of the word: "waw drater" [*štipi dřvati*]. One can also find metathesis in Russian folk theatre. For example, in the play *The Naked Lord*, take the following conversation between a lord and a village elder:[1]

GENTLEMAN: Did my stallion really croak [*pokolel*]?

ELDER: He died, my lord (*pomer*).

GENTLEMAN: You're sure he croaked?

ELDER: He's dead.

GENTLEMAN: Well tell me how he croaked.

ELDER: I'll tell you why he died: As soon as your dear mama, the one-eyed bitch, croaked, they carried her to the cemetery. He was upset, became over-excited, and broke his leg and died right there.

GENTLEMAN: What do you mean my mama died?

ELDER: The old bitch croaked.

GENTLEMAN: You're sure she died?

ELDER: Sure. She croaked.

GENTLEMAN: Do you see, Maria Ivanovna, horses die and people croak. (Ončukov 1911)

Synonym

[...] As an example of play with synonyms, I will offer the [...] phrase of the King from a Czech puppet play: "Buy yourself two ropes, hang yourself on one [*na tom jednom obes sebe*], and on the other be hanged [*a na tom druhym tebe*]." In Russian folk theatre, play with synonyms can be found in *The Naked Lord*.

GENTLEMAN: How can this be? I had wine cellars, cellars full of Rhine wine.

OLD MAN: There were, sir. We went down there once and found two bottles of Rhine wine, took 'em, and they got smashed.

GENTLEMAN: Did you drink them?

OLD MAN: No, [we] got smashed. (Ončukov 1911)

Homonym

Often in the plays of Czech puppet theatre we come across homonyms—words that sound the same but have different meanings.

STUDENT: I make my living giving lessons [*hodiny*].

VOŘIŠEK: What do you give?

STUDENT: I give classes [*hodiny*].[2]

VOŘIŠEK: Give me any watch [*hodiny*] that needs to be repaired, and I will stop it completely.

STUDENT: I train little children.

VOŘIŠEK: I'm too old for training. (Vesely 1914–1916, 1:92)

Another example:

STUDENT: The red paint is too loud [*mnoho křiči*].

VOŘIŠEK: It roars like a lion. (Vesely 1914–1916, 1:93)

In one Czech play there is a long dialogue based on the surnames of a joiner and a shoemaker, in which the client and the artisan simply cannot understand one another:

STUDENT: You can't be the joiner František Vořišek.

VOŘIŠEK: I am František Vořišek, but only a shoemaker. (Vesely 1914–1916, 1:92)

These last two sentences explain the misunderstanding.
 We also find play on homonyms in Russian folk theatre:

ATAMAN: *(Asking the Jew)* What did they hang him for ["by" and "for" are the same pronoun in this case]?

THE JEW: By the neck by a rope.

ATAMAN: Yes but for [by] what fault?

THE JEW: Not by the fault, but by the neck by a rope.

ATAMAN: What did they hang him for [in this case, also: "what did they hang him in"]?

THE JEW: A blue caftan.

ATAMAN: To hell with him *(The Jew is thrown out)*. (Ončukov 1911:105)

This dialogue is built [...] on the fact that different meanings are ascribed to the same pronoun by different characters.
 Phrases can acquire a series of different meanings when left unfinished. This scene from a puppet play is based on the use of unfinished sentences and the different meanings attributed to pronouns by various characters:

VEVERKA: My compliments, are you the master of the house?

MASTER: Yes, I'm the master of the house. What can I do for you?

VEVERKA: I was talking with the clerk Mr. Mrázek and he sent me . . .

MASTER: In that case, I know everything, if Mr. Mrázek sent you. But you know, I'm an honest old man, and I don't want to deceive anyone—I must tell you the truth: She is old, terrifically old.

VEVERKA: Mr. Mrázek told me . . .

MASTER: And besides I lent her to this musician and he took her God knows where in the middle of the night and broke her leg in a fight; I gave her to him in good condition, and look what comes of it!—Well to make an agreement, give me 20 gold pieces. It goes without saying she's worth the money. [...]

VEVERKA: I am a bank official and I want to get married. I get a salary of 1,200 gold pieces and I'm looking for a wife with a suitable dowry. Mr. Mrázek told me that you have a 24-year-old daughter and that she came with a dowry of 20,000 gold pieces, but he deceived me, since you admit that she's old and shrill and has a broken leg. I don't even want to see her. Good day!

MASTER: You mean you didn't come here to buy the harp? That's a different matter! My dear sir, I have a 24-year-old daughter, and she does come with a dowry of 20,000 gold pieces.

VEVERKA: But is she shrill?

MASTER: The harp is, but my daughter sings all day long.

6. *A traditional Devil, by Dušan Petráň (1991); with Faust (anonymous, 19th century); Kašpárek, by Jitka Rímská (1989); a Black Devil, by Mikoláš Sychrovský (mid-19th century); and, in the background, a Big Devil by Václav Krčál (1990). (Photo by David Schmidlapp; courtesy of Vit Hořejš)*

VEVERKA: Her leg's not broken?

MASTER: That's the harp's leg, not my daughter's. My daughter has legs like a table. Here's the thing. I have an old harp for sale, and Mrázek promised me he would find a buyer for it, and also a groom for my daughter. I thought you wanted to buy the harp. There's the reason for the whole misunderstanding. Ha! Ha! Ha! Let's go, my dear man, I will introduce you to my daughter. I think you will like her. (Vesely 1914–1916, 1:140–41)

[...]

Metaphor

Czech puppeteers are great lovers of metaphorical expressions. Let me give an example:

A knight is beating all his servants with a stick. Meanwhile, a guest arrives. "Pardon me please," says the knight to the guest, "for not saying hello to you. But you know, when a person is putting his house in order, he's always absentminded!" (Vesely 1914–1916, 3:120) [...]

Realization of Metaphor

By realization of metaphor we mean the poetic method used when a metaphorical expression is interpreted in terms of its original, literal meaning. For example:

BEGGAR: A poor wandering artisan asks for your kindness in offering any support [*o nějakou podporu*].

GENTLEMAN: What do you need support for [*na co shcete podporu*]? You've got a stick in your hand and can lean [*podepřít*] on it all you want. [...] (Vesely 1914–1916:112)

In *Faust*, Kašpárek announces:

> I know what to do. I'll crawl up on that little table and sit on that little book. Hop! The whole time I will be studying. It [education] will seep into my head, and if it doesn't get to my head it will get as far as my stomach, and even then I will have it in me just the same! (*He sits on the book*). Heh-heh! I have seated myself marvelously. And it's already creeping in, like ants! (Vesely 1914–1916:26) [...]

Here is an example from the Russian folk play *Tsar Maximillian*.

TSAR MAXIMILLIAN: Who's there? Someone of high rank?

MAXIMKO: The highest of all.

TSAR MAXIMILLIAN: Is it a field marshal?

MAXIMKO: No, I am not . . .

TSAR MAXIMILLIAN: Well is it a general?

MAXIMKO: No, I didn't die [*ne pomiral*].

TSAR MAXIMILLIAN: It's a colonel [*polkovnik*].

MAXIMKO: No, I'm not a corpse [*pakoinik*].

TSAR MAXIMILLIAN: Well who is it then?

MAXIMKO: Well aim higher [*povyše*]).

TSAR MAXIMILLIAN: Well don't tell me it's the one who walks on the rooftops [*po kryše*]?

MAXIMKO: Well yes, I am he, Tsar, your excellency.

Repetition

Separate words and phrases are repeated in order to create a comic effect. [...] Whole phrases or complexes of phrases are repeated in their entirety without any changes, or with very minor changes:

> There once was a Tsar, the Tsar had a courtyard, in the courtyard hung a washcloth [*mochala*]. Shall we start from the beginning [*s nachala*]? There

once was a Tsar, the Tsar had a courtyard, in the court hung a washcloth [*mochala*]. Shall we start from the beginning [*s nachala*]?... etc.

In Czech folk theatre Kašpárek is always singing the same song. Here not only the same words are repeated, but also the same melody. Kašpárek (sings):

> This is the first verse,
> This is the first verse,
> This is the first verse,
> Verse, verse, verse.

Then, just like the first verse, he sings:

> This is the second verse,
> This is the second verse,
> This is the second verse,
> Verse, verse, verse.

After that he sings: "This is the third verse" and so on, [...] just like the first verse.

In another type of repetition, a conversation takes place between two characters, during which the second character successively repeats the last words of the first character. Here is a scene from Czech puppet theatre.

STUDENT: Make me a flute.

VOŘIŠEK: A flute.

STUDENT: Of linden tree wood.

VOŘIŠEK: Of linden tree wood.

STUDENT: When you make the hole, make sure you make it smooth.

VOŘIŠEK: Make it smooth. [...] (Vesely 1914–1916, 1) [...]

Scenes Built on Contrast

Here one character pronounces words that make a dramatic impression. Another character says words that sound like those of the first, but which differ sharply in meaning and make a comic impression. For example:

MIL'FORT: Before we shoot ourselves, we must say good-bye to our sweethearts.

KAŠPÁREK: Go to it! I'll go after you.

MIL'FORT: Akh, my darling Otilia!

KAŠPÁREK: O, you big-toothed Terezia!

MIL'FORT: I part from you with sorrow [*se smutně loučím*]!

KAŠPÁREK: I introduce you to the jaws of hell [*drapu te poroučím*].

MIL'FORT: For your sake I go now into eternity.

KAŠPÁREK: I'm going to the hotel to get drunk out of spite. (Kopecký n.d.:455)

We find similar scenes in Russian folk plays. For example, in *Tsar Maximillian*:

TSAR MAXIMILLIAN: On my head you see my crown [*koronu*],
In my hands, a scepter [*skipert'*],
On my chest, crosses [*kresty*].

ADOLF: On your head I see your cow [*korovu*],
In your hands a violin [*scrypku*],
And on your chest pestles [*pesty*]. (Vinogradov 1914, version II:61) [...]

Nonsensical Speech

By nonsensical speech we mean the use of interjections and words that have
no meaning, but are used to express the mood of certain characters. In the fol-
lowing example, *khm* or *khe* is added to each phrase of everyday expressions:

Little paths, little poles, *khm*!
Silver is used to make wheelbarrows, *khe*!
Rent money and tax money, *khm*!
Paper cold pieces, *khe*!
A cage beneath your clothes, *khe*!

Nonsense words color the following speech of Kašpárek:

Hopsa, Hejsa, tryndy ryndy
letos neni jako jinky
kdyby bylo jako jindi
Hopsa, hejsa, tryndy ryndy. (Kopecký n.d.:218)

[Let's dance, tryndy ryndy
This year is not like other times
If it were like other times
Let's dance, tryndy ryndy.]

Compare this with an example from Russian folk theatre:

Priveli-li vy ko mne i go-go?
Ja by ero o-go-go. ["o-go-go" refers to the "neigh" of a horse]
Na tvojo o-go-go
Nashol o-go-go
Bultykh! Jako proslavisja! (Vinogradov 1914, version II:80)

[Would you come to me o-go-go
I would o-go-go him
On your o-go-go
(He or I) found o-go-go
Plop! Glory be!]

*7. A Peasant Couple,
made by an unknown 19th-
century carver. (Courtesy of
Vit Hořejš)*

Characteristic Peculiarities in the Language of Certain Characters

Let us examine the phonetic, morphological, and lexicographic changes
which appear in the speech of individual characters. We will look primarily at
the observations made by Professor Jindřich Vesely about the speech of char-
acters belonging to the upper classes:

Many of the phrases used by typical puppet characters come from the
Czech language in the period of its decline. There is an abundance of
Germanisms, a mishmash of foreign and Czech words, and also terrible
grammar, especially in passionate scenes, in which the puppeteer uses in-

correct word endings to make them distinct from everyday life. It is frightening. Whereas ordinary people speak normally (for example Škrdla, who speaks like an ordinary provincial, inserting appropriate proverbs into his speech), Faust speaks to a lady created by the Devil, who tries to distract Faust from the cross: "Would you please go with me to my room for a couple of black coffee!" [*na pár šalkové černého kávy*] Puppeteer Třiška's William Tell says "Mahommed, Diana, and Jupiter, me Turkish gods" [*me turecké bohove*], to which Oldrich replies: "Fall on your knees" [*Radni na své kolena*].

Škrdla or a knight from Kozlovitz would say it quite simply: "For two cups of black coffee" [*Na pár šalků černýho kafe' nebo "černý kavy"*] and "on your knees" [*na svy kolena*]. In this way the puppeteer deliberately makes the speech of the upper-class person incorrect. (Vesely 1913:38–39)

Such emphasis on the speech of the upper classes cannot be found at all in Russian folk theatre [...]. It is true that to caricature the speech of racial minorities all forms of deformation are used, but that is only for the speech of minorities. [...]

Now we come to an examination of the way in which the speech of minorities has been passed down in Czech puppet theatre. The speech of Jews is marked by aspirated German pronunciation of the consonants (mostly the dental and the labial consonants). [...] The Latinization of the Czech language in puppet theatre plays also occurs. [...] Czech words are given Latin endings such as "um" and "at." [...] There is a Russian folk anecdote in which the son of a peasant returns home from the seminary where he was studying. In a conversation with his father, he constantly adds the ending "us" to Russian words.

Repertoire

Until now we have examined separate passages and scenes of Czech and Russian folk theatre, as we would have examined the style of any other literary work. Now we will say a few words about the specific dramatic peculiarities of folk theatre.

We will look first at the repertoire of Czech puppet theatre, which is extremely varied. Among the 51 plays published by the son of the famous Czech puppeteer Matej Kopecký, are the old medieval dramas such as *Doktor Faust* and dramatizations of historical legends such as *Oldřích and Božena*, and dramatizations of anecdotes such as *Sir Franc of the Castle*, and so on. The most popular of all are the plays about knights and chivalry.

Folk puppeteers liked to perform chivalrous plays best, for they always make the greatest impression. The heroic content of these plays always arouses interest in our people, who have always loved historical things. They were attracted by the rich, multicolored costumes of the knights, and their shining cuirassiers and helmets. All historical plays—in which the characters are knights, kings, and noblemen—were taken by the puppeteers from Czech history, as evidenced by their posters. (Zátka 1915:121)

The Russian philosopher Prince Sergei Trubetskyi made the interesting observation that people love those plays best in which princes and counts appear. The passion of popular audiences for these kinds of plays is perfectly understandable: there is much more unusual and entertaining in them than in plays about the life of common people. And, vice versa, people of a higher class would be more interested in plays about the life of common folk because it is unknown to them and more unusual.

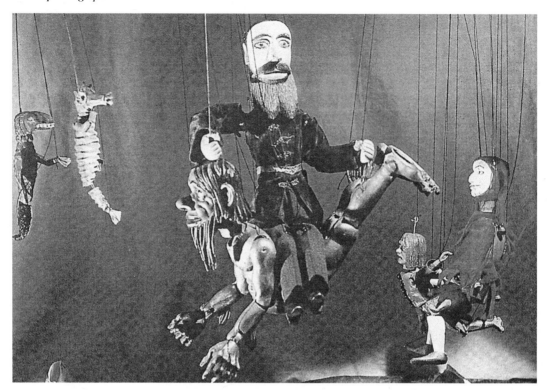

8. A scene from the Czechoslovak American Marionnette Theatre's Faust, *featuring traditional and contemporary Czech puppets. From left: Seahorses (Aleš puppets) by Münzberg (1912–1918); Faust (carver unknown, 19th-century) riding Vodník (The Water Spirit) by Modrý & Žanda (c. 1920–25); Kašpárek (or Pimprle) by Jitka Rímská (1989) riding a small Vodník (also by Münzberg). (Photo by David Schmidlapp; courtesy of Vit Hořejš)*

In the most popular Russian folk play, *Tsar Maximillian*, the main characters are the Tsar, knights, courtiers, and supernatural beings. [...] The characteristics of certain characters in *Tsar Maximillian* remind us of characters in chivalrous plays of Czech puppet theatre. [...]

Composition of the Plays

Czech puppet theatre is dependent on the characters of urban Czech live theatre. Czech puppet theatre has survived on the same plays offered by the regular theatre, with the exception of certain medieval plays, which became part of the puppet theatre long ago. If we look at the repertoire of the puppeteer [Matej] Kopecký, we will see that it contains plays from various epochs and many different literary trends. For this reason there is no unity in the compositional construction of Czech puppet plays. There is no unity, for example, in the development of dramatic fables. Before we speak of the composition of Czech puppet plays, it is necessary to analyze Czech plays of the live theatre.

This is not so in Russian folk theatre. Russian folk theatre has almost no connection to theatre of the higher classes, and for that reason, was forced to follow its own path and independently generate its own original methods, such as the formation of separate episodes and the connection of them into a unified play. It is true that *Tsar Maximillian* derived from a school drama, but we can see that in its subsequent development *Tsar Maximillian* greatly diverged from the compositional methods of scholastic drama and took an independent path.

Now we will examine those changes that Czech plays have suffered after falling into the hands of puppet theatres. First of all we must look at the improvisations of puppeteers.

They would not stick to the original text of the play, but would adjust it according to their needs. They would change the text partly according to

the organization of their particular theatre, and partly according to the tastes of the public. They would throw away everything that was not necessary for the puppets, decorations, or props, and there was no way to avoid this situation. They would add everything that in their opinion was liked by the public and would insert huge sections that had nothing to do with the course of the play's action. For example, they would add the public's favorite scenes from other plays. (Vesely 1914–1916, 3:122)

Vesely compared manuscript texts with published versions from which the manuscripts were derived, and made some observations about what led the puppeteers to make alterations from the published text. Here is a selection of such alterations:

GHOST: From time to time when I heard confessions, I would hear, over and over again—

ZDĚNEK: From time to time? You did?

GHOST: There, where the Elbe embraces the Orlitsa [etc.]

It was difficult for a puppeteer to change his voice so often and only for such short questions as "From time to time?" and "You did?" so these questions would be removed from the speech, and the ghost would simply say:

When I heard confessions from time to time I would hear over and over again: There where the Elbe [etc.] [...]

The same thing occurs in scenes where there are many characters onstage, and several of them are supposed to be talking at once about some incident or other. In such a case the puppeteer makes his work easier by having only one character tell the story, while the other characters play the role of mute extras. Usually one knight will speak instead of a whole crowd of knights (although in Klicpera's variation other knights will participate in the conversation too). [...]

In the Russian *Petrushka* puppet theatre there is no scene in which more than two characters speak at once, and no scene in which several characters would immediately start talking. In Russian puppet theatre, as in folk theatre with live actors, improvisation is given free reign: because of their political attacks, Russian puppeteers, just like their artistic colleagues of the Czech puppet theatre, have often had to pay off the authorities. The best evidence of the extent of the development of improvisation in Russian folk theatre with live actors is the strong differences in the separate variations of the plays *Tsar Maximillian* and *Lodka* [The Boat]. Interestingly enough, even the characters who play an important role in a majority of the variations, such as Tsar Mamai in *Tsar Maximillian,* do not appear at all in some other versions. In some cases this can be explained by a lack of players (compare this with the elimination of roles due to lack of puppets in Czech puppet theatre). A clear example of the kind of radical changes to which the original text is subject is Pushkin's poem "The Hussar." This poem, which appeared in *Tsar Maximillian* almost without alteration, has been so completely changed in certain variations that neither its form nor its content can be recognized.

Costumes

We have already shown that historical plays have attracted the public with their colorful and well-made costumes, but these costumes sinned against historical truth.

Costumes contradicted history and were highly stylized. They were sewn from colorful material and abundantly decorated with gold and silver braids and fringes, multicolored gems and shiny coins. The artistic splendor of the puppet costumes, the abundance of colors, and the brilliance of the decorations all reminded one of the Rococo style and the brilliant cuirasses and the war-like arms of the time of the Napoleonic wars. (Vesely 1914–1916, 2:116)

Puppets representing nobility from the cities and castles were especially splendidly dressed, but no attention whatsoever was given to the question of historical authenticity. "The peasants differed from the nobility with their national costumes, though these costumes were also inaccurate" (Vesely 1914–1916, 2:21).

The main purpose of the costumes adorning the characters of Russian folk drama is primarily to differentiate the principle characters from the surrounding public. Of course, it goes without saying that the actors wanted their costumes to reflect at least a particle of historical truth. [...]

9. King and Queen by Bohumil Veselý for the Münzberg Company (c. 1912–1922). (Photo by David Schmidlapp; courtesy of Vít Hořejš)

The Audience

Theories of theatre pay little attention to the audience, but observations of the audience can serve as interesting evidence of how strongly a play is perceived and what sort of influence it exerts on the surroundings. A series of interesting observations on the young audiences of Czech puppet theatre has been published in the journal *Loutkář*. The audience very often took part; for example, when the robber Hrainoha is tracking "Gašpárek [a variant pronunciation of Kašpárek]." At the moment when Gašpárek appears onstage, the whole audience cries, "Gašpárek, don't go that way, Hrainoha will kill you, that robber is on your trail!" Gašpárek replies in a mixture of Czech and Slovak: "You think I'm afraid of that scoundrel? I have a hard skull, and I'll teach him with this stick!" As he says this he points to a long stick. "Bravo, Gašpárek!" resounds from all sides. "Hrainoha will pay for this," announces a 70-some critic behind me. "What? You think Hrainoha is made of wax or something? He can stand up for himself better than that!" answers the only partisan for Hrainoha, seven-year-old Martin from Hamry. "My dear esteemed audience, hold your tongue! I'm going on," Gašpárek reminds them. The performance continues.

Hardly any observations have been made about the audience of Russian folk theatre. Let us just note that in Russian folk theatre the audience often participates by singing the chorus. It is also interesting to note how originally the children in Czech audiences interpret the speech of the puppet actors. In one play the King says: "Run and arrest them, so that they won't escape with that corpse!" Young boys often change the words of the king: "Run and arrest that corpse so he won't escape!" Or the king says: "Three times each day pull him by both legs!" and the boys: "Three times each day pull out both his legs..." (Veil 1914:2).

A formalistic analysis of the linguistic devices of the comic characters of Czech puppet theatre shows their abundance and the ways in which they are uniquely distinct from the linguistic construction of comic characters in contemporary comedy. Comparing linguistic devices of Czech puppet theatre and Russian folk theatre, we have found that they have much in common. Of course, this resemblance cannot be explained by the influence of Czech theatre on Russian theatre or vice versa, but by the unity of the tastes and demands which have drawn audiences to both theatres, and also the tastes of the improvisers of these linguistic "lazzi"—Czech puppeteers and the performers of Russian folk theatre.

—translated by Michele Minnick[3]

Translator's Notes

1. In Russian, there is a verb, *pokolet'*, which is usually used to refer to the death of an animal, but not of a person. Although not a literal translation, I am using the verb "croak" to help illustrate the difference between the two verbs.
2. In Czech *hodiny* can mean lessons, hour, or clock.
3. We would like to thank Valentina Zaitseva for her assistance with the Russian translation, and Vit Hořejš for his assistance with the Czech translations and for the images accompanying the article.

References

Bogatyrev, Pyotr
1923 "Cesskij kukol'nyj i russki narodnyi teatr." *Sborniki po teorii poeticeskogo jazyka* 6. Berlin-Petersburg: OPAJAZ.

Kopecký, Antonin
n.d. *Comedies and Plays* [including *Doctor Faustus, Oldřich and Božena, Sir Franc of the Castle, The Cook, or The Estate Won at Cards, Don Juan, Anton Belendardo, The Witch Megera, Zid Siloch*].

Ončukov, Nicolai Evgen'evich
1911 *Northern Folk Dramas* [including *The Boat; Tsar Maximillian*, versions I and II; *The Gang of Thieves; The Naked Lord*]. Saint Petersburg: A.S. Suvorina.

Veil, Em.
1914 "Z drobnych vspominek [A Few Small Memories]." *Loutkář* 1:2.

Vesely, Jindřich
1910 "About Puppets and Puppeteers." *Czech-Slovak Ethnographic Journal* 5:n.p.
1913 "From the Vocabulary of Wooden Actors of the Maizner Family Puppeteering Dynasty: A Contribution to the History of Folk Drama." *Czech-Slovak Ethnographic Journal* 8:38–39.
1916 *Doktor Faust.*

Vesely, Jindřich, ed.
1914–1923 *Loutkář*. Vols. 1–10.

Vinogradov, Nikolai N.
1914 "Folk Drama *Tsar Maximillian*" (versions I, II, III). *Sbornik ORJaSAN* (Petrograd) 90, 7.

Zátka, Francisek
1915 "South Bohemian Puppeteers." *Loutkář* 2:121.

Modicut Puppet Theatre

Modernism, Satire, and Yiddish Culture

Edward Portnoy

Among the hand-puppet theatres that cropped up in New York during the 1920s was the Modicut theatre, an offshoot of the flourishing Yiddish theatrical-literary culture. Created in 1925 by artists-writers-satirists Zuni Maud and Yosl Cutler, Modicut enjoyed great success in Yiddish-speaking communities in the United States and Europe. Modicut, satirizing Jewish and general politics and culture of the day, provided an experience unlike anything previously seen in Yiddish theatre.

Puppet theatre was not part of traditional Jewish *shtetl* life mainly because of the biblical proscription against the creation of graven images (Deuteronomy 4:16–20). However, Jews living in the Pale of Settlement (the areas of Poland and Ukraine to which they were restricted under the Tsarist regime) undoubtedly saw traveling *Petryushka* puppet theatres on market days.[1] These Slavic puppet theatres often portrayed Jews as villainous characters, thereby tainting an enjoyable medium for Jewish audiences (Shatsky 1930:449). But Jews watched these shows. Yosl Cutler, for example, painted a scene of a traveling theatre in a memoir of his shtetl, Troyanets (1934:161); and Khaver-paver described a puppet theatre in a Ukrainian shtetl marketplace whose audience was comprised of "Jews and peasants."[2] This was his first theatre experience (Khaver-paver 1963:405). Although there is no documentation to support it, it is possible that amateur puppetry existed in some form within the small towns of the Pale, particularly in connection with Purim, a holiday whose traditions include drinking alcohol, masquerading, and public performance.

The 1920s was an awkward period for Jewish immigrant artists working in Yiddish in New York City. On the one hand, Yiddish literature and theatre began to reach an artistic maturity previously unknown. On the other, its audiences were diminishing because the severe new immigration laws of 1921 and 1924 restricted the inflow of East European Jews and because the acculturation process had begun to reduce the number of Yiddish speakers. Despite this, as the Yiddish idiom collided with American sensibilities and culture, an explosion of literature, poetry, and plastic arts occurred. The Modicut theatre was part of that explosion.

In the course of its brief eight-year existence, Modicut was seen by thousands. Press accounts and contemporary eyewitnesses indicate Modicut was an exceptionally creative and uniquely Jewish cultural expression. As virtual newcomers to modern literature, drama, and plastic arts, Yiddish-speaking Jews explored possibilities in the modern era that had been closed to them in

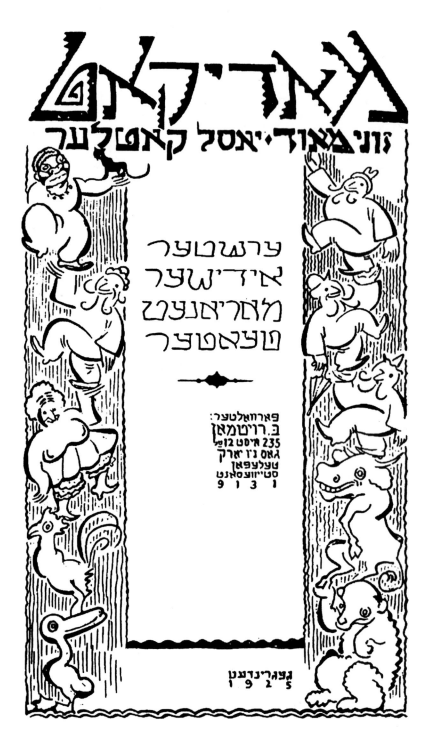

*1. A program cover for the
Modicut puppet theatre
(1925–1926). (Courtesy of
Edward Portnoy)*

the parochial atmosphere of the Old World. Moreover, the immigrants as-
similated American culture into Yiddish arts. Modicut appealed both to a gen-
eral public and to intellectuals, merging Yiddish with avantgarde art and
popular culture to produce humor as well as political and cultural criticism.

Zuni Maud immigrated to the U.S. in 1905 from Russian-ruled Poland and

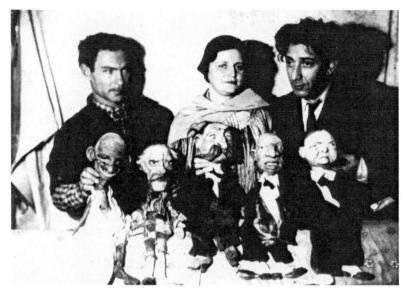

2. *From left to right: Yosl Cutler, Bessie Maud, and Zuni Maud on tour of the USSR in 1932. The satirical puppets are (from left to right) Mohandas Gandhi, Ramsey MacDonald, Leon Blum, Vol Strit, and Herbert Hoover. (Courtesy of the collection of Philip Cutler)*

was artistically active on the Yiddish literary scene from 1907 on, contributing illustrations to anthologies and cartoons to journals and newspapers. Yosl Cutler arrived in the U.S. from the Ukraine in 1911. He first worked as a sign painter, but was brought into the Yiddish literary world by satirist Moyshe Nadir around 1919. Cutler wrote vignettes which he illustrated himself. Maud and Cutler met during the early 1920s at the offices of the Yiddish satire journal *Der groyser kundes*, where Maud had worked on and off since 1909 and where Cutler had just been hired. They struck up a friendship and began to collaborate artistically. The two men worked on theatre set designs and opened a gallery/studio together on Union Square which they called "Modicut," a combination of their names (Maud 1955:47–48). Together, they created the Modicut puppet theatre and minor works of art such as theatre posters and drawings. Separately they produced cartoons, drawings, paintings, sculpture, poetry, and prose.[3] Maud's cartoons were a visual narrative of Jewish culture of the teens and '20s. He addressed serious cultural and political issues in a humorous manner, evoking laughter and thought at the same time. Cutler's stories were an unprecedented fusion of Eastern European Jewish folk culture, modern American Jewish life, politics, and avantgarde art. Though they were partners, Cutler and Maud's artistic styles were not similar. Maud, influenced by his teachers, painters Robert Henri and George Bellows, mainly remained true to their "ashcan" style of realism. Cutler, on the other hand, was a modernist who experimented with cubism and surrealism. The Modicut puppet theatre combined Maud's cynical humor with Cutler's fantastic Jewish grotesques. Their difference was also their strength. Meylekh Ravitsh, poet and literary critic, wrote:

> Truly, if there was anyone who ever doubted that a pair is prearranged in heaven, he should take a look at Zuni Maud and Yosl Cutler. Such an artistic duo, each complementing the other so wonderfully is truly a rarity in this world. Maud is short—Cutler is tall; Maud has a deep bass, a murky, dark bass; Cutler has a bright, cheeky, boyish tenor; Maud is full of Jewish folkloric tradition, Cutler is an expressionist—but when they're together there is no contrast whatsoever. (1929:984–85)

Noyekh Shteynberg, in his 1929 anthology *Idish amerike*, concurred: "Cutler is the opposite of Maud. Maud is difficult, Cutler—easy. Maud is stubborn, Cutler—acquiescent. Maud is brutally critical, Cutler—naive and mild" (1929:298). The poet Zishe Vaynper also commented on how different their personalities were, writing that their artistic work together created a kind of harmony which brought them to their artistic goal. He further stated that they were the only artists who brought an element of fun into the proletarian movement (1933:91–92).

Their work, both collaborative and individual, is what Yiddish literary scholar David Roskies called "creative betrayal": subversions and reinventions of Jewish traditional forms to encompass current, artistic, cultural, and political situations. As they synthesized Jewish tradition into their modernist, bohemian world of 1920s New York, Maud and Cutler not only turned that world upside down, but also put it in front of a funhouse mirror. Despite their penchant for satire, it is clear that their folklore was dear to both of them and would remain an integral part of their work, no matter how much they twisted it. Their art was a result of their alienation, not only from their shtetl childhoods and from Jewish tradition in general, but also from American Jewry at large.[4] Yiddish, bohemian artists connected politically to the Communist Party—they were on the periphery of a periphery, and this made them revolutionaries within Jewish society. Their treatments of Jewish life helped their audiences—entering modernity carrying a great deal of cultural baggage—to laugh at themselves.

The 1920s was a renaissance for puppetry in New York City. Under mainly the artistic dominance of such prominent artists as Remo Bufano and Tony Sarg, the puppet theatre had grown popular. Shakespeare ran in puppet theatres in New York's uptown theatre district, while more modern works by Arthur Schnitzler and Edna St. Vincent Millay were being performed in Greenwich Village (McPharlin 1948:331–42). But although the Lower East Side was only blocks away from Greenwich Village and a quick subway ride away from Broadway, it may as well have been a different country. The Yiddish immigrant culture of the Lower East Side, with its own press and theatre, was, with a few exceptions, a world apart—yet an extremely vital world with five daily newspapers and a dozen or so Yiddish theatres catering to the 1.5 million Jews who had emigrated to New York since the end of the 19th century.

During the summer of 1925, Maud and Cutler were hired by Director Maurice Schwartz to create the scenery for his Yiddish Art Theatre's production of Avrom Goldfaden's *Di kishefmakherin* (The Sorceress). Schwartz, attempting to ride the popular wave of artistic puppet theatre, asked the two artists to create hand puppets for a scene in the show. Schwartz cut the scene prior to the premiere because he felt the puppets were difficult to see from the house.

Maud and Cutler brought their puppets back to their studio and spent a night remaking them into two Jewish characters, and then improvising dialogue for them (Maud 1955:47). Maud and Cutler began to take these hand puppets with them to the literary cafés they frequented, to create humorous diversions to the often serious activities taking place there. Friends in their literary circle suggested they create a puppet theatre. Maud and Cutler took the idea seriously—and they began building more puppets and writing plays. In early December 1925 all the major Yiddish newspapers published press releases announcing the imminent opening of the Modicut Yiddish puppet theatre. Small announcements appeared indicating that Jacob Ben-Ami, a renowned actor on both the Yiddish stage and Broadway, was excited about the new theatre and wanted to work with it.[5] This collaboration never came to pass, but it certainly helped broaden popular interest.

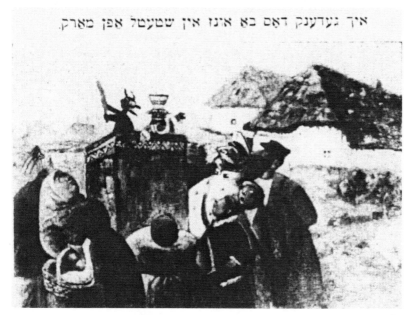

איך געדענק דאָס בא אונז אין שטעטל אפן מארק.

Maud and Cutler's theatre opened on 17 December 1925. Tickets to the shows had to be purchased at their friend Moyshe Nadir's newly dubbed Artisan-café (previously advertised in the *Morgn frayhayt* as "Nadir's Communist Café"), a place where a glass of tea could be purchased at *proletarishe prayzn* (proletarian prices). The first Modicut theatre was located near the heart of the Yiddish theatre district, on Twelfth Street close to Second Avenue. The space itself was formerly a children's clothing factory—and Maud and Cutler left the cutting tables and machinery on the floor for effect. The seats were simple wooden benches. There was little decoration, with the exception of surreal-looking faces painted on the gas meters. Clearly, this was to be both a folkloric and a proletarian theatre. Maud and Cutler hired Jack Tworkov, an artist from Buffalo who had worked with Remo Bufano, to assist in making puppets and in directing some of the plays (McPharlin 1948:328). Tworkov would later become a leading figure in modern American painting. For most of the 1926 season, "Modicut" became "Modjacot," incorporating the "ja" of Jack, and Tworkov's *Minuet*, a puppet dance set to Beethoven inspired by a Bufano piece. This was the only non-ethnic, non-political piece in their repertory. Tworkov left after one season with them (Teller 1968:27).

In their puppet plays, Maud and Cutler fused fantasy, satire, politics, and Jewish consciousness, bringing their *Groyser kundes* caricatures to life. Though puppets were not part of Jewish tradition, Maud and Cutler adapted them to Jewish life smoothly by appropriating Jewish folk themes and characters. Initially, the plays were mainly folkloric, anticlerical comedies, but they soon became more politically oriented, particularly with the onset of the Depression. The exaggerated features of their puppets leaned to the grotesque, and their sets later tended toward the surreal, which led to many comparisons with Chagall (Frank 1929:6). Modicut's art and commentary were modernist, while much of its language, themes, and characters flowed directly from traditional folk sources.

Unfortunately, very few Modicut play texts have survived (including one each by Maud and by Cutler), though one can get some idea from excerpts, programs, and press reports. The first Modicut play, *Der magid* (The Itinerant

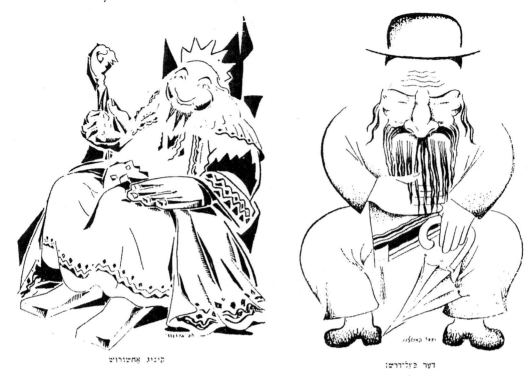

קיניג אחשוורוש דער פיזל־דרשן

4. *King Akhashveyresh from Modicut's Purim-shpil,* Akhashveyresh. *The heavy shoes were often used to create walking and tapping sounds for the puppets. (Rendering by Zuni Maud; courtesy of Edward Portnoy)*

5. *Yosl Cutler's rendering of the puppet character Der bal-darshn (The Preacher). Though the play in which this puppet appeared is unknown, it was likely an anti-religious piece. This conjecture is based on the grotesque and overblown features of the sketch as compared to the many similar antireligious cartoons that were part of Cutler's oeuvre. (Courtesy of Edward Portnoy)*

Preacher), was a religious satire in which an itinerant storyteller comes to a town and gives a stirring *droshe* (sermon). The *shames* (sexton) is so impressed that he pleads with the magid, who is already on his way to the next town, to give another droshe. After a good deal of comic wrangling, it becomes apparent that this magid has only one droshe.

The second Modicut production was Maud's *Akhashveyresh,* a full-length Purim *shpil* that was well received critically and printed in its entirety in the journal *Unzer bukh* (Maud 1928). *Akhashveyresh* is a traditional telling of the Purim story with parallels to medieval Purim shpiln: written almost entirely in rhyming couplets with a *loyfer* (or master of ceremonies) introducing the characters and offering commentary. The text follows the basic story of Purim, in which the evil Haman schemes to convince King Akhashveyresh to destroy the Jewish community, but is foiled by Mordechai and his niece Esther. Haman is finally hanged on his own gallows.

In Maud's version there are a number of creative innovations. More emphasis is placed on Akhashveyresh's drunkenness, and his consumption of *shlivovitz* (kosher brandy) in particular. Satirizing the Yiddish theatre, Bigsn and Seresh, the king's two servants, speak *daytshmerish,* a Germanized form of Yiddish often used in the popular Yiddish theatre to indicate high-level language. And in order to associate the hero of the story, Mordkhe *ha-yehudi* (Mordechai the Jew), with common, workaday Jews, Maud refers to him as Motl, a diminuitive of Mordkhe. An example of the breadth of the satire occurs when Konferensiye, the loyfer, introduces the second act:

In der tsayt fun dem entrakt zaynen yorn fil farlofn,
Pasirungen pasirt, nor ken nisim nisht getrofn.
Nisht tsu ton un nisht tsu makhn,
nisht tsum veynen, nisht tsum lakhn.

Hobn mir vi undz gefelt
in shpil es nisht arayngeshtelt.
Tirtltoyb, oyerhon,
tsveyter akt fangt zikh on. (Maud 1928)

[During intermission many years flew by,
Things happened, but no miracles occurred.
Nothing to do or to make of it,
Nothing to cry about, nor to laugh about.
We did what we wanted to
And didn't put the (events) in the play.
Turtledove, Chicken,
Second act begins.]

The authors made the assumption that the audience knew the Purim story and was engaged in the current Yiddish literary and cultural scene. Here, they poke fun at the Yiddish theatre by noting how certain productions removed plot material from plays without much concern. They also mock the poem "Tirtltoyb," (Turtledove) by their friend, introspectivist poet Yankev Glatshteyn.[6] By introducing a fictitious "Persian national poet," Khashdarfun, Maud plays on the low status of poets in Jewish life—an issue he was familiar with because of his literary connections. Khashdarfun recites his latest poem and is thrown a nickel by Konferensiye. Mordkhe is asked how he likes the poem and replies, "Don't bother me, I've no time for jokes. Don't mix yourself up in my *megile* (the traditional Book of Esther): it's none of your business." Here, Maud questions Modicut's own work of cultural subversion by having a character from the Book of Esther tell them to leave traditional Jewish texts alone. Since both Maud and Cutler were alienated from Jewish faith and practice, their artistic retreat back into it becomes more poignant in terms of the possibilities of Jewish secular art. The fact that they chose to parody a Purim shpil reveals a paradox: in rejecting tradition, they relied upon it.

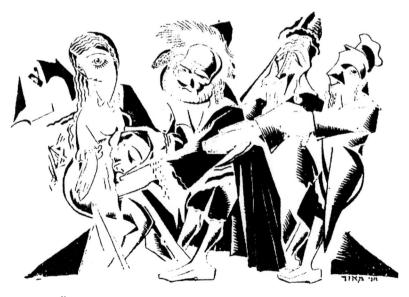

6. In Zuni Maud's rendering, the puppet rabbi pulls the dybbuk *out from under Leah in Modicut's version of* Der dibek. *(Courtesy of Edward Portnoy)*

זיני מאוד

דער „דיבוק"

The freewheeling comedy and satire of *Akhashveyresh* emerges in the variety of unusual ways in which Maud and Cutler approached their traditional theme. The play includes typical scenes from the Lower East Side, such as the sudden appearance of an Italian pushcart peddler selling everything from eyeglasses and galoshes to bananas. Other unlikely elements in this Purim shpil include an "African Dance," in which two black hand puppets dance to the "St. Louis Blues."

Modicut's rollicking, broad comedy was apparently memorable, according to the many reviews and memoirs of the play. In one scene, the King has difficulty falling asleep. When he hears snoring, Akhashveyresh says, "Oy, a pleasure...I'm snoring...a sure sign that I'm already sleeping"—however he soon realizes that it isn't he, but his servant Bigsn, who is snoring. A strong verbal element of the play was the frequency of made-up words and nonsense rhymes, which were Maud's trademarks. The few photographs available indicate that the painted set of the puppet stage was surreal, with crooked, elongated doorways and windows, and long painted shadows.

Other productions in the first Modicut season included Cutler's *Af vos tustu krenken* (Why Should You Be Sick), a folk comedy in rhyme about a father, Zalmen, who arranges with Eliye the *shadkhn* (matchmaker) to find a match for his daughter Sheyndl. When the shadkhn brings a suitable match, Sheyndl is pleased, but Zalmen is unwilling to pay the shadkhn, causing Sheyndl to take ill. Doctor Yuki is brought in and prescribes a young man for the sick girl. In the end, Zalman agrees to pay and all ends well. During this first season they also performed *Di feferdike yidelekh* (The Peppy Little Jews), an operetta with song and dance which showcased Cutler's renowned sense of rhythm with twin hand puppets which danced in time (YIVO Institute).

The success of Modicut's first season allowed them to open their second year around the corner from the old loft at a new, larger theatre on Second Avenue where they performed nine shows per week. For the second season Maud wrote *Der dibek*, a parody of Sh. An-ski's *The Dybbuk*, satirizing the numerous productions of the play then being performed in English and Yiddish on the

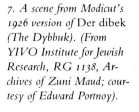

7. A scene from Modicut's 1926 version of Der dibek *(The Dybbuk). (From YIVO Institute for Jewish Research, RG 1138, Archives of Zuni Maud; courtesy of Edward Portnoy).*

New York stage. In Maud's version, Leah and her dybbuk (the soul of Khonen, the boy who pined after her, which has inhabited her body) live on Delancey Street, and various theatre troupes including the Yiddish Art Theatre, the Neighborhood Playhouse, and the Vilna *trupe* (all of which were performing the play that season) arrive and unsuccessfully attempt to drive out the dybbuk. After these efforts, the "rabbis," or, in this case, the directors of each respective theatre group, decide to summon Khonen's late father, the *mes toer* (immaculate corpse), in a final attempt to exorcise Khonen from Leah. But the father doesn't understand his son's English, and is upset that Khonen has fallen in with "*goyim*" (a joking reference to the Neighborhood Playhouse's English-language version of the play). This was Maud and Cutler's most brazen satire on popular Yiddish culture to date and the first unambiguous indication that theirs was becoming a theatre that would accurately satirize Yiddish popular culture. For a number of critics and theatregoers who had tired of the many productions of *The Dybbuk* that season, Modicut's parody was welcome comic relief.

Maud and Cutler often changed their texts to accommodate current events. In a later version of *Der dibek*, the puppet rabbis were modeled on Abraham Cahan, the domineering editor of the *Forverts* newspaper, and Herbert Hoover, whose head was represented as a rotten apple. In yet another incarnation of the show, Leah was portrayed as Mae West and one of the rabbis was Franklin Roosevelt, who waved the N.R.A. Eagle over Leah and chanted, "WPA, NRA, CCC," in order to exorcise the dybbuk (Cutler 1936). A scene which remained a mainstay of the parody was one in which the rabbis, while attempting to yank the dybbuk out from under Leah, lined up with their hands around each other's waist and pulled to the "Song of the Volga Boatmen." Among other items pulled out from under Leah, instead of the concealed dybbuk, was a large herring (Goldberg 1995; Norbert 1995).

Modicut's audience, culled mostly from the half-million Yiddish speakers on the Lower East Side, found this combination of literary parody, social satire, and slapstick engaging and hilarious. In keeping with the traditions of puppet theatre, there was a warm, even intimate, interaction between the puppeteers and their audiences, particularly if well-known literary and theatre personalities were in the crowd, or if Maud or Cutler spied an attractive woman from behind their stage (Norbert 1995; Novick 1995). If, for example, the writer Moyshe Nadir was in the crowd, Konferensiye, the hand-puppet master of ceremonies, would ask the assembled, "Is Nadir here?" To which the audience would reply in unison, "Yes, Nadir's here." "So, let him stay," Konferensiye would answer. The writer Khaver-paver was in the audience when Konferensiye asked "is Khaver-paver here?" After the usual routine, and Konferensiye's, "*Nu*, let him stay," the puppet turned to Khaver-paver and said, "If he is here, he ought to turn around and take a look in the corner where a beautiful Jewish girl, one he might like, is sitting." The "beautiful Jewish girl" later became Khaver-paver's wife, thus promoting Konferensiye from master of ceremonies to matchmaker (Delavellade 1995; Khaver-paver 1963:402–03; Teller 1968:26–27).

The second extant Modicut play is Cutler's *Sokhrim fun fefer* (The Pepper Merchants), a fantasy piece written for children (Cutler 1955). A Jewish version of *Goldilocks and the Three Bears*, the play concerns two Jewish pepper merchants who are accosted while praying in the woods by a family of bears who plan to eat them. The young bears plead with their parents to give them "yidelekh mit khale" (Jews with challah). The parents tell the children they cannot eat the Jews until they finish praying, so the bears wait until the Jews conclude their prayers and then put them in a large pot. Hoping to be saved, the Jews plead, first with the bears, then with some wandering *klezmorim*

(klezmer musicians), the playwright, and finally the audience. In the end, the Jews convince the bears that because they are pepper merchants they taste "more bitter than poison" and they are finally released. In *Sokhrim fun fefer* Cutler parodies the folksongs "Bulbes," and "Bobe Yakhne" and the children's rhyme "Patshi-patshi kikhelekh" by altering their texts and adapting them to a fantasized Yiddish bear culture. The language in Modicut was rife with Jewish folklore and cultural allusions; a Yiddish rich in the ways of the Old World, but capable of adaptation to new experiences and forms.

Another example of their appropriation of outside themes and comedic synthesis was Maud and Cutler's "Chinese" play *Tshing tang po*, in which the characters are given hybrid Chinese-Jewish names like Ting-ling-shmul and Ling-ting-shmultshik. The puppets become involved in the slapstick robbery of a box of honey, which results in the accidental destruction of precious Ming vases (Potamkin 1933:6). Because the text is not available, it is not clear exactly what kinds of cultural composites were created in the play. In any event, it seems likely that the appearance of this "Chinese" piece is the result of the immigrant's desire to remove himself from the position of "other" by finding a character who appears to be even more exotic than himself.

The only other Modicut works to appear in print were those written for them, such as Moyshe Nadir's *Af yener velt* (In the Other World), a comic an-tireligious piece in which the Angel Gabriel is forced to grovel before God and constantly tell Him how great and important He is (Nadir 1932:155–61). The Modicut production, according to Khaver-paver, made this situation ironic by using Maud's deep bass voice for the Angel Gabriel and Cutler's boyish, high-pitched voice for God (1963:403). In addition to the Nadir play, Maud and Cutler adapted existing plays such as Avrom Reyzn's *Dem shadkhns tekhter* (The Matchmaker's Daughters) and Sholem-Aleykhem's *Sheyne balebatim* (Fine Businessmen).

All the Modicut puppet plays were accompanied by music, much of which was written by Mikhl Gelbart and Moyshe Rappaport. In addition, the plays often included parodies of popular Yiddish theatre songs, such as Cutler's *Di blekherne kale* (The Tin Bride), which was an adaptation of the song "*Yome, Yome.*" Maud's play *Biznes* (Business) contained a parody of the Yiddish the-atre song "Ikh bin a border bay mayn vayb" (I'm a Boarder at My Wife's) called "Ikh bin bay mir der boss in shop" (I'm the Boss of My Own Shop). Maud and Cutler wrote a number of other original plays that have not sur-vived. They include: *Der laytisher mentsh* (The Respectable Man), *Shleyme mit der beheyme* (Shleyme with the Beast), *Farn shpil un nokhn shpil* (Before the Play and after the Play), and *Der betler* (The Beggar).

Maud and Cutler were popular with intellectuals and general audiences alike, and won critical acclaim from all precincts of the Yiddish press, which was virtually unanimous in praising Modicut during its first few years. This was an unprecedented moment of agreement in the usually contentious Yid-dish press, and particularly surprising since Maud and Cutler were connected to the *Groyser kundes* and the communist *Morgn frayhayt,* associations which made them *personae-non-grata* in certain literary and press circles. An interest-ing aspect of this acclaim was the frequent attachment of the label "intellec-tual" to Modicut. The *Tog* advised "the intellectual Jewish audience" to go and see Modicut, and the *Morgn frayhayt* commented that "all sworn intellec-tuals have unending praise for the puppet comedies."[7]

It is clear that Maud and Cutler were aware of the novelty of their theatre, and they publicly emphasized this by offering their audiences postperformance lectures on the history of puppet theatre by such critics as Dr. Aleksander Mukdoyni (pen name of Aleksander Kapl) and historian Yankev Shatsky, as

well as entr'acte discussions with well-known Yiddish writers Moyshe Nadir and Avrom Reyzn and, occasionally, themselves. Audiences continued to swell, and by Passover of 1926, Modicut was selling out special midnight shows at the much larger Schildkraut Theatre (*Forverts, Morgn frayhayt, Der tog,* and *Morgn zhurnal* 1926). However, to increase attendance, Modicut occasionally offered special rates to its audiences, for example admitting "any mother accompanying a child" free during Hanuka, 1926 (*Der tog* 1926).

Mukdoyni, an imperious culture and theatre critic, described his experience of watching Modicut in the 5 January 1926 *Morgn zhurnal*. At first he feared that "some of our Yiddish Bohemians would be toying with an amateurish puppet theatre." Mukdoyni hoped that Modicut would create a theatre using high-level Yiddish, as opposed to the inferior, low-level language often found in the popular Yiddish theatre. Following a brief history of puppet theatre, Mukdoyni pointed out that after centuries of puppet theatre all over the world, one had finally cropped up among Jews, who were "merely a few thousand years late." "However," he added, "as of yet, an authentic Jewish puppet theatre does not truly exist: only a couple of Jewish Bohemians have decided to joke around and have come up with the charming Modicut theatre." Mukdoyni provided some concrete criticism of their show: "the humor isn't literary enough; the artists don't move the puppets enough at the right time; the voices don't match the characters and the puppets look too much like *shtetl* Jews" (Mukdoyni 1926a). Finally he concluded that Maud and Cutler were "dilettantes." He noted, however, that the first shows indicated that real artists were at work who could further develop their craft if they weren't rattled by its initial success. Mukdoyni clearly had high expectations for this small puppet theatre, an indication that he was aware of Modicut's popularity and was concerned about its influence as a cultural medium within the community.

Other initial press responses to the tiny theatre were most often exuberant. Nearly all the reviews engaged in the kind of *kibitzing* that characterized the intimacy of the Yiddish-speaking Lower East Side. Reviewers in the major press organs *Forverts, Morgn frayhayt, Der tog,* and *Morgn zhurnal* discussed the concept of *eygns,* or "our own," and how Modicut was a uniquely Jewish phenomenon. They analyzed Modicut's importance for Yiddish culture and for the range of possibilities then available to Jewish artists. For these critics, the idea that theatre could be original *and* culturally Jewish was very attractive, especially since they seemed to feel that Yiddish theatre too often looked to Broadway for ideas and approval. They considered the Modicut an opportunity to see an artistic endeavor *in der heym,* or "in our own house," a rare occurrence that should not be missed. The puppet medium notwithstanding, the critic Leon Krishtal commented in the anarchist *Fraye arbeter shtime* that "Modicut is successful because of its originality and because it does not mimic gentile theatre" (1926). B.Z. Goldberg, son-in-law of Sholem-Aleichem, wrote in *Der tog* that Modicut is Jewish in form and content while at the same time modern and artistic. He expressed surprise at the warmth of Modicut's language, rhymes, and music, and noted that Maud and Cutler knew their Jewish sources and were thus able to discern what is truly *yidishlekh,* or imbued with a deep sense of Jewishness (Goldberg 1926). These reviewers all seemed to sense a lack of originality and Jewish spirit in the Yiddish theatre of the period, and as a consequence often showed an unmitigated enthusiasm for Modicut.

On the other hand, despite their laudatory comments, pundits of the Yiddish press also had criticisms of Modicut. For example, amidst all the critical praise in the *Morgn frayhayt,* R. Yuklson complained in that paper that the puppets "didn't jump around enough" and that the "benches in the theatre were too hard" (Yuklson 1926). The religiously orthodox *Idishe tageblat* criti-

cized the artists for skipping over thousands of years of history and ignoring the biblical commandment against the creation of graven images (Blay 1928).

Three months after his initial lukewarm response, Mukdoyni returned to the subject of Modicut to examine how the theatre was progressing, and now he wrote lovingly about the puppets, as if they had found a place for themselves in Yiddish culture. "Under a cold sky in the barren desert of our cultural life," he commented, "a puppet theatre is growing." Echoing the radical positions of Edward Gordon Craig, Mukdoyni even wished that the actors of the Yiddish theatre could perform as well as the puppets of Modicut (1926b). Six months later, Mukdoyni wrote incredulously of his initial estimation of Maud and Cutler as artists who only wanted to joke around. Now he considered their theatre "so charming, so lovable and so alive," and celebrated the beginning of its second season by announcing exuberantly, "We have a Jewish marionette theatre." The stodgy Mukdoyni even admitted to having laughed at Modicut's satire, which he now considered "crafty and clever," and wondered if "the hustling, materialistic Jewish masses deserve such quality." He characterized the portrayal of Jews on Broadway as crude and inept, but, in reference to Modicut, noted "how lovely, intelligent and charming it is in our own atmosphere." He exclaimed "what a shining light we have right here" (1926c). Mukdoyni's comments reveal a number of interesting aspects of the culture surrounding Yiddish theatre. It is clear that he considered Modicut's puppet shows a serious theatre of satire, and not simply mass entertainment. He also used the opportunity of his Modicut criticism to condemn the current state of acting in the Yiddish theatre, as well as the way in which the non-Jewish theatre portrayed Jewish characters. For Mukdoyni, Modicut captured a particular Jewish essence, which could not be found in the work of live actors.

Critics in the Yiddish press might have been overly effusive because Modicut was the first successful Yiddish puppet theatre. However in non-Yiddish precincts there was also critical interest in Modicut. Modicut was featured in the June 1926 issue of the influential American journal *Theatre Arts Monthly* as "one of the most interesting of the new puppet theatres" that opened that year (Aronson 1926:20). And throughout the 1920s, when the profusion of puppet theatres in the United States reached its peak, Modicut was one of the few companies consistently mentioned by that journal. In addition, the renowned Russian puppet master Sergei Obratsev, in his autobiography, *My Profession*, commented that of all the numerous puppet theatres he saw during his eight-month tour of Europe and the United States in 1926, Modicut was one of the three most memorable (1985:33).

An interesting aspect of Modicut's existence is that it was not, in fact, officially called a theatre, but rather the "Modicut Club," as tickets found in Zuni Maud's archives in the YIVO Institute reveal. An article in the *Morgn zhurnal* of 7 December 1926 indicates that the purchase of a ticket to a Modicut play was akin to buying a membership in that club, if only for a few hours. This unusual arrangement stemmed from an eviction attempt by Maud and Cutler's landlord, who apparently did not like them, their politics, or their theatre. He brought legal proceedings against them on the grounds that his building was not zoned to house a theatre. However Maud and Cutler prevailed over the landlord through the unlikely method of having their puppets plead for them. In fact, they did not even bother to hire an attorney. They simply showed up in court with their puppets in hand. The judge was evidently so impressed with them that he insisted they perform *Akhashveyresh* for the court, which they did. After seeing a quickly improvised English version, the judge helped assure the continuing success of Modicut by ruling that although the building was not technically zoned for a theatre, Maud and Cutler could have a "club"

for which they could sell "memberships" instead of tickets. According to the *Morgn zhurnal*, the judge, the district attorney, and the bailiff then all bought "memberships" in the new Modicut Club. An extant Modicut ledger indicates that the print runs of their membership tickets went from 1,000 at the beginning of 1926 to 15,000 by the end of the year (YIVO Institute).

An important element of Modicut's success was the artistic value of Maud and Cutler's hand puppets. Many critics commented on how human the puppets appeared onstage, despite their nature as caricatures, and on how authentically Jewish they looked, from the silk *kaftonim* and *taleysim* (prayer robes and shawls) on traditional Jews to the workaday clothing on Lower East Side working-class Jews. The faces of the puppets were stereotypically Jewish, and some resembled the artists themselves. Maud and Cutler also exploited gestures, such as the rotating thumb of a pondering *magid*, a typical gesture made by Jews when interpreting religious verse, or the flapping ears of the *loyfer*. Maud and Cutler would sometimes spend months working on particular puppets, trying to perfect a wrinkled brow, a smile, or a raised eyebrow. These technical innovations were typically executed by the strings attached through the back of the puppet, which, when pulled, would cause the puppet's eyebrows or eyelids to raise. In the mid-1930s, for example, Maud developed a "trick" puppet of Hitler. With the pull of one string, the puppet's arm raised in the Nazi salute, its mouth opened to reveal fangs, and a lock of hair in the middle of his head stood straight up.[8]

In addition to performing in their own space in New York City, Modicut performed in smaller venues, improvising shows in Jewish schools and worker's clubs in and around New York (Kramer 1996; Trauber 1996). Their summers were spent practicing and performing at the Maud family's summer resort in the Catskills, "Maud's Zumeray," a center for left-wing arts and politics. It is interesting to note that the only item under lock and key in the entire resort was the closet containing their puppets. Zumeray's sliding fee scales attracted shop workers who, when they came up to vacation there, would often bring scrap material for the artists to use for their performances (Goodlaw 1996). In 1927 Modicut toured Jewish communities on the East Coast, the Midwest, and Canada on a tour under the sponsorship of the *Morgn frayhayt*, for which Khayem Suller, a former *Morgn frayhayt* editor, recalls organizing Modicut performances in the left-wing Yiddish school system (Suller 1995). The following year, Modicut played in and around New York and on the East Coast.

In 1929, Modicut toured Europe where they met with great success. On their way to the continent Maud and Cutler fired their manager, but they were able to make enough contacts once in Europe to schedule shows in Paris, London, Brussels, and Antwerp. Modicut received high praise for their sophisticated art and humor from the reviewers in *Di post* and *Di tsayt* in London. Writing in *Di post*, Y. Shayak commented that at some points the audience was not able to control its laughter (1929). In Paris a reviewer in *Parizer haynt* was less enthusiastic, but favorable and supportive nonetheless (Alperin 1929). In anticipation of their tour of Poland, the Paris shows were also reviewed in Warsaw's *Literarishe bleter* by A. Alperin, who reveals such interesting details as the fact that the first Paris show was a special performance for the city's literary and artistic community, and was presided over by Sholem Asch. Presciently, Alperin also predicted that when Modicut arrived in Warsaw its show would first be a hit with the literary crowd at "Tlomatskie draytsn" (the address and nickname of the Yiddish Literary Union in Warsaw), followed by great success with the rest of Polish Jewry (Alperin 1929:787).

He was exactly right. In Warsaw, Modicut performed twice each night in the performance hall of the Literary Union and ended up playing approxi-

mately 200 shows there. The Warsaw Yiddish press responded with unmitigated praise. After the first few performances, literary critic Nakhman Mayzl wrote in *Literarishe bleter*:

> The entire program is full of extraordinary folk-humor, wonderful ideas, and splendid technique. We have here truly Jewish wrinkles and gestures, words and mumbles, sighs and groans, which come about from Jewish sources and a Jewish way of life. (1929:964)

The Warsaw Yiddish press in general was full of praise for Modicut. The socialist Bund's *Naye folkstsaytung* gave a glowing review and recommended Modicut to "all Jewish workers" (Beys-shin 1929). *Leytse nayes* wrote that "all of Jewish Warsaw impatiently awaits their exuberant performance" (1929). These articles, as well as articles in the leading Warsaw dailies *Haynt* and *Moment*, remarked with surprise that a puppet theatre from America could be so genuinely yidishlekh (Khoshekh 1929). This praise was important, since Poland was the source and center of Yiddish culture.

When it became apparent that Modicut had no plans to perform in the Polish provinces, a tour was hastily organized (Maud 1955). They spent a month in Vilna, playing 75 sold-out performances in a row. Articles and reviews in *Vilner tog* were as effusive and excited about Modicut as those in the Warsaw press. At the last performance in Vilna, audience members mounted the stage to ask Modicut to stay, and a moving letter from Zalman Reyzn (editor of *Vilner tog*) was read aloud, but Maud and Cutler continued on to Bialystok and other smaller locales throughout Poland (Reyzn 1930). Following Modicut's departure from Vilna, a Yiddish puppet theatre called *Maydim* was organized (Rogoff 1996); meanwhile, in Warsaw, Modicut enthusiasts created a fan club. Through Maud and Cutler's work, puppet theatre had become a fully Jewish medium.

By the time Maud and Cutler were ready to begin their second European tour, during the winter of 1931/32, communist artistic culture had become more oriented to the expression of proletarian themes. Modicut was most closely identified with the communist political community, and although Maud and Cutler did not relinquish all of their folkloric material, they began to follow the new proletarian emphasis. An indication of how politicized their theatre had become by the early 1930s is Nosu Bukhvald's review of a New York performance of new material they prepared for their tour of the Soviet Union. This special, sold-out show in Irving Plaza was organized by the communist daily *Morgn frayhayt*. Bukhvald writes:

> The themes and the clear proletarian orientation of the two new plays are truly something new for Modicut. Instead of making fun of the old *magid* from the *shtetl*, Maud and Cutler have brought their work to the closer thematics of shop, boss, exploitation, imperialism, depression and war. (1931:8)

In addition to a skit about a sweatshop, they also brought world politics to their tiny stage with puppet versions of President Herbert Hoover, British Prime Minister Ramsay MacDonald, and Mahatma Ghandi. In this particular play, Hoover and a puppet called Vol strit (Wall Street) decide that the best way to help the economy is to start a war. However, their plans are foiled by masses of workers. This development provokes the leaders of the world to complain that the workers have only just entered the play and have commandeered too large a role in world affairs—an obvious reference to the Soviet

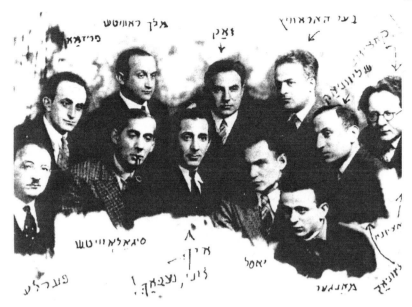

8. *Maud and Cutler (in center) among the writers of the Warsaw Literary Union at Tlomackie 13, December 1929. The writing on the photo is Maud's. (Photo by Alter Kacyzne. From YIVO Institute for Jewish Research, RG 1138, Archives of Zuni Maud; courtesy of Edward Portnoy)*

Union. This class-oriented material replaced the Old Country–related figures with which Modicut began. While Bukhvald liked the text, he commented that the plays didn't work as well as the old ones; but, he added, time and practice would take care of this problem. He reassured the public that certain key elements of Modicut's style remained, including grotesque, absurd action and jokes, as well as satire and dialect. Bukhvald lauded their switch from simple, social satire to the struggle of the revolutionary proletariat.

The enthusiastic response Modicut received in the Yiddish-speaking community of the Soviet Union (December 1931 to April 1932) is particularly interesting in light of the decline of official Soviet support for Yiddish cultural activities which did not fit into the theme "national in form and socialist in content." Jewish folkloric material was now considered objectionable in the USSR, a potential problem for Modicut, for whom folklore had always played a central role. In the Moscow Yiddish daily *Emes*, a brief article describes the origins of Modicut and mentions the "significant interest" in their performances (*Emes* 1932:4). According to the article, the Modicut performances were held in smaller venues such as the "Club for Theatre Workers, the International Club and the Theatre for Young Activists, among others."

Following Maud and Cutler's initial performance at the "Press-house" in Moscow, tables and chairs were brought up on the stage and a discussion of their works was held by the officials of GAMETS (State Union for Music, Stage and Circus). After some discussion, including comments that some texts would require alteration to make them acceptable for Soviet audiences, it was decided that Maud and Cutler would be officially invited to remain in the USSR as part of the GAMETS organization. They were put on salary and housed in the Grand Hotel for three months; however, quite significantly, no shows were organized for them. Since official attitudes toward Yiddish culture from abroad had soured during this period, it is possible that after their initial performances they were discouraged by the Soviets from performing. Despite the long period they spent in the Soviet Union, far fewer articles appeared in the Soviet press about their exploits than did in their previous year's tour of Poland, and reportage of their performances, although unquestionably

praiseful, seems reticent. During their long stay in Moscow their enthusiasm evidently began to wane, and after five months Maud and Cutler decided to come home to New York.

Though their first Moscow performance had taken place in the meeting center for journalists, there is no printed information, archival or otherwise, to indicate that they connected with writers and artists from Soviet Yiddish literary circles. However, based on their circle in New York and the connections they made with Yiddish literary figures in Paris, Warsaw, and Vilna the previous year, it seems likely that they spent time with a similar Yiddish literary circle in the Soviet Union. The very fact that they performed in the "Press-house" in Moscow, as they did the year before in Warsaw's Literary Union, indicates such a connection.

When they returned to the U.S., Maud and Cutler wrote and performed in and around New York, in addition to their usual summer activities at "Maud's Zumeray." Both continued writing for the *Morgn frayhayt* and its satellite journals, *Hamer* and *Signal*. The lack of press reports and reviews of new shows in the year following their return from the Soviet Union indicates a reduction of activity. This lull in their work, or at least press reports thereof, may have been indicative of problems in their relationship. Maud and Cutler disbanded their partnership and their theatre in mid-1933 due to an argument, the reasons for which are unknown. Khaver-paver wrote that certain friends of Yosl had convinced him to break up their theatre. "It was a tragedy when Zuni Maud and Yosl Cutler separated. [...] How many thousands of workers and simple folk were thrilled by them . . . how many thousands of children from the Yiddish schools did they charm?" (1963:403–04). Both Maud and Cutler continued performing puppet theatre, alone and with other partners, but neither achieved the success that they had had together, although Cutler, who began to work with puppeteer Lou Bunin, was apparently more successful than Maud, who brought in Bere Yano.[9]

In May 1935, Cutler left New York for California, ostensibly to make a puppet film of his own version of the Dybbuk parody.[10] With puppets and stage in tow, he stopped in Jewish communities on the way to perform in

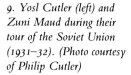

9. Yosl Cutler (left) and Zuni Maud during their tour of the Soviet Union (1931–32). (Photo courtesy of Philip Cutler)

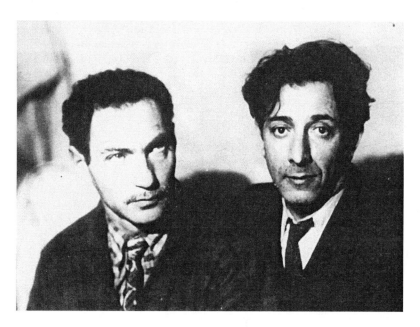

shows organized by the *Morgn frayhayt*. On 11 June 1935, while en route between Minneapolis and Denver, he was killed in an auto accident near Iowa Falls, Iowa. It is testament to the popularity of Modicut and Cutler that, according to *Der tog* and *Der morgn frayhayt* estimates, there were between 10 and 15 thousand mourners at his funeral. Though the huge procession and memorial service took place on New York's Lower East Side, no mention of it is found in the English-language press. Maud was devastated by his estranged partner's death, so much so that he was unable to attend the funeral or the memorial events surrounding it. However, he continued to write and draw for the *Frayhayt* and other left-wing journals, as well as perform puppet theatre.

Though Yiddish cultural modernism experienced a great upsurge in all artistic realms during the first half of the 20th century, it experienced a premature decline due to Jewish acculturation in America followed by the annihilation of the Jews of Eastern Europe during World War II. Modicut serves as a small example of the possibilities that existed for Yiddish culture during this period. This small hand puppet theatre engaged the Jewish working masses of New York and other areas of the U.S., as well as those of Western Europe, Poland, and the Soviet Union. Its popularity is testament to the enjoyment it brought to its audiences while it addressed themes current in Jewish life from the late 1920s to the mid-1930s. The medium of puppetry was important in this respect, because the flexibility of the form allowed for many more performance possibilities than human actors could offer. Modicut could bring the ancient characters of the Purim story to the Lower East Side of New York or mock the political leaders of the world, presenting all this to Yiddish speaking audiences in their own language and as part of their own culture. For Yiddish speakers who reveled in their language and literature, Modicut provided cultural autonomy for a people that had no official autonomous status. In its simple and humorous manner, Modicut fulfilled the Yiddish speaking community's need for a popular expression of the clash between tradition and modernity, and its consequent synthesis.

Notes

1. For more on Petryushka and its role in Russian theatre and culture, see Kelly (1990).
2. All translations, unless otherwise noted, are mine.
3. Illustrations by Maud and Cutler can be found in hundreds of Yiddish books, journals, and newspapers from 1907 to 1956.
4. See Roskies (1995:5–8) for more on the issue of "creative betrayal" in Jewish cultural innovation.
5. See *Morgn frayhayt, Forverts, Der tog,* and *Morgn zhurnal* for the week of 7 December 1925 for examples.
6. For the original version of Glatshteyn's poem, "Tirtltoyb," see Harshav (1986:55).
7. Maud and Cutler also attempted to further increase their "intellectual" audience by placing advertisements in both *The Nation* and *The New Republic* (in September and October 1926), although their success in the English-language world was undoubtedly limited since they did not perform in English.
8. Though most of Modicut's puppets have disappeared over the years, three of Yosl Cutler's puppets resurfaced at an exhibition of puppet art at the Cooper-Hewitt Museum in 1981. They were loaned by puppeteer Lou Bunin, who worked with Cutler following the breakup of Modicut.
9. In a review in the 1934 edition of *Puppetry: A Yearbook of Puppets and Marionettes,* Donald Cordry describes a show Cutler did with The Workers Laboratory Theatre, which was attended by "interesting people with accents and wild dark hair." Cordry is charmed by Cutler's grotesques and, in likening the puppets to the age-old Punch, he declares the show "a triumph" (Cordry 1934).
10. A 17-minute film of three short performances by Cutler exists under the title *Yosl Kotler un zayne marionetn* (Yosl Cutler and his Puppets) in the archives of the National

Center for Jewish Film at Brandeis University. The film, produced by Joseph Burstyn in 1935, was likely a screen test for the full-length film he wanted to make.

References

Alperin, A.
1929 "Der yidisher marionetn teater." *Literarishe bleter* (Warsaw) 41, 18 October.

Aronson, Boris
1926 "Modicut Yiddish Marionette Theatre." *Theatre Arts Monthly*, June:20.

Beys-shin (Shefner, B.)
1929 "Voyle, heymishe amerikaner (di premiere fun amerikanish=yidshn marionetn=theater in varshe)." *Naye folkstsaytung*. Warsaw, 27 November.

Blay, A.
1928 "Modikut." *Idishe tageblat*. New York, 2 March.

Bukhvald, Nosu
1931 "Modikot af a nayem veg." *Morgn frayhayt* (New York), 30 November.

Cordry, Donald
1934 *Puppetry: A Yearbook of Puppets and Marionettes* (Detroit).

Cutler, Philip
1995 Interview with author. 10 December, Boynton Beach, FL.

Cutler, Yosl
1934 *Muntergang*. New York: Farlag signal bam proletpen.
1955 "Di sokhrim fun fefer." *Yungvarg* (New York), 6 June.

Delavellade, Celia
1995 Telephone interview with author. 1 December, Los Angeles, CA.

Der tog
1926 *Der tog* (New York), 26 and 27 March, 2 December.

Emes
1932 "Teater un kino: di 'modikotn' in moskve." *Emes* 4.

Forverts
1926 *Forverts* (New York), 26 and 27 March.

Frank, N.
1929 "Fun mayn teater vinkl." *Parizer haynt* (Paris), 23 September.

Goldberg, B.Z.
1926 "Modikot." *Der tog* (New York), 8 January.

Goldberg, Itche
1995 Interview with author. 20 November, New York, NY.

Goodlaw, Bea
1996 Telephone interview with author. 2 December, Los Angeles, CA.

Harshav, B.
1986 *American Yiddish Poetry*. Berkeley: University of California Press.

Khaver-paver (Einbinder, Gershn)
1963 *Gershn in amerike*. Warsaw: Farlag idiszbukh.

Khoshekh (Tunkel, Yoysef)
1929 "Modikot—dos marionetn teater." *Moment* (Warsaw), 12 December.

Kramer, Aaron
1996 Interview with author. 16 February, Oakdale, NY.

Krishtal, Leon
1926 "Di libe modikot shpil." *Fraye Arbeter shtime* (New York), 10 January.

Leytse neyes
1929 *Leytse neyes* (Warsaw), 6 December.

Maud, Zuni
1928 "*Akhashveyresh.*" *Unzer bukh* (New York) 2–3, February-March.
1955 "Tsu yosl kotlers tvantsikstn yortzayt." *Zamlungen* (New York), June.

Mayzl, Nakhman
1929 "Di modikot forshtelungen." *Literarishe bleter* 49, 6 December.

McPharlin, P.
1969 *Puppet Theatre in America.* Boston: Boston Plays.

Morgn frayhayt
1926 *Morgn frayhayt* (New York), 26 and 27 March.

Morgn zhurnal
1926 *Morgn zhurnal* (New York), 26 and 27 March.

Mukdoyni, Aleksander
1926a "Marionetn." *Morgn zhurnal* (New York), 5 January.
1926b "Modikot." *Morgn zhurnal,* 26 March.
1926c "Modikot." *Morgn zhurnal,* 8 October.

Nadir, Moyshe
1928 *Mayne hent hobn fargisn dos dozike blut.* New York: Mayzl farlag.
1932 *Teatertekstn.* New York: Freiheit Publishing Co.

Norbert, Nat
1995 Interview with author. 16 November, Brooklyn, NY.

Novick, Shirley
1995 Interview with author. 10 October, New York, NY.

Obratsev, Sergei
1985 *My Profession.* Moscow: Rudiga Publishing.

Potamkin, H.
1933 "Modicut." *Young Israel* (New York), May.

Ravitsh, Meylekh
1929 "Di marionetn kintsler Zuni Maud & Yosl Cutler." *Literarishe bleter* 50, 13
 December.
1982 *Mayn leksikon* 4, 2. Tel-Aviv: Farlag Y.L. Perets.

Reyzn, Zalman
1926–1929 *Leksikon fun der nayer yidisher literature, prese un filologye.* Vilna.
1930 "Der gezegenungs" ovnt lekoved modikot." *Vilner tog,* c. February.

Rogoff, David
1996 Interview with author. 20 May, New York, NY.

Roskies, David
1995 *A Bridge of Longing.* Cambridge: Harvard University Press.

Shayak, Y.
1929 "Dos idishe marionetn teater." *Di Post* (London), 22 December.

Shatsky, Yankev
1930 *Arkhiv far der geshikhte fun yidishn teater un drame.* Vilna and New York: YIVO
 Institute.
Shteynberg, Noyekh
1929 *Idish amerike.* New York: Farlag lebn.

Suller, Khayem
1995 Interview with author. 7 November, New York, NY.

Teller, J.
1968 *Stangers and Natives: The Evolution of the American Jew from 1921 to the Present.*
 New York: Delacorte Press.

Trauber, Jerry
1996 Telephone interview with author. 8 February, Brooklyn, NY.

Vaynper, Zishe
1933 *Idishe shriftshteler.* New York: Farlag oyfkum.

YIVO Institute
n.d. General Theatre Archive RG 118.

Yuklson, R.
1926 "Vi lialkes shpiln zikh in idishn marionetn teater." *Morgn frayhayt* (New York), 16 April.

Articulations

The History of All Things

Theodora Skipitares

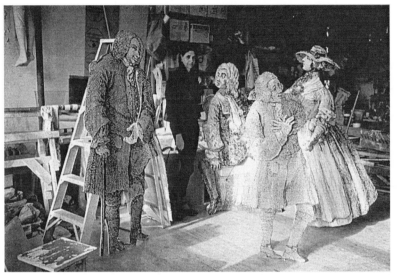

Costa Picadas

Artist's Statement

My earliest performances, in the late 1970s, featured objects that were masks or costume extensions of my own body. Dresses and skirts of unusual materials—3,000 walnut shells, 90 pounds of glass, dozens of fresh fish—became an integral part of my autobiographical performances. After a while, I felt alone onstage in these solo works, and I began to create small likenesses of myself to take on supporting roles. These were my first puppets. Soon, there were so many "little Theodoras" onstage that I gave up performing and became the director instead. My works expanded out from autobiography to large-scale subjects such as the history of American invention, genetics, food and famine, and medicine. I have always felt that puppets have an innocence and a purity that make them especially effective in illuminating social and political issues. Those qualities, in addition to their ability to express and transmit to audiences deeply felt emotions, have led me to incorporate, over the past 20 years, a wide variety of puppets in my works.

MASK PERFORMANCE, 1977, Artists Space Gallery, New York

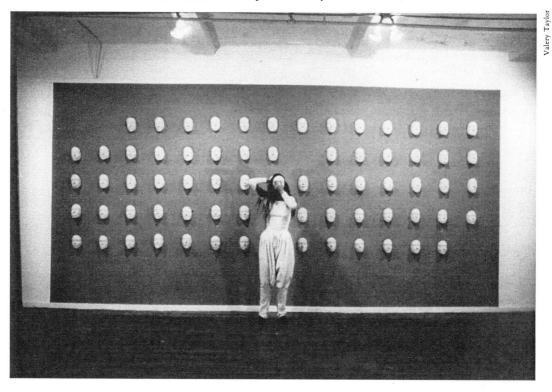

Valery Taylor

My first piece, a solo performance and gallery installation using 72 life-cast masks of my face in different expressions. The performance consisted of vocal and movement improvisations. During the day, these, plus another group of my masks, were on display.

THE VENUS CAFE, 1979, Byrd Hoffman Studio, New York

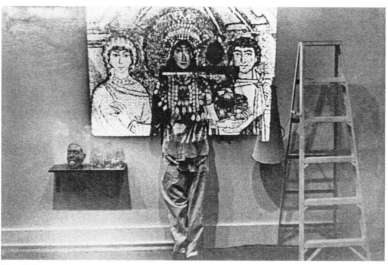

Valery Taylor

Autobiographical performance using objects, masks, costumes, slides, film, and audiotape. It concerned the conflicts I felt living in between two cultures, Greek and American. Shown is a slide of the Empress Theodora superimposed over my own face. From the text: *So, in one afternoon, I was transformed from a Gypsy whore to a Greek virgin and bride. Sort of like a Byzantine fairy tale. Sort of like Theodora, the one-time prostitute who became the Holy Empress of Constantinople.*

THE MOTHER AND THE MAID, 1980, The Performing Garage, New York

Sarah Van Ouwerkerk

Another solo performance continuing the theme raised in *The Venus Cafe*, the conflicts I felt as a person torn between two cultures. In *The Mother and the Maid*, I went beyond autobiography to consider how Greek myths resonated in my everyday life. Shown is my back onto which is projected Greek village women. Below is a ceramic plate onto which I project various images. Later in the performance, I dropped the plate and it shattered.

SKYSAVER, 1981, gallerie ak, Frankfurt, Germany

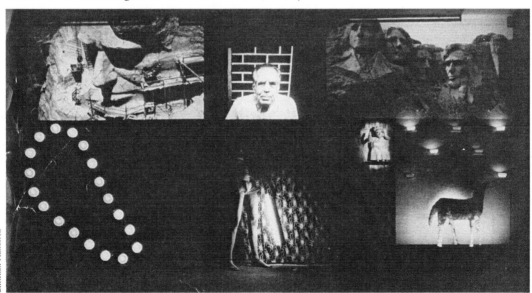

Christian Hanussek

Solo performance. At that time, I was teaching painting to mental patients in New York. The piece investigated the life and art of the insane, in my own experience and throughout history. From the text: *John Petrolak is 58 years old, institutionalized for 28 years. For the past two years, he has been working on one pencil sketch of Abraham Lincoln. Each week, he draws two or three lines of the face and stares at it for hours.*

MICROPOLIS: Seven Portraits and a Landscape, 1982, The Performing Garage, New York

This was my first play for puppets—with 20 of them. Three performers worked with eight miniature tableaux, each with individual sound and light systems.

Sylvia

You can't see them, but my body is full of needles. They hang from me like pinecones. I heard last week that the governor died of a blowjob. In the papers they called it a natural disaster. The doctors tell me I'm to be released soon. I have a job waiting as a fashion designer. Gloria is one of my sponsors. So is Louis Duy-De. I'm going to be a celebrity. I'll be on all the talk shows and featured in People *magazine. I'll probably marry Pat Boone soon. I'll fly first class. I'll sip the perfect martini as I chat about my life with Gore. I was born with cachet. (Text by Garry Rich)*

Eli Langner

Hotel

Bob van Dantzig

Eli Langner

Urban Landscape

As a child, my eyesight was sharpened by certain skies.
Their features darkened my whole appearance.
The phenomena came alive.
Now, the inflections of time and the infinity of mathemat-
ics are tracking me down.
I put up with civic acclaim, famous among weird children.
I dream of a war, of unthinkable logic.
(Text by Rimbaud)

On the Road

Eli Langner

THE AGE OF INVENTION, 1984, Theatre for the New City, New York

A piece for five performers with 39 scenes, 300 puppets, a film, and a score by Virgil Moorefield.

Part 1 — The Eighteenth Century
Prologue: Fade-up. A female buffalo puppet (four feet long) stands next to her three daughters, who function like a Supremes backup chorus.

> "Buffalo Gals"
> *Livin' with the white man*
> *Stead of livin' with the Indians*
> *Sorta like the landlord*
> *Who bought the place from under you.*
> (Song by Martha Wilson)

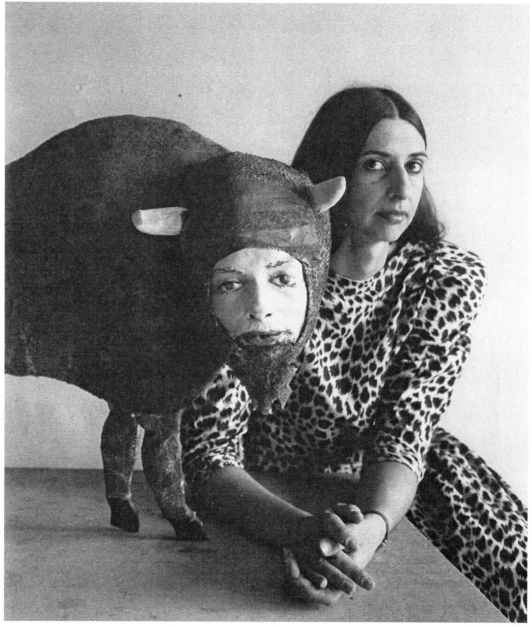

Cynthia Friedman

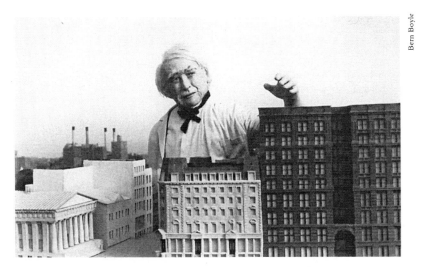

Bern Boyle

Part 2 — The Nineteenth Century

EDISON: A scientific man busies himself with theory. He is absolutely impractical.
An inventor is essential practical. Anything that won't sell, I don't want to invent.

Part 3 — The Twentieth Century

SALESMAN: Some surgeons go to Stanford or Harvard. My medical education took
place in the garage behind my house, in emergency rooms, and morgues. At first, my
role was watching or holding an arm while residents patched it up. From then on, doc-
tors began increasingly to consult me about new prostheses and to ask me to perform
surgery in the operating room. I could have refused, but frankly, I was concerned about
losing business at the hospital. It was one of my major accounts.

Eli Langner

DEFENDERS OF THE CODE: *A Musical History of Genetics,* 1987, Apple Corps Theatre, New York

Five manipulators, three musicians, and 50 puppets. Score by Virgil Moorefield, lyrics by Andrea Balis.

A laboring woman is attended to by three medieval midwives who encourage her to give birth at an astrologically auspicious moment.

Every race has its characteristic nose, and from its shape and size may be determined the degree of development attained by that particular race.

Adam Bartos

EMPIRE AND APPETITES:
A History of Food and Famine

1989, Theatre for the New City, New York

A musical with six performers and 100 puppets. Score by Pat Irwin, lyrics by Andrea Balis.

Dance
A 10-foot aluminum and wood ape-man marionette crawling on all fours gradually rises up onto two feet.

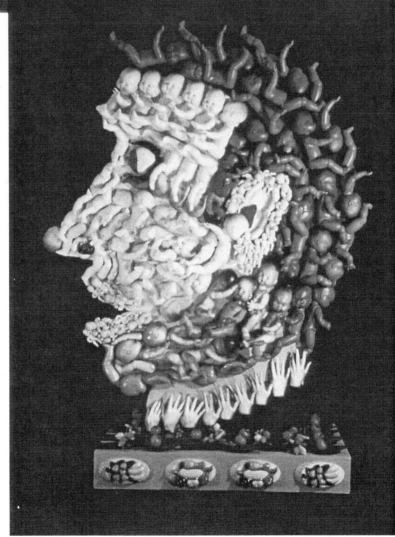

"Song of Malthus"
The population of the earth progresses mathematically. The generation of the food supply progresses arithmetically.

THE RADIANT CITY, 1991, American Place Theatre, New York

This play is about the legendary master builder of New York, Robert Moses, who from the mid-1920s until 1968 determined the shape of today's New York, and had enormous influence on the rest of urban America. Five people manipulated 150 puppets. The five-piece band played music by Christopher Thall, with lyrics by Andrea Balis.

A 12-foot-long Robert Moses puppet surveys mid-Manhattan.

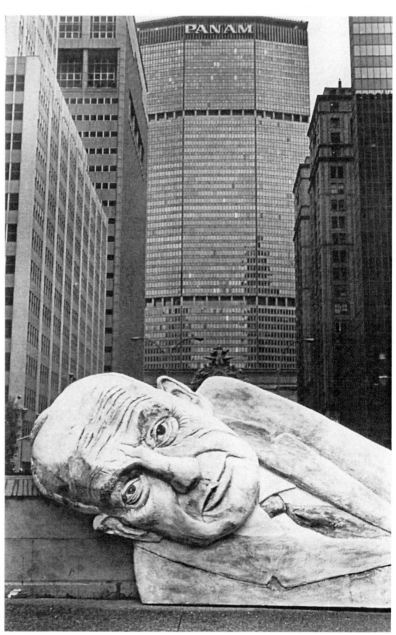

Valerie Osterwalder

Wheel of Power: A 12-foot Ferris wheel identifies each of the 12 unelected positions Moses held simultaneously in New York City and New York State governments.

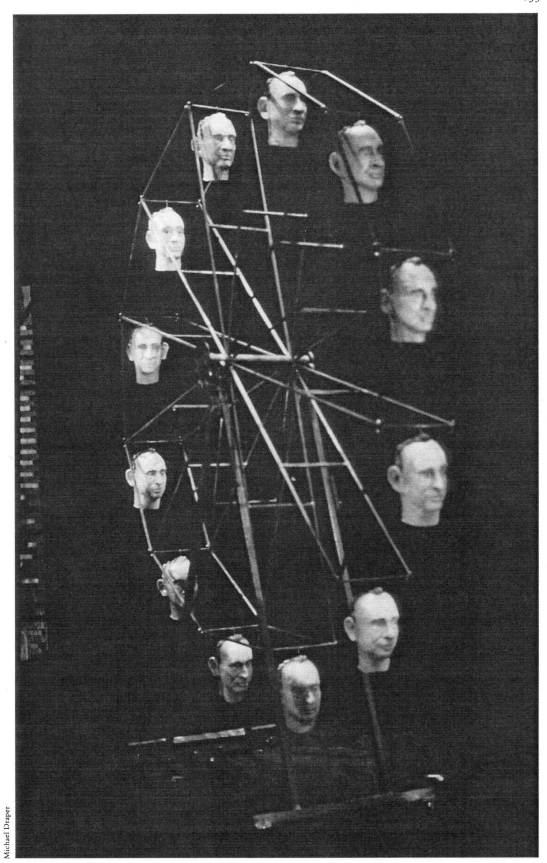

A group of New York-
ers evicted from their
homes to make room for
highways haunt Robert
Moses in a dream.

Michael Draper

Michael Draper

"The Bill Song"
You got to write it right
To get your bill to fly
You'd be amazed
Just how much crap gets by.
(Song by A. Balis)

UNDERGROUND, 1992, La MaMa E.T.C., New York

When a 1960s radical resurfaced after hiding "underground" for more than 20 years, I became fascinated with people who live, work, and hide underground. This was a piece for six manipulators and 50 puppets. Score by Bobby Previte.

Bomb Shelter

CHET: *I'm sure we'll be out of here any day now, gang. (Pause)*
JUNE: *Of course we will, honey.*
(Text by Sebastian Stuart)

Egypt

Death presents itself to me like a familiar road.
As when one returns from war to one's own home.
(Text from Egyptian *Book of the Dead*)

UNDER THE KNIFE: *A History of Medicine,* 1994, La MaMa E.T.C., New York (First version, University of Iowa, 1994)

Michael Draper

For the first time, I experimented with ambulatory performance—spectators moved to 12 different environments covering La MaMa's large Annex Theatre, its lobby, and the stairway leading up to the theatre. The play was about the history of medicine. As spectators moved, they traveled in time from the past to the present. The play used 22 performers and 100 puppets. The score was by Virgil Moorefield. In addition to my own writing, I used texts by Greg Armknecht, Art Borreca, Erik Ehn, Diana Son, Maggie Conroy, Jack Shamblin, and Jamie Leo.

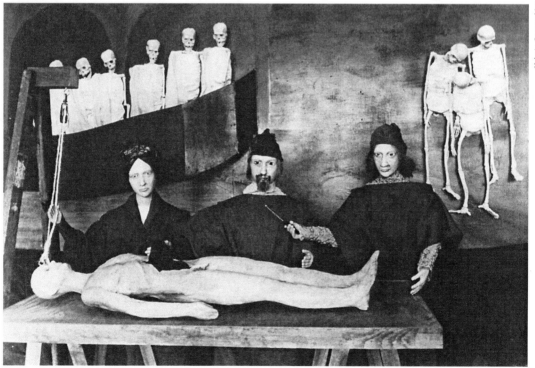

Valerie Osterwalder

Dissection (scene 9)

VESALIUS: It was my first year of university that I learned of it, opening bodies. My teacher said, "Before royal crowds, they do, they take criminals and they open them, there, sometimes still alive, that while breath remains they might seek out the secrets of nature."

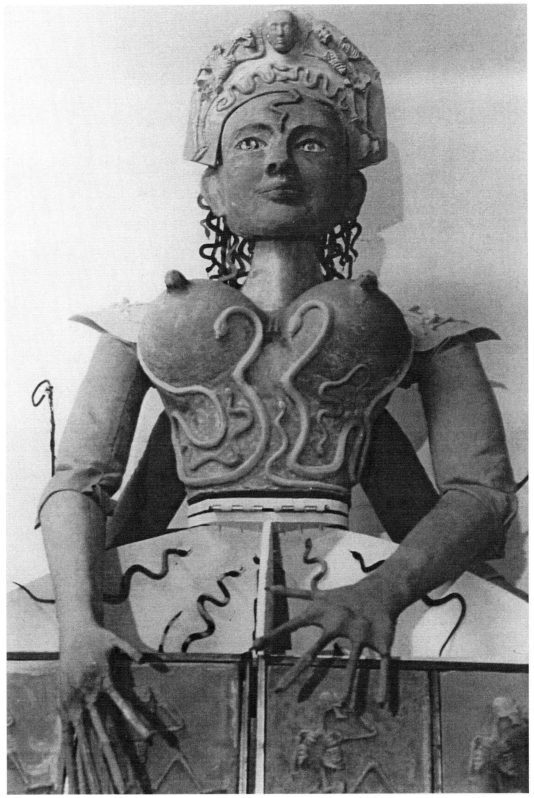

Medusa (prologue)
Sung text: *He who takes the blood from the veins of my left can heal the sick and raise the dead. He who takes the blood from the veins of my right can cause disease and bring destruction.*

BODY OF CRIME PART 1, 1996, La MaMa E.T.C., New York

This is a history of women in prison. Another ambulatory performance, spectators travel through 10 environments in and around La MaMa's Annex theatre. There were five performers and 50 puppets with a score by Barry Greenhut. Part 2 was presented in April 1999.

Valerie Osterwalder

Scenes from the Salem witch trials.

In prison, the accused, Mary Warren, did deny her testimony. By the time she gave up her denials she was having fits so violent that her legs could not be uncrossed without breaking them. She seems to have been driven insane by the refusal of the magistrates to accept her sanity.

Valerie Osterwalder

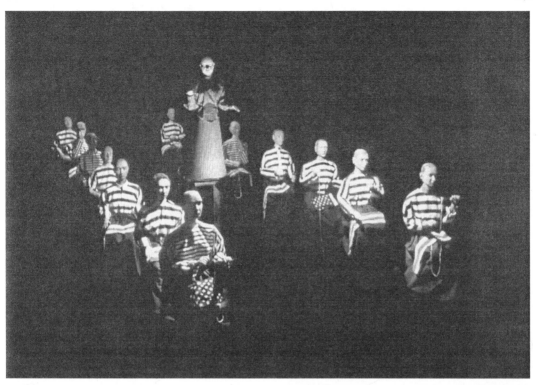

Arthur Aubry

Inmates sewing in a 19th-century American prison.

Valerie Osterwalder

Based on criminological studies, I made a sideshow of late-19th-century criminal women.

INSTALLATIONS, 1995 and 1998, 60 Broad Street, New York

These motorized figures were part of two exhibitions in abandoned spaces, featuring multimedia. The first exhibition was presented in a former office building, the second in a former bank.

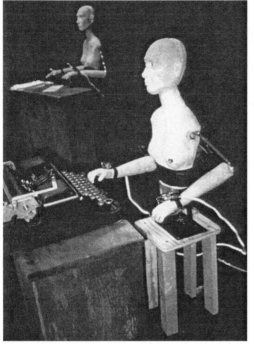

Why is she all lit up? 1995
Three latex figures, motors, typewriters, audiotape.

Patty Hearst 1998
One paper puppet, motor, videotape, CD.

Valerie Osterwalder

George Hirose

A HARLOT'S PROGRESS, 1998, The Performing Garage, New York

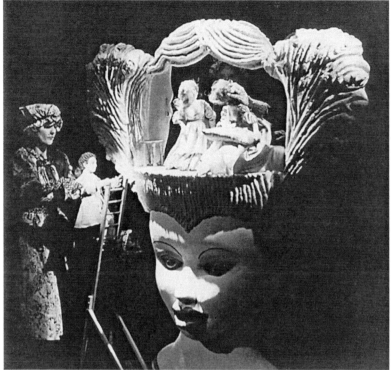

A chamber opera for puppets based on William Hogarth's engraving series of the same name. Thirteen performers, 60 puppets, with a libretto and score by Barry Greenhut.

Tom Brazil

Inside a gigantic animated woman's head, an intimate scene between Moll and her loyal maid, Lucy.

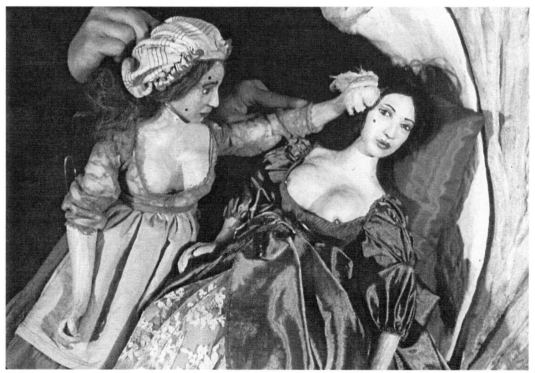

Marianne Courville

If Gandhi Could Fly . . .

Dilemmas and Directions
in Shadow Puppetry of India

Salil Singh

Gandhi Falls As Hanumān Leaps

January 1996 marked an important event in the evolution of shadow pup-
petry in India: the National Shadow Puppetry Festival at Dharmasthala,
Kárnátaká, brought together major troupes representing the six distinct styles
from as many regions.[1] Within the span of a few days one could see how
shadow puppetry had survived and where it seemed poised to go next. The
purpose of the festival, however, went beyond these academic concerns.
Jointly funded by the New Delhi–based Indian government cultural agencies
Sangeet Nāṭak Akādemi and the Indira Gandhi National Centre for the Arts,
the festival was meant to provide a boost to practitioners of an ancient art
who are struggling in the face of the modern era to remain a vital part of the
cultural fabric of the nation. Thus, along with performances of works using
the *Rāmāyaṇa* and *Mahābhārata*, there were also premieres based on three epi-
sodes from Gandhi's life: the forcible eviction of the young Gandhi from the
segregated train in South Africa, the Salt March on Dandi led by Gandhi in
defiance of British laws, and the *Swádēshi* (self-reliance) agitation. Troupes
from five different states were commissioned by these government agencies to
develop works that would complement the ancient repertories; Gandhi's life
was viewed as a modern-day "epic" of sorts. Perhaps performing a new my-
thology would give an ancient art a bridge into the future.

But the result was anticlimactic. Puppeteers in whose hands shadows of
mythical heroes had danced and cavorted, accompanied by passionate songs
and cascading music, suddenly found themselves struggling awkwardly with
bland images of a national hero, uninspired and uninspiring. They tried val-
iantly to fulfill their commission, yet it was apparent that the "experiment"
was revealing only the futility of this attempt to take this traditional art "for-
ward." The iconography of representation and the stylization of presentation
based on the old epics dried up, as people, places, and events took on a literal-
ness that was at war with the very soul of the medium. As one of the partici-
pating scholars, Dr. Nāgabhūshan Ṣarmā, put it in an open session following
the performances, it was "a noble idea gone terribly wrong."

What precisely had gone "wrong"? What was forgotten, what violated, that
Gandhi could not get off the ground—whereas Hanumān in the *Rāmāyaṇa*
can leap effortlessly across the Indian Ocean and burn down the golden city of

Lanka? How does shadow puppetry stand in modern India as it attempts to define its place in a culture more and more dominated by mass media?

The Curse of Rāma

When asked where and how shadow puppetry began, Tyāpenāhálli Hōmbaiyāh's 96-year-old eyes light up as if he is about to reveal to the listener a tremendously important, holy secret. He leans forward and narrates, his voice taking on the mellifluence which has serviced, thousands of times, thousands of couplets from the epics:

> When Lord Rāma was preparing to leave the earth, the ferryman Guha, who had earlier rowed their boat across the river, wept in grief. "What are we to do now, Lord? You are leaving us!" Seeing his sorrow, Rāma spoke to him thus: "Take this, my image, and with it, tell my story to others." And with these words the god gave a shadow puppet to Guha. From that day onwards we, the descendants of Guha, have been shadow puppeteers. We *must* do it—it is the curse of Lord Rāma upon us.
> (Hōmbaiyāh 1996)[2]

Hōmbaiyāh is probably the oldest living puppeteer in the south Indian Kárnátaká style of shadow puppetry. He performed well into his eighties, his career spanning much of the 20th century. Today his name lives on in his family troupe—the Hōmbaiyāh Troupe—which is still performing around their home in the Mándya district of Kárnátaká. The epic stories Hōmbaiyāh celebrated are indistinguishable from his life, his beliefs, and his history. The shadow puppets were gifts of the gods, but they were also a kind of curse, for the community of puppeteers is bound by Rāma's edict to repeat his epic story in perpetuity. Such is the power of the fable as the puppeteer, who is wrapped in the mythology of the story he narrates, his whole life poured into its enactment. The lack of a clear, precisely known and documented history has allowed (perhaps even required?) the myth to step in, serving as a "surrogate history." Therein is all that is glorious as well as calamitous in Hōmbaiyāh's career: he has never needed nor sought another justification for why his art is of consequence, nor is he likely to be able to provide one, even if its very survival depended on it. Yet, as numerous observers (such as Seltmann 1986; Vēņu 1986; Kŗishņaiyāh 1988; Ṣarmā 1985; Blackburn 1996) have noted, audiences and patronage are rapidly drying up under the onslaught of a high-tech urban environment transforming the Indian countryside.

Neighboring Kárnátaká is the state of Āndhra Pradēsh, where *tōḷubōmmalátá*, another style of shadow puppetry which uses puppets up to six feet tall, has evolved. Jonathan GoldbergBelle, observing performances of tōḷubōmmalátá, offered glimpses of the ways in which it has survived even as it is in decline. A selection from a transcript of a performance speaks eloquently on this topic. Two clowns—Bángarakkā, the female flirt, and Jūttūpōligádu, "the hairy Pōligádú," her jealous husband—exchange remarks on the state of the art:

JŪTTŪPŌLIGÁDU: Give me a kiss, give me a kiss.

BÁNGARAKKĀ: You want a kiss, little one?

JŪTTŪPŌLIGÁDU: Yes.

BÁNGARAKKĀ: Take a kiss.

JŪTTŪPŌLIGÁDU: Please, people have asked about the history of tōḷubōmmalátá.

PUPPETEERS: Ah.

JŪTTŪPŌLIGÁDU: Fifty years is a day, they say.

PUPPETEERS: Ah.

JŪTTŪPŌLIGÁDU: That they say "fifty years is a day" is true...

PUPPETEERS: Ah.

JŪTTŪPŌLIGÁDU: Once there were seven types of drama...

PUPPETEERS: Ah.

JŪTTŪPŌLIGÁDU: But cinemas, dramas, *vīdhīnātakās* [street theatre], *harikathās* [religious storytelling] and such things have pushed tōlubōmmalátá aside...

PUPPETEERS: Ah.

JŪTTŪPŌLIGÁDU: Its fame is there. It's known from here to there... (in GoldbergBelle 1984:67)

Traditionally, Indian shadow puppetry has been passed on in hereditary caste lines. Performances carry ritual significance, though the degree of significance given to this aspect varies considerably from region to region, and even from occasion to occasion. The ritual aspect of puppetry contains within it the very heart of the issues concerning the future of shadow puppetry in India: material as well as spiritual survival for performers as they practice their art; and the significance audiences ascribe to witnessing a performance. Obviously, if these wellsprings run dry, the descendants of Guha will lay down their puppets for good.

Tōgalugōmbeaṭṭa

Gods from Goatskin

The shadow puppet is more than a colored piece of leather dancing before a flame; it is the momentary appearance of the divine among humans. But how does the animal skin, "polluted by death" in Hindu cosmology and touched by the hands of low-caste puppeteers, become the conduit to the sublime world of the gods?

In tōgalugōmbeaṭṭa (leather puppet play), the rituals surrounding the making and deployment of the puppets are testimony to the elevation of the puppet characters and the spiritual significance ascribed to the event of shadow puppetry. For example, the auspicious task of creating the figures of the gods is preceded by prayers and offerings to the deities for the success of the enterprise (Helstein 1979:17; Kṛishṇaiyāh 1988:56). According to Mel Helstein, after performing prayers wishing for success in the endeavor, the puppeteer essentially "goes into seclusion" for the period of time during which the figures of the major gods are constructed and incised with their characteristic patterns (1979:13). As for demonic characters such as Rāvana, there is a ritual to ward off the potential evil effect upon the viewer of witnessing their presence (Kṛishṇaiyāh 1988:56). When a character is ready for performance, worship is conducted at which flowers and incense celebrate the metaphorical "birth" of the puppet as it takes its place in the repertory.

There is also a practice that illustrates the extraordinary link between puppets and performers, maintained over a lifetime and then passed on to their progeny. With Killekyátha, the mischievous and playful clown, generations of puppeteers express this vital link by placing a tuft of their own hair in the crop of hair which rests atop and distinguishes the puppet's head. The puppet,

handed down over generations, is alive with the hair of many generations, a literal, direct link to the past, even in the hands of the youngest performer, as he or she first lifts up the puppet at the age of nine. And, after a long life of "service," a puppet has a unique way of "retiring" from the stage. When it is too old to withstand the rigors of performance, it is given a "water burial"—left to float away in the currents of a river, laid to rest the way Hindus disperse the ashes of the cremated into the Gaṅgā river.

Unlike their Kerala counterparts, the tōgalugōmbeaṭṭa puppets of Kárnātakā are translucent, appearing as colored images on the cloth screen when they are held under the light. Furthermore, the performance style is based more on a single puppeteer or small ensemble of puppeteers, accompanied by one or two musicians/singers. The troupes use a small, mobile stage, moving from village to village during the performance season, performing on commission within clearly defined traditional "boundaries" which have assigned a certain number of villages to each troupe, thus resolving any territorial disputes and avoiding direct competition with other troupes. In recent years, some "border stones" have been unearthed, showing the lines of demarcation where one troupe's sphere of operation yields to another (see Kṛishṇaiyāh 1988:64–66), although the mechanism by which such boundaries historically have been determined is unknown.

There are at least two major occasions for the performance of tōgalu-gōmbeaṭṭa, both symbolically connected to fertility. At the end of the long, dry summer, the performance of certain shadow puppet episodes is traditionally linked to the advent of rainfall. Other occasions, such as weddings, can also involve shadow puppet shows. The enactment of the epics is an auspicious blessing showered upon the bride and bridegroom.

Gundu Rāju, of the Hassan district, has 58 villages that he considers his exclusive sphere of operation. As he unveils his family collection of shadow puppets, it becomes slowly apparent that there are two kinds of puppets inhabiting the weatherworn wrappings. One type is more contemporary, with moving parts, whereas the second type belongs to the "old style" where large, colorful puppets present exquisite, dancing pictures on the screen. This older style depends on iconographic symbolism. For example, a major epic character may have a complex mosaic of geometric patterns of mythical birds or beasts associated with the deity surrounding the figure. In other instances, the puppet may represent two or more warrior figures mounted on a single chariot. Because these puppets do not have individually articulated limbs or moving parts, the puppeteer simply brings the entire image onto the screen, manipulating it as a complete scene, while songs and narrative explicate the story connected to the image.

These old puppets, meant to be seen under the enticing light of oil lamps, take on the glow of fire, making the ancient colors spring to life, even after a hundred years of use. Since the puppets themselves are so detailed with ornaments and complex, interrelated compositions, there is little need for moving limbs or individually articulated parts. Yet today's audiences are not content—the expectations for a performance increasingly revolve around "action" and "movement" of a rather different kind, expectations born from the instantaneous leaps in visual narratives shown with such ease in movies and television. Excerpts from an interview with Gundu Rāju reveal some of these concerns:

SINGH: Where are the old-style puppets from?

RĀJU: From my father. He was the one who made them and I have inherited them from him.

SINGH: How did you learn from him?

RĀJU: By accompanying him as he traveled to perform. As a small boy I would sit next to him behind the screen, watching him perform. Then, slowly, he began to give me little things to do, like holding the puppets ready for him. Soon, I became a part of the troupe.

SINGH: What was the style of his performances like?

RĀJU: The older puppets were harder to manipulate—they required more skill, because they had little movement built into the puppet. So, the performers had to create the sense of movement through how they handled it as a whole, and it was a more "descriptive" style. For example, a character would arrive on the screen, and the narration would comment on his magnificent appearance—his crown, his attire, his personal qualities. Then, the light of the oil lamp created a very special atmosphere. It was like a dream world, seen from a distance...a world of gods. People used to bow before the puppet figures in worship and prayer.

SINGH: How is this different today?

RĀJU: The old audiences were very informed—if we were to miss an important detail, as for instance, the sacred thread of the higher castes on his body, they would immediately notice it, and demand to know why it was not there! Today, audiences are neither so discerning nor as demanding. They want brightness and movement—more "action" from the puppets. So, our new puppets now have moving arms and other limbs.

SINGH: Are you still following the old ways of making the puppets?

RĀJU: I know the technique, but is very difficult to do that. The old method uses all vegetable colors from various herbs and flowers, mixed by hand. Up to two months are needed for making a single color. So, we now use pre-mixed paints available in the stores.

SINGH: Do you still use the old and the new puppets together in performance?

RĀJU: Yes, for example, when it comes to scenes of war, we use the old puppets showing warriors on chariots, all in one composition. At other times, the newer puppets are used. (Singh 1996a)

Also audiences have less patience with the poetic light of the oil lamps. People want to see everything, fully illuminated; this is the age of electrical floodlights, so why sit in gloomy shadows? Some of the old-style puppeteers have capitulated to such demands by bringing in newly made puppets with articulated limbs to combine with the old, and by performing under electrical lighting. Predictably, the outcome has serious drawbacks: The new puppets look like garish imitations in contemporary colors, overexposed in the wash of floodlights. The emphasis is no longer on the pictorial, visual qualities provided by the patterns and natural dyes of the old method. The new puppets cannot hold their own next to the artistry of the old ones. Meanwhile, the old puppets also seem to fade; gods and demons begin to lose their vibrancy, as if the electric light is lethal kryptonite for these superheroes of the Hindu epics.

Tōḷpāvā koothu

The complex negotiation of performed ritual within ritual performance is the hallmark of traditional shadow puppetry. This aspect is best seen in the temple-theatre performances of tōlpāvākoothu (*tōḷ* = leather, *pāvā* = puppet, and *koothu* = play). In the Palghat region of Kerala, Tamil-speaking families of shadow puppeteers have been performing for centuries exclusively in temple theatres called *koothumādams* each facing a temple of the goddess Bhagavati

1. *Performances of tōḷpāvā koothu are held annually in this typical* koothumadām *in a temple compound in Kerala. (Photo by Salil Singh)*

and resembling a rectangular brick building with one side left open for the shadow screen. All-night performances of the *Rāmāyaṇa* are staged within this modest structure as a form of prayer to the goddess for as many as 21 nights in a row. The legend of the puppet play's Kerala origin recounts that Bhagavati was away on a mission from Shiva to annihilate the demon Darika. While engaged in the fight, Bhagavati missed the epic battle between Rāma and Rāvana which ended the great war recounted in the *Rāmāyaṇa*. The shadow play is performed in order for the goddess to witness the *Rāmāyaṇa*. Thus, the belief goes, Bhagavati is always present at the performance.

On the first day of the Āryankāvu temple performance a flag is hoisted to mark the beginning of the festival and, at dusk, lamps are lit around the courtyard and before the idol of the goddess. Many instruments accompany the performance, and prominent among them is the ensemble of virtuoso percussionists who pound out their intricate rhythms for hours before the performance in a ritual summoning of their audiences. The master puppeteer thrice seeks the permission of the temple authorities to begin the process of tying the cloth screen to the stage, which is a permanent architectural feature of the courtyard. Upon being granted permission, the puppeteer ties on the screen, to the accompaniment of the sounding of drums and fireworks outside. By this time a large crowd has usually gathered in eager anticipation. Around 9:00 P.M. the "oracle" of the temple emerges after his ceremonial bath, circles the temple thrice with sword in hand, and blesses the master puppeteer with the words: "I am pleased with you. Show me the *Rāmāyaṇa* story without a fault. I shall stand by you and render you all help" (Vēṇu 1986:24). Then he throws a handful of rice at the performers and others present. A flame, brought by him from a lamp burning before the idol of the goddess, is used to light the 21 lamps behind the screen. The performers proceed to sanctify the space of performance in the ceremony called *rángápoojā* or "worship of the stage," with offerings of coconut, rice, and flowers, which are later distributed by the head puppeteer among his troupe. Only then can the performance begin to enact the epic over the next 21 nights, from nightfall to dawn.

On the last day of the cycle, for the scene in which the victorious Rāma returns from exile for his coronation, some temples employ an elaborate ceremony in which the puppet character of Rāma's chief general, the monkey

god Hanumān, forges a curious link between the fictional life of the shadow screen and the world outside. The puppet Hanumān is carried on the back of an elephant in a ceremonial procession to a nearby river. In the preceding nights this puppet has assumed the gigantic form appropriate to a son of the wind god Vayu to crush vast armies of such elephants in the battlefield. On this day Hanumān fetches from the river holy water used in the coronation scene later that night—the puppeteers will sprinkle the water on the screen as a blessing at the moment of the coronation. When the performance is over, the screen is removed ceremoniously at the same time the flag (hoisted above the temple at the beginning of the festival) is brought down, accompanied by fireworks on a grand scale. The chief puppeteer cuts the screen into many pieces, distributing the pieces among the performers (Vēṇu 1986:24). The screen, which has borne witness to the exploits of the gods, no longer exists as a whole, but its "legacy" will be carried away by each of the performers.

Clearly, tōḷpāvā koothu is significant for patrons as well as audiences, an important form of ritual prayer that bestows blessings upon those who undertake the task of commissioning, sanctioning, contributing towards, or even simply witnessing the epic cycle. For their marathon efforts, the performers, in turn, are assured the virtue of having spent their lives reciting the sacred texts for the goddess and, according to Kṛishṇán Kutty Pulāvar, the 76-year-old stalwart of tōḷpāvā koothu, for having "instill[ed] good deeds in the hearts of mankind" (Singh 1996b). More important, the tradition itself remains relatively insulated from the onslaught of mass media.

Nevertheless, even within this relatively stable and deeply tradition-bound style, several profound changes have already taken place. There are nearly 70 sites of tōḷpāvākoothu performance in central Kerala, most of them a lot less prestigious than the Āryankāvu temple, and the performances held at these temple theaters today are far from the color and pomp of the Āryankāvu per-

2. In a performance of tōḷpāvā koothu, Kṛishṇán Kutty Palāvar (in the shadows, extreme right) narrates an episode from the Rāmāyaṇa from backstage. Other puppeteers manipulate the shadow figures on the screen. (Photo by Salil Singh)

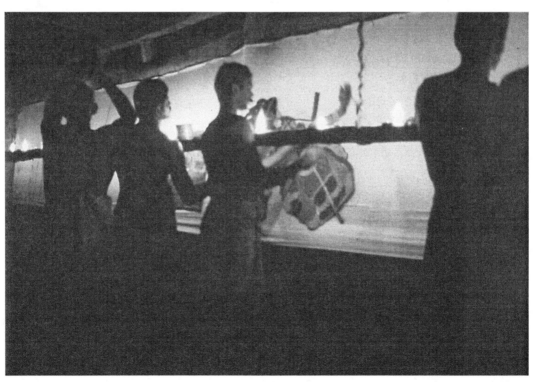

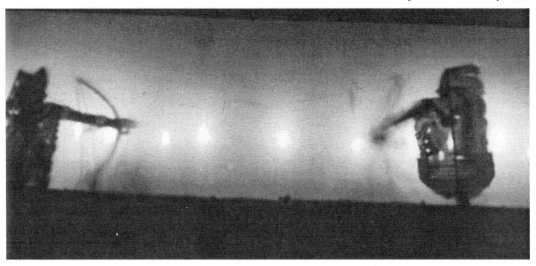

3. *Krishnan Kutty
Pal var's troupe performs a
pivotal battle scene from the
Rāmāyaṇa. Rāma's
brother, Lakshmana (left),
and the demon Indrajit, are
facing each other on the
battlefield. (Photo by Salil
Singh)*

formances. For example, take what I experienced on the first night of a 1998 Tōḷpāvā performance marking the beginning of a 14-night cycle of the *Rāmāyaṇa* by Krishṇán Kutty's troupe at the Kooḷankárā Bhagavati temple theatre in Eḍapāl, a bustling trading center near the Arabian Sea in western Kerala.

When I arrived, the Kooḷankárā Bhagavati temple was freshly painted and decorated with festive pennants hanging from a long rope extended across the gigantic trees encircling the courtyard. On each banner was a representation of Bhagavati in red and black, fluttering in the brisk evening breeze. The beginning of the annual Pooram festival was marked with the raising of the ceremonial flag before the temple. Across from the temple, virtually in the middle of a recently harvested rice field, sat the koothumādam, framed by a picturesque backdrop of palm trees extending as far as the eye could see.

Several points are worth noting about the physical relationship of structures to each other in the temple compound and vicinity. First, the koothumādam is not part of the formal confines of the temple itself, but a separate structure facing it. This bears testimony to the fact that while the shadow play is still connected to the location and orientation of the shrine, it is not directly a part of temple ritual or practice. Such an arrangement is typical in Kerala; historically, the main reason for this has been the access to the performance this grants all people, irrespective of caste. Second, the spot where the koothumādam sits today is not the original site of the structure. The old structure was located directly across from the main entrance to the temple, in the open area adjacent to where the temporary stage is now erected every year (plate 1). According to Bālan Nāir, ex-secretary of the Temple Committee in Eḍapāl, due to increasing pressure from the local citizens, in 1991, the old koothumādam was torn down and shifted further back, to make room for the temporary stage at each year's festival. This was done primarily to accommodate the large numbers of people who gather for some of the events organized on that stage during the fortnight of the festival; these events range from classical dances to contemporary dance-dramas on religious themes, in addition to glitzy entertainments like magic shows (Singh 1997a).

The result of all this has been a curious spatial symbolism (which none of the people I spoke to seemed aware of): the koothumādam has been pushed back and a temporary stage erected between it and the shrine, obstructing the view of the shadow play. Furthermore, the sightlines from the koothumādam to the

rice fields

East

koothumadam

HOUSES

open
area

tree

temporary
stage

(approx.)
100 yds.

tree

entrance

PATHWAY

HOUSES

shrine

temple wall

4. This plan of the Koolankárá Temple in Eḍapál shows the relationship of the koothumādam and temporary stage to the shrine. All dimensions are approximate and not to scale. (Graphics by Salil Singh)

idol of Bhagavati within the shrine are now terrible. On the temporary stage (resembling a gigantic television set), every local version of modern entertainment (dance-dramas and magic shows) is played out night after night, using all the available technology of theatrical lighting, amplified sound, and scenery. Meanwhile, the permanent koothumādam sits in the background, with puppeteers waiting patiently for these modern shows to wind up so that they may begin their performance with the aid of oil lamps in the dead of the night.

Heightening the irony, within the cozy living room of one of the houses adjacent to the temple compound a rerun of an old Hindi disaster-blockbuster, *The Burning Train*, was being enthusiastically watched on television by the residents. As I waited outside in the temple compound I was invited in for a cup of tea. Mr. Sreedharan, the old patriarch of the family, urged me to join him for the movie, but to his puzzled disappointment, I declined politely, drawn outside by sounds emanating from the temple. Even though he could witness the puppet play virtually from his living room window, Mr. Sreedharan felt no compulsion to watch anything other than his cable-connected color TV screen.

At approximately 6:00 P.M., the priest of the temple lit the ceremonial bronze lamps leading up to the main entrance of the shrine. An ensemble of musicians playing on drums and an oboe-like instrument called the *nādaswaram* began playing around these lamps, as if serenading the Bhagavati deity. At 8:00 P.M. a five-member *chendā* drum ensemble took over with explosive, energetic bursts of rhythm. The puppeteers, meanwhile, had arrived by bus and taken a simple evening meal at the home of the family who sponsored the first night's events. Soon thereafter, they made themselves at home in the empty koothumādam, laying out the puppets needed for the opening.

At approximately 8:45, Lakshman, the youngest son of Kṛishṇán Kutty Pulāvar, as representative of the troupe, entered the temple. The oracle of the temple brought out a piece of cloth which had been provided by the sponsor,

and held it out to Lakshman, along with a ladle-like blackened iron utensil (*tooku viḷakku*) which held a flame lit from lamps within the shrine. Lakshman quickly prostrated himself on the floor in obeisance, received the cloth and the flame and brought them out to the koothumāḍam. There, the flame was hung from a hook on the roof just outside the front facade of the koothumāḍam. Inside, the troupe began to stretch the cloth screen across the opening of the theatre, pinning it to the edges with long thorns (*karas*) they collect from a particular bush growing wild in the Kerala countryside. Next, several puppets were taken out and also pinned to the cloth forming the opening tableau for the night's episode: *The Mutilation of Soorpanakhā*, featuring Rāma, Lakshmana, Seetā, and the demon Sambhukumāra in the forest. (Of course, none of these puppets was yet visible from outside the koothumāḍam, since there was no illumination from the inside to cast their shadows on the screen.) Once this was accomplished the entire troupe of five quietly stretched out inside the theatre and went to sleep.

It was now past 9:00 P.M. and, at first, this seemed like a curiously laid-back approach to an opening night. It was as if the puppeteers had spun a fragile cocoon within which they now rested, insulated from the world outside except for the pounding sounds of the drums filtering through the thin cotton of the cloth screen. Later, when their actual performance began—no sooner than 2:25 A.M.—I understood this lack of urgency. At about 9:30 the drummers emerged from the temple, led by the temple oracle, now in his full regalia, carrying the sickle-shaped sword which is his ceremonial prop and wearing brass anklets with bells that punctuated his every step.[3] After a few minutes of intense drumming in the courtyard, as the oracle paced back and forth before the ensemble, the drums stopped and a smaller procession broke off; a single drummer and a young boy carrying a flaming torch to show the way through the dark followed the oracle to the koothumāḍam. Inside the koothumāḍam some hundred yards from the temple, Kṛishṇán Kutty heard the procession approach and emerged to stand before it. The oracle, in his role as the representative of Bhagavati, approached Kṛishṇán Kutty and quietly touched his bowed head with his sword, blessing him and granting him permission to tell the *Rāmāyaṇa* for the goddess. The oracle wore a garland of flowers from the shrine; he took it from around his neck and handed it to Kṛishṇán Kutty as a final symbolic blessing from the goddess to the performers.

The procession returned to the temple and everything was quiet for a moment. Impatient for the puppet play to begin, I had spread out my straw mat in the field before the koothumāḍam, armed with my notebook and a flashlight. Yet, the preliminary events of the night were far from over: a performance of *Kṛishṇāttam*—one of the forms of classical Indian theatre enacting legends of the god Krishna—now began on the temporary stage closer to the temple. It was performed by a famed Kṛishṇāttam troupe from the Guruvāyoor Temple, the holiest Hindu shrine in Kerala, just an hour to the south of Eḍapāl. It was 2:00 A.M. when all outside activity finally ceased and the puppeteers arose to commence drumming within the koothumāḍam, announcing the formal beginning of the tōḷpāvā koothu.

The flame hanging outside the front facade was now taken inside, and at 2:25 A.M. Kṛishṇán Kutty honored the stage with a small *pooja* (ritual ceremony) in the koothumāḍam to make it ready for the performance. He also offered blessings to the sponsor and his family, who had made an appearance within the theatre and were standing by respectfully. The male head of this family (an electrical engineer), his wife, and their adult daughter all stayed for the few minutes it took to complete the ceremony, and then quietly returned to their house, which was adjacent to the temple compound. Finally, the puppet play began as the flame from the temple was used to light a series of oil

lamps mounted on a strip of bamboo, thus illuminating the puppets on screen for the viewers outside.

Perhaps I should say viewer, since I realized with a rather unsettling awareness that with the departure of the sponsoring family, I now sat all alone in the middle of that rice field, and was consequently the sole spectator for the night's performance. All those who had made it to the end of the Krishnāttam had by now gone home. Aside from the swaying palms above me and the rustling of leaves from the gigantic banyan tree sheltering the koothumādam, not a single sign of life remained outside. Inside the koothumādam, in the gentle flickering light of a row of oil lamps, the soft opening invocation chant was being sung by the puppeteers, paying homage to the god Ganapati and the long line of ancestral tōlpāvā artists and teachers who had preceded them in this enterprise. I remember standing up in a mixture of disbelief and alarm: it was a moment of true existential anguish. I was sitting alone in the middle of the night in an open field in a strange town, very far from anyone I knew except for five performers who were invisible behind a cloth screen inside a small building before me. I realized that even if I were to get up and leave or perchance fall asleep on my straw mat, most likely the performers would not know it, for I was as invisible to them as they were to me. The performance would go on uninterrupted. And, if it did, was this an act of theatre?

A Question of Audience

These troubling issues had also been raised by Stuart Blackburn who, upon emerging from the koothumādam at that same venue in Edapāl 12 years earlier, realized that the oral recitation he had been zealously recording from within, had gone unheard by anyone else outside the theatre. This necessitated a retheorizing of what was happening. While Blackburn observed that: "the goddess Bhagavati, as host of the temple, is considered the ritual audience for the performance" (1996:12), he also theorized an "internal audience" wherein the puppeteers perform for each other, serving as both doers and receivers of the ritual show. I think Blackburn's first supposition is closer to the truth. The puppeteers would not perform unless they believed there was the palpable presence of the goddess surrounding the koothumādam, witnessing the play, and that dire consequences would follow if they were to compromise on their performance. Irrespective of the "internal audience" they provide for each other, the central fact of the event revolves around an "imagined audience" at best, not the "absent" one which Blackburn defines. Viewed in this way, the event is just as much a theatrical form as any with a live audience in attendance.

But what do the puppeteers think? They do not conceive of the goddess as present in any literal sense, as if she were residing in the idol within the inner sanctum of the temple and watching through the doors of the temple facing the koothumādam. Indeed, every night the play was enacted in Edapāl the priest of the temple was usually long gone by the time the play began, leaving behind him a locked temple compound with the inner sanctum firmly sealed off to the outside. As such, the idol of the goddess would be completely closed off to the koothumādam. It is not the *murthi* (idol) but the fire from the temple that is understood to represent her presence (Singh 1997b).

In other (rare) instances, as in the temple at Chālissēry, the koothumādam itself is situated not facing the shrine of the goddess, but at right angles to it, as seen in plate 5.[4] When asked about this unusual arrangement, and how one could expect the goddess to properly "view" the shadow play, given this orientation of the koothumādam, Krishnán Kutty Pulāvar replied with characteristic philosophical calm: "The goddess is everywhere. She is *sakti* [energy].

main entrance to temple

Shrine

temple wall

audience

area

Puppet Theatre

5. *A plan of the temple complex at Chāliṣṣēry shows the perpendicular orientation of the koothumādam with respect to the shrine. (Graphics by Salil Singh)*

She does not reside in any one place, nor in any one thing" (Singh 1997c). It appears that there is no problem of sightlines after all!

It is worth noting that Kṛishṇán Kutty's troupe, which represented the Kerala style at the National Festival in Dharmasthala, was the only one that did not take up the Gandhi commission even though they had been offered a considerable sum of money as incentive. Instead his troupe chose to perform a condensed version of the *Rāmāyaṇa* with oil lamps—a detail that set it apart from all the other troupes who, without exception, used the convenience of electric floodlights to present their excerpts.

Why Gandhi Couldn't Fly...

If the intent of the Gandhi commission was to give traditional shadow theatre and its practitioners a subject capable and worthy of being adapted into a contemporary play using the resources of their ancient art, the request was on the surface not far off the mark. After all, here was the story of a larger-than-life national saint and hero full of highly dramatic events and images to draw from. The award of money gave the puppeteers the luxury of creating without scraping the bottom of the pot of their own dwindling resources. However, Gandhi proved far too rooted in contemporary history, too close to the *real* to be mythologized. In the commissioned shadow shows, the entire iconography of Gandhi's story was constrained by photographic images of him, and this resulted in literal re-enactments of his life-events: puppeteers were unable to find ways to use the traditional stylization which allows the epics to live in the realm of the fantastic. Perhaps the most dismaying instance of this was the

scene in which Gandhi boards the train at a small station in South Africa. In the performance by Murugan Rão, a shadow puppeteer from Tamil Nādu, the name of the station was written on a small banner to indicate place (a practice alien to shadow puppetry in India), but the banner was unreadable because it appeared on the screen backwards. Murugan Rão, I realized, did not know or understand a word of English. Someone had hastily put the banner together for him as a way of representing an otherwise unknown place, and he was simply doing the best he could with it. In that performance, it seemed that as Gandhi fell from the train, so did Murugan's confidence and facility with his own art—a sad spectacle to behold from one who is otherwise an expert, virtuoso solo performer capable of enacting entire epic stories single-handedly.

For the current generation of puppeteers, even Gandhi's life is already a distant, faded event in the long history of their country. Nineteen-year-old Venkatésh Kumār, who performed in a version of the story by the troupe of his father Veeranna, confessed as much publicly in the discussions that followed the festival. "Does this story have roots in our culture like the *Rāmāyaṇa* does? How could we be expected to succeed with it?" he asked, not without anguish, as scholars and organizers listened in silence.

Lacking any significant roots in the cultural traditions of the puppeteers, Gandhi's story left the puppeteers with no contact with the surrounding preliminaries, which sanctify and elevate the puppets for an enactment of the epics, nor was there any great *reason* to engage in them. They assumed a guarded solemnity of tone and were eager not to be seen introducing "irreverent" elements into the story of a founding father of modern India. Few clowns dared appear, and even when they did, they could not construe events as a gleeful dance of bawdy frivolity, connecting the "here and now" of the audience to the "then" of the narrative. Finally, and most importantly, the Gandhi episodes did not have the resonance of myth.

The contemporary puppeteer is torn between two alternatives: either to abandon precedent expediently, without recourse to an equally powerful aesthetic which could propel the art into the future; or to repeat tradition without adapting it to today's cultural realities. In the first alternative, as in Kārnātaka's tōgalugōmbeaṭṭa, puppeteers struggle to retain the integrity of their art while trying to keep their audiences entertained. The second alternative, as we have seen in the tōḷpāvā koothu of Kerala, slowly pushes puppeteers and their art into an all but abandoned ritual performed in the solitude of the night without a human audience. Does not the art of shadows, which has survived for over two thousand years, contain within it the seeds of tenacious adaptability which will allow it to rejuvenate itself from the ashes every time the lamps are lit again?

The path followed by Bélagallu Veeranna's troupe, in the Bellāry region of Kārnātakā, may lead to an answer. Rather than bow to popular demands and attempt to create a hasty hybrid that would be neither effective nor true to itself, Veeranna has concentrated on celebrating in his art a contemporaneous mythology along with the ancient. So his troupe performs stories of such famous historical figures as Shivāji, the 17th-century Marāthā warrior-king who took up arms against the Moghul invaders, organized bands of horsemen, and successfully declared his independence. These performances successfully create an updated folklore outside of the ancient epics, yet not as contemporary as the Gandhi episodes. Veeranna's figures, inspired by the old puppets, still manage to find a stylized integrity, which makes them appear both familiar *and* exotic; real as well as full of fantasy. They move when necessary, dance when needed, yet are able to present a visual richness of detail that allows them to function as iconic landmarks in the narrative, representing places, palaces, and landscapes. Veeranna's stories are not as familiar as those of the epics,

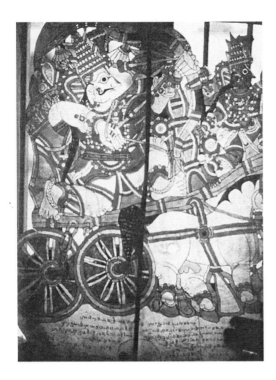 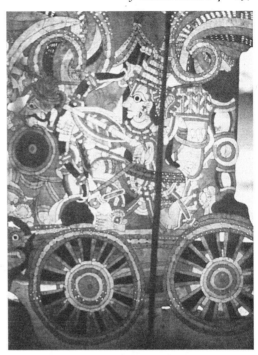

6. & 7. Old-style tōgalugōmbeaṭṭa puppets from Gundu Raju's repertoire. In plate 6, Arjuna, from the Mahābhārata, *rides his chariot with Krishna as charioteer and guide. (Photos by Salil Singh)*

yet they are just the kinds of stories that children grow up with and adults never tire of telling. Although based in the heart of the Carnātic (South Indian) music tradition, Veeranna's narrative freely incorporates motifs of North Indian classical music, and one of his sons, Venkatēsh Kumār, has even gone on to become a well-known exponent of that style. Such eclecticism gives the Veeranna troupe a firm ground from which to step forward. Judging from the relative success this troupe seems to be enjoying, audiences have found that their work fulfills a need not addressed by television or film, yet without the elaborate rituals and religious connotations that define the Kerala style. Whatever happens to Indian puppet theatres will emerge from within. Outsiders, however well intentioned, can only step back and watch, hoping that another Hanumān will leap, yet again, across the ocean.

Notes

1. The National Shadow Puppetry festival was held at Dharmasthala, Kárnātaká, from 23 to 28 January 1996, under the auspices of the Sangeet Nāṭak Akādemi, Indira Gandhi Centre for the Arts, and the Regional Resource Center for Folk and Performing Arts. Nineteen different puppet troupes were invited from six different regions of India to participate, representing all the regions which have developed and retained distinct styles of shadow puppetry. These were, namely: Orissa and Āndhra Pradēsh in southeastern India; Māhārāshṭra in the southwest; and Kárnātaká, Tamil Nādu, and Kerala in the deep south.
2. Rāma, an incarnation of Vishnu in Hindu mythology, is the hero of the epic *Rāmāyaṇa*, which is one of the major stories performed in shadow puppetry all over India and southeast Asia.
3. Bhadrakāli is usually depicted carrying such a sword, in her warlike mode.
4. Chāliṣsēry is located just off the major highway connecting Shōranur and Pattāmbi, towards the western regions of the Tōḷpāvā territory.

References

Blackburn, Stuart

1996 *Inside the Drama House: Rama Stories and Shadow Puppets in South India*. Los Angeles: University of California Press.

GoldbergBelle, Jonathan

1984 "The Performance Poetics of Tōḷubōmmalátá: South Indian Shadow Puppets." PhD diss., University of Wisconsin, Madison.

Helstein, Mel., et al.

1979 *Asian Puppets: Wall of the World*. Los Angeles: UCLA Museum of Cultural History.

Hōbaiyāh, Tyāpenāhālli

1996 Videotaped interview with author. 28 January, Dharmasthala.

Krishnaiāh, S.A.

1988 *Karnataka Puppetry*. Udupi: Manipal.

Ṣarmā, Nāgabhūshan

1985 *Tolubommalata: Shadow Puppet Tradition of Andhra Pradesh*. New Delhi: Sangeet Natak Akademi.

Seltmann, Friedrich

1986 *Schattenspiel in Kerala: Sakrales Theater in Sud-Indien*. Stuttgart: Franz Steiner Verlag.

Singh, Salil

1996a Interview with Gundu Rāju. 24 July, Hāssan.
1996b Interview with Krishnán Kutty Pulāvar. 24 July, Koonatharā
1997a Interview with Bālan Nāir. 17 January, Eḍapāl.
1997b Interview with Bālan Nāir. 11 December, Eḍapāl.
1997c Interview with Krishnán Kutty Pulāvar. 12 December, Koonatharā.

Vēṇu, G.

1990 *Tolpava Koothu: Shadow Puppets of Kerala*. New Delhi: Thomson Press.

Rediscovering Mask Performance in Peru

Gustavo Boada, Maskmaker with Yuyachkani

an interview by John Bell

For over two decades Yuyachkani has been considered not only the most important independent theatre group in Peru, but a leader from the 1970s generation of Latin American theatre groups. Yuyachkani, under the direction of Miguel Rubio, became well known for productions that combined the political theatre aesthetics of Bertolt Brecht, the anthropological theatre approaches of Augusto Boal and Eugenio Barba, and, perhaps most importantly, a rediscovery and reappraisal of the performance aesthetics of Andean culture: the dramatic dances, music, masks, and costumes of its fiestas. Not all Yuyachkani productions use masks or puppets, but the company is characterized by an ability to incorporate them effectively into its work, and an openness to do so wherever they seem to offer a powerful means of communication.

Gustavo Boada began working as a maskmaker with the group in 1987. He also taught maskmaking techniques at Peru's National School of Dramatic Art, and has worked with the Gran Circo Teatro of Chile as well as Puerto Rico's El Mundo de los Muñecos. Boada currently teaches puppetry at Brooklyn College's School of Education, and creates his own puppet and mask productions, such as *Antigone Now* and *Wasalisa*. I first met him in 1997 in Vermont, at a workshop of the International School of Theater of Latin America and the Caribbean (EITALC) led by Bread and Puppet Theater, and entitled "Paper Maché vs. Neo-Liberalism." Boada returned to Vermont to work with Bread and Puppet in the summer of 1998, and this interview was held in the Bread and Puppet Museum on 27 July 1998. Teresa Camou provided simultaneous translation.

BELL: Could you explain what Yuyachkani is?

BOADA: The name Yuyachkani is a Quechua word that means "I am thinking, I am remembering." In other regions, where Quechua is a bit different, it means "I am your memories, I am your thoughts." Yuyachkani comes from the attitude of young people in the 1970s who had decided to make theatre based on political ideas and the social problems of Peru. This reflection on the problems of the country obliged us to travel a lot to towns very far from the city.

1. Yuyachkani maskmaker Gustavo Boada and one of his masks: a commedia dell'arte Arlecchino. (Photo courtesy of Archivo G.C. Yuyachkani)

BELL: When did the theatre start?

BOADA: It started in 1972. Miguel Rubio and Teresa Ralli, only 17 and 20 years old, were part of an experimental theatre group named Yego. And because they witnessed a miners' strike and the violent way the police took control of the situation, they really felt affected by those problems, and they started to believe that they had to make some kind of theatre. They learned about the existence of political theatre, and this led to the first appearances of Yuyachkani.

Discovering Masks

BOADA: In 1973 they had a performance in Allpamina, a mining town. They did a piece called *Puño de Cobre* (Fist of Copper). The story was based on a strike at a copper mine named Cobrisa. The show talks about how the police killed some of the miners who had gone on strike—there are a lot of stories in Latin America about these kinds of situations. The actors were acting in blue jeans and white T-shirts, and after the performance the miners told them that they really did like the show, but that "next time, don't forget your costumes."[1] They thought they had forgotten their costumes, because for the miners—who are very connected with nature, and appreciate colors—for them happiness is color. Mask imagery is very important for them, and dance is an equally important element. They didn't think any other kind of theatre existed. But *Puño de Cobre* didn't use any of these elements. This event made Yuyachkani realize they were making a very different kind of theatre than what the population knew. So they decided they had to figure out not only how to investigate social problems, but also how to investigate traditions, and the significance of each element of those traditions.

BELL: Did Yuyachkani begin to use masks after this?

BOADA: Yes, they did shows in each community they visited, and after the show there would be an exchange: the people from the community performed their dances, and the company learned the music, the songs, and the dance. That's where they started accumulating masks, from many different places, of many different types and materials, and started to perform with masks.

BELL: Why was this type of mask theatre unknown to Rubio, Ralli, and the other members of Yuyachkani?

BOADA: The reference points for people involved in theatre at that time were Western: European theatre, Spanish theatre. They didn't know any other kind of theatre existed, because they were young people, from the city. These traditional Andean performances did not separate theatre from dance and music. They were dance/opera syntheses, like Peking opera, which combines music, acting, dance, acrobatics.

BELL: What were the first shows done after this experience you've described?

BOADA: The first was *Allpa Rayku* [1979], which was based both on the popular fiesta of Andahuaylas and the story of the seizure of lands there by the people of the town. There had been a leftist military revolution in 1968 and a new agrarian reform law in 1969 that promoted land redistribution. The landowners hired armed guards to keep their land, but since these landowners did not have the law on their side, the *campesinos* fought and took the land.

BELL: And that show used a lot of elements of popular culture?

BOADA: Yes: masks, costumes, colors, the Quechua language.

BELL: Did the structure of the show reflect different ideas?

BOADA: It had the structure of the fiesta, and the fiesta's arrangement of scenic groups.

BELL: Does this also involve calling the presentation a fiesta instead of a theatre piece, a drama?

2. Gustavo Boada in his mask workshop. (Photo courtesy of Archivo G.C. Yuyachkani)

BOADA: Yes. The story begins with a conflict: there is a fiesta, but the fiesta is interrupted because the news arrives that there's been a revolution and the land can be owned by those who work it. The dramatic conflict is mixed with the structure of the fiesta.

BELL: Have all of the shows of Yuyachkani since that moment used masks or other popular theatre forms?

BOADA: Yes, in this show and those that followed, they started using a lot more musical instruments, and worked with masks.

BELL: What was the response to these shows, in Lima or other cities, where people like the actors in Yuyachkani had grown up with European ideas of theatre?

BOADA: Well, for many years Yuyachkani was doing shows in the provinces. They didn't have a place to rehearse, and so they always performed in the countryside.

BELL: Not for an audience in Lima?

BOADA: There was an audience in Lima later, generally in the universities, or among immigrant populations of miners or campesinos on the outskirts of the city.

Mask Traditions in Peru

BELL: Are there a variety of different types of mask theatre in Peru? I remember a knitted mask was used in *Adios Ayacucho*; what other different types of mask traditions are there?

BOADA: At a certain moment in Peru an independent theatre movement grew outside of the commercial and traditional classical theatres. The movement was based, more or less, on the same thinking as Yuyachkani. About 40 groups in the whole country appeared, and they did research in different ways. A group from Cajamarca called Algovipasar, for example, studied the fi-

3. Yuyachkani incorporated Andean performance traditions—masks, costumes, colors, and the Quechua language—in their 1982 production Allpa Rayku. *(Photo courtesy of Archivo G.C. Yuyachkani)*

estas in their province and had a particularly regional identity. It's the same thing that happened with Yuyachkani.

BELL: Does Yuyachkani have a connection to any particular cultural identities?

BOADA: Yes, more with some than with others: with Puño, Cuzco, Huancayo.

BELL: Which popular traditions are seen in different masks? For example, if there are masks made of wool in some areas, are there masks of wood in others? Is it similar to Mexico, where different regions have different mask styles?

BOADA: There are many varieties of masks. For example in Huancayo, the capital of the province of Junin, they make masks of painted screen—they have a Spanish origin. Five minutes from Huancayo there is a town named Mito, which makes masks out of wood. But 20 kilometers further, they make screen masks again. It's not a question of proximity or distance, but of identity. In higher elevations, where there are a lot of sheep, wool is the only material for making a mask, and that's why they use it. In some places they use gourds to make masks, in others, animal skin.

BELL: Has there been a lot of anthropological or folkloric research into these mask traditions?

BOADA: In Peru there are a lot of anthropologists researching mask designs as well as their meanings. But their research is only interpretation, because it is not based on what the people think. Moreover, when researchers ask indigenous people or campesinos about the origins of something, a very ancient rejection repeats itself—because the Spaniards came in the same way, asking them if they knew about any "yellow metal," and the Inca Atahualpa ordered everyone to bury the cities where the gold was. Later, in colonial times, after Tupac Amaru revolted and the Spaniards killed him [in 1781], they prohibited all cults, rituals, and holy objects of the old religious traditions, including traditional costumes, music, and dances. From that moment on there has been a feeling among indigenous people to close off information about the significance of these traditions.

Becoming a Maskmaker in Peru

BELL: I wanted to ask you about your personal connection to Yuyachkani, how you came to work with the group, and how you came to be the primary maskmaker in the group.

BOADA: Before I met Yuyachkani, I was a sculptor. I had a studio with other artists, and one day in 1987 Yuyachkani came to see my work, after they had seen Bread and Puppet in Puerto Rico. They wanted to do a workshop with giant puppets in Villa El Salvador, an urban neighborhood in which the majority of people were immigrants from Ayacucho. And they asked me if I would like the idea of working with giant puppets, giant sculptures. This is how I met them. I worked with them for three months in Villa El Salvador, and then I came back to my studio. I started to study theatre for a year, and then Yuyachkani proposed that I work with them. So I quit my theatre studies and began to make masks.

BELL: What was your sculpting like before you started working with Yuyachkani?

BOADA: Before working with Yuyachkani, I was looking for a form of animated sculpture of image or color. I investigated emptiness, the absence of mass. Not the external form, that is, the one you can touch, but the internal

form. I imagined the public inside a sculpture. It was a search for something, and when Yuyachkani took me on for the workshop, I saw that these huge animated figures suggested a very interesting path to me. That's why I decided to study a lot of theatre and read.

BELL: When you started making giant puppets with Yuyachkani, how did you know what to do?

BOADA: When you do huge sculptures, you have to think of the armature that that big volume is going to have, and what material can support all that weight. When I knew I was going to use paper, I had to calculate which material could support the paper without weighing too much. We used chicken wire, cutting it and giving it shape, and then we applied the paper. That was the first time. Later I saw that chicken wire was very expensive, so we started to use clay, and the different structural techniques to support clay, and we used paper.

BELL: So were you inventing this yourself as you went along?

BOADA: Yes.

Pukllay: *Playing Theatre As Fiesta*

BELL: Could you describe a recent production of Yuyachkani which uses masks or puppets, how these objects are used in that production, where they came from, and how you conceived of them and built them?

BOADA: Our most recent production, which we have been working on for two years [1996–1998], is called *Pukllay*, which means "let's play." It's a game based on the fiesta we have been going to for five years, in a town called Paucartambo, in the region of Cusco. The fiesta is connected to the worship of the Virgin of Carmen of Paucartambo. In it, there are 20 *comparsas*, groups of dancers who use the same mask, although the Caporal or Capitán and his Lady use different masks. There are 20 characters, or 20 comparsas, who each have a different significance, and they move around the village, having encounters with each other, wars, and dances. There are some characters, called *saq'ras*, who only walk on tops of roofs: they're a kind of devil that comes from the rainbow. It's taken some time to investigate this tradition, to understand the significance of the choreography, the costumes, and the roles of the characters, because the characters can have one role in the fiesta and another during the religious ritual. In the religious event they have a role relating to the Virgin; but in reality at that moment she represents not simply the Virgin but an ancient Andean god, Mama Pacha, or Mother Earth. It's difficult to interpret something which, as I explained earlier, people don't want to explain: the significance of their rituals. While anthropologists create their own interpretation, we create another interpretation of the show, not of its religious or anthropological significance, but of its representational play: the relationships between the characters and the audience, and among the identical characters in the 20 different saq'ras. At the same time, we are also doing research about the masks. We're not necessarily going to copy the traditional masks, but situate them in a kind of re-creation in a basically different space: a big plaza in Lima.

BELL: I saw a videotape of a Yuyachkani performance at night in a big plaza in Lima. Was this the same show?

BOADA: That was the first attempt at the show. We tried out the materials we had at that moment, but we saw that everything was too low.

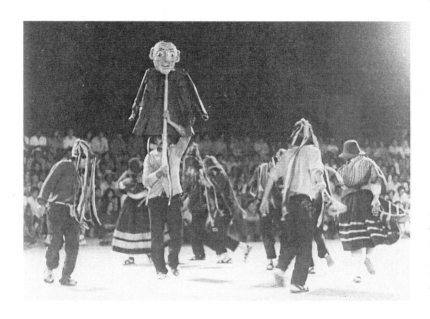

4. *Using puppet, dance, and fiesta structures as political theatre: Yuyachkani's* Allpa Rayku, *1982. (Photo courtesy of Archivo G.C. Yuyachkani)*

BELL: How do you mean?

BOADA: We didn't have a lot of height. The audience couldn't see, so the solution was to build big movable platforms where we could place masked and sitting idols, something like sphinxes.

BELL: I believe I saw masks of many different character types: a doctor, maybe a lawyer, and a politician. Is that correct?

BOADA: All the characters that we perform in this show are from the Paucartambo fiesta. They are characters created by the imaginations of the artisans; it is very probable they have recognized the character they want to satirize in their masks. For example, El Doctorcito (a doctor of law) represents the lawyer who is always using the law to cheat. He performs a ceremony to marry someone from the audience with a man dressed as a woman. After they are married, the bride takes something from her new husband, and the husband chases after her. She goes to the Doctorcito to tell him to fix the situation, and the Doctorcito says to the husband, "You know sir, you just got married, and you have to share everything you have." The settlement at the end is that the man has to buy a case of beer for the comparsa.

BELL: This is what happens in the original fiesta, or in the Yuyachkani performance?

BOADA: In the fiesta. But these types of situations help us to create other situations.

BELL: What are the differences between the situations Yuyachkani creates and the indigenous ones you've been looking at?

BOADA: In the first place, we do the show in Lima, the capital, which is normally not a favorable climate for this tradition. To do it in the most important place in the city, the Plaza Mayor, and to bring together more than 40,000 people, is a very important moment for the people of the city, who will see the old traditions from where they're from. This is one of the reasons why we do it.

BELL: Are you trying to recreate an old tradition?

BOADA: No, what we do is a re-creation, but in the Paucartambo fiesta, the principal element of dramatic action is the Virgin of Carmen. We don't do that. We created two characters: the Caporal de Contradanza (the Chief of the Dance) and the Lady of a Majeño, who are the masters of the fiesta.

CAMOU: What is a Majeño?

BOADA: Majeño is a powerful, prosperous businessman. A little despotic. And the Lady is his wife. The Caporal de Contradanza is a person who has a lot of land. In *Pukllay* these characters organize the fiesta for some important people; so we can bring in political characters: a policeman, the mayor, a priest—those are always the main characters.

Pukllay begins with a procession through all the streets. The masters of the fiesta go around the plaza, mount a little platform, and call for the bullfight to begin. It's a comic or satiric bullfight called *Waca Waca*. A bull comes out—it has a frame like a hobbyhorse with a small head of a bull—and it chases everybody. The bullfighter trembles, hides himself in his cape, and plays bullfight with the audience. Finally, the bull goes up on the platform and everybody runs away. At this moment the Saq'ras, the devils who come from the rainbow, appear on the roof with fireworks and go to the platform, and a female Saq'ra, the China Saq'ra, is swinging on a swing. They get to the point where the bullfight is going on; and the Chief Saq'ra lassos the bull and pulls him to the ground. Then, while the Chief Saq'ra is occupied with the bull, the rest of the Saq'ras climb up to the China Saq'ra (the wife of the Chief Saq'ra) to grab her and take her away, because the Chief Saq'ra isn't there. This subversion of order indicates an absence of power. It's very traditional in the fiestas: to create an absence of power, a dramatic moment where the conflict is very strong and people believe that something could happen, that perhaps some *real* Saq'ras could come and take her away. But that doesn't happen because the Chief Saq'ra returns, and there is a ritual battle, a real competition, which is to climb to the top of a pole where there is a bouquet of flowers. The one who gets the flowers gets the China.

Masks and Ritual Performance in the City

BELL: This is a very different type of theatre than European theatre. It's not based on text, character, and plot. When you do this show in Peru, what do you want to say with it?

BOADA: In the first place, the significance of this type of performance is that it is unsupported, marginal, in an open public space, and you don't have to pay an admission, so it's an audience that doesn't go to theatres. It's a big project, which we believe will give something back to the people who have nourished our theatremaking, because what we do comes from them, from what we have learned from them.

We have also learned, from anthropological theatre, actor training, the culture of the body, presence, etc. Those are projects in what we consider traditional theatre work, in traditional spaces, but it's not the only form we value; we also value work in these very big spaces. The thing that doesn't change is that we need to make a theatre in which people once more feel a connection to their roots. We don't want to stop using symbols that the people of these communities can recognize.

BELL: Are masks central to this?

BOADA: Yes, many plastic elements, not only masks, but structures also.

BELL: But if these people live in the city of Lima, how can this be part of their past? Aren't they, as city dwellers, disconnected from it?

BOADA: Lima is a city that for a long time has had large immigrations from the north, south, and center of the country. This immigration has been a continual, permanent phenomenon for 30 or 40 years. The population is not only "urban." Very few of the immigrant communities on the outskirts of Lima are actually urban spaces. These neighborhoods, which are generally 20 or 30 minutes from the center of Lima, are where we do shows, in very small performing spaces, so people can identify with their culture, with their identity. If they spend the whole year working, when the fiesta of the patron saint of their old village comes, all the people from that village will want to come together to reproduce their fiesta. This is how they live.

The Contemporary Function of Masks

BELL: What do masks do that is different than actors' theatre, and why do you think that's valuable, especially in the situation of Peru?

BOADA: I think the mask is a very ancient element of humanity, going back to the time it was used to hunt animals, because the mask produces a transformation—or the person using the mask *thinks* that a transformation has taken place. This transformation is dependent on the person's convictions: a belief that because of the mask you transform into something, you become something else. Many people don't have that conviction, and when they put on a mask they continue to be the same person. So when they are acting, you can recognize the same person, and the mask doesn't produce anything. But if that person is convinced he is another person, he can allow his imagination to create actions that are different from those he repeats every day. For me, in prin-

5. Incorporating traditional Central American puppets in a contemporary political play: actors and a Nicaraguan-style gigantona *in Yuyachkani's* Los Hijos de Sandino *(The Children of Sandino), 1981. (Photo courtesy of Archivo G.C. Yuyachkani)*

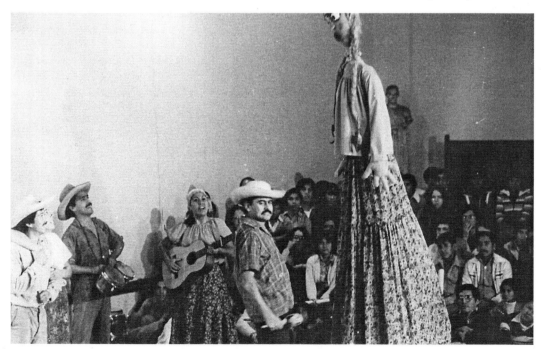

cipal, it's this, but that's not really a sufficient explanation; it's pretty lightweight. For me, the mask is an element that initiates an internal process in which the actor mobilizes sensations to produce, in the first place, an idea of a space, and secondly, the actor's vision of the mask: a special intuitive knowledge of what the mask can and cannot do. But this process is not rational. The mask rejects thought, although not spontaneity and freedom.

I know that there are theatres, like the Japanese, in which improvisation is not permitted, but I come from a tradition of masked performers who improvise, whose role is not always consistent. For example, a Ukuku, a character with a wool mask used in *Adios Ayacucho*, is a figure who at one point in the fiesta of Q'Ollorriti [a Quechua word meaning "snow star"] is a comedian. However, when he hikes up to the higher elevations as a representative of the community to find a large piece of ice, he carries it on his shoulder and walks back through very dangerous mountain passes to his village. The ice is ritually cast into the earth so that there will be a good harvest that year. Those are two different roles, but Ukuku always has the same character. For us, this is very different from thinking that a character has one type of codified movements. For example, when the mask of a woman in noh theatre leans forward, it means she's crying. For us it's very different.

BELL: For you it's more open?

BOADA: Yes, it's much more open, more explosive; movements are much faster. But there are also movements of waiting, of silence, of sadness, which can be slow.

BELL: When you make masks, it seems to me that you're aware of various existing mask traditions. I imagine that you utilize those traditions, but do you change them? The reason why I ask is because there's an issue about using indigenous culture to make modern theatre, that it's a kind of theft.

BOADA: Of course, yes. It's a way of legalizing robbery. But I've been making masks for more or less ten years, learning by copying not only masks of Peru but of the commedia dell'arte and Asian theatre. It's an exercise in the knowledge of forms, not of acquiring a structure.

When I travel—I travel a lot to fiestas—I first get to know the masks. I don't go to collect masks, but to see what process takes place between the mask and the dancer. I am not very interested in the mask if it is not connected with the dancer. I want to see how the dancer assumes the mask, because the mask has a lot of meaning for a dancer. Those processes are the ones that interest me, more than copying a mask, because the image that the dancer has of himself, of his character, is more important than the mask itself. Because the mask is not, finally, the material form but the corporeal form of the character. That for me is the mask. It's not only the mask that moves but the whole body.

The Present and Future of Mask Performance

BELL: What is the political situation of Yuyachkani, and how does the use of masks affect that? It seems to me, when you were speaking a year ago here, that Yuyachkani has a difficult position between, say, the militant left of Sendero Luminoso [the Maoist Shining Path guerrilla movement], and the right of the government.[2]

BOADA: Because of the process of violence we have had in Peru, the spaces to have different ideas, where one can speak of solidarity, of community, of common strength, to talk sometimes about socialism, communism, have di-

minished. A lot of people are afraid to have new friends because of the danger that they could be Senderistas [members of the Shining Path guerrilla movement], or someone from the MRTA [the Tupac Amaru Revolutionary Movement]. During all these years people have become withdrawn, and don't visit each other. Or if there are visits between friends and their discussions have a political theme, someone could logically believe, because you don't agree with some things, that you might be a Senderista. This fear of talking about politics and our current situation makes people uninterested; they disappear. And political parties disappear, political leaders disappear, ideas disappear, and new proposals disappear, because no one has the strength to do it. This is the type of dictatorship I was talking about: not a concrete or specific dictatorship, but a structure of dictatorship, an apparatus.

BELL: And how does mask theatre relate to that?

BOADA: In the sense that the mask *always* alludes to an identity, to a behavior, to an action. A mask never ceases having action, it always suggests something. I think that when theatre groups go out into the streets with big images, they are suggesting roles or attitudes of sadness, anger in the conscience of the spectator. They can express states of mind to the spectator. And the spectators can relate those states of mind to something in their own lives. You can see in the audience someone who feels that such an image is making fun of them. For example, if there's someone in the audience who looks like [the over-life-sized Bread and Puppet authority figure] Uncle Fatso, who smokes a cigar, and the guy in the audience looks like he's smoking a cigar too, then logically there's going to be a reaction.

6. *Street theatre with masks in an immigrant community on the outskirts of Lima: Yuyachkani's* Un Dia en Perfecta Paz *(A Day in Perfect Peace), 1987. (Photo courtesy of Archivo G.C. Yuyachkani)*

BELL: You see yourself in the mask.

BOADA: Exactly.

BELL: Do you think there's a future for masks in the 21st century? Because masks are typically thought of as a very ancient form, and the future often wants to get rid of ancient forms.

BOADA: No, that's impossible, because in the history of theatre the great moments of theatrical renaissance are initiated with a return to the mask. The-atre began in Greece with masks, and returned, after the medieval period with the masks of commedia dell'arte, and then also in the 1970s, with puppets, masks, and African and Asian theatre influences. Every time the theatre is drowned, it has always recovered this object. And it's not something crazy, because the mask is the origin of the theatre.

And the mask is not, for me at least, only an object, but a process through which actor and matter come together to make an image. That's why there's a big difference between sculpture and masks. Sculptures are always saying very general things, but the mask always says something that invokes a society, a moment, a problem. Sculpture tries, with many elements, to describe a his-torical fact, or a feeling, but a mask makes use of relations between eyes, nose, and mouth to express a feeling, not an idea. The human being will interpret his feelings in the face of reality, so when the human being has been touched by a feeling, it's as if the doors are opened, and his reality can be seen. That is to say, the person becomes sensitive. It's as if the person was like a suit of ar-mor: when it's opened, there's a human inside, with feelings, the ability to feel everything that is going on. That's why I don't think that theatre will give up the mask. I think it's an element of formation for actors. It has many uses. However, it's also very good that there are people who *don't* use masks. There was a time in Peru when all the theatre groups used masks—it was hor-rible. There were a lot of assassinations, murders of the theatre.

BELL: They were using masks badly?

BOADA: Yes, they were building them wrong and using them badly; they would just put them on their faces. But it's good that that happened, because right now in Peru the fashion has passed and the people who do use masks are people who have learned how to use them, and for whom it's taken a lot to learn how to do so.

BELL: In the little towns where Yuyachkani first learned about masks, are the old fiestas still vibrant, or are they dying out?

BOADA: In some places, very few, they are conserving their traditions. But in the majority of towns, the fiestas are not happening anymore. What hap-pened is that in the outskirts of Lima in the immigrant communities they con-tinue the traditions but they're mixed with elements of urban culture. For example, they don't play the *charango*, traditional drums, and flutes, but mod-ern instruments like saxophone and electric guitar instead.

BELL: Without masks?

BOADA: Yes, they use masks, always. In Peru, if there is a masked dance, it will always be performed with masks. It has a meaning, I don't know what it is, but it would lose that meaning without masks.

—*translated by Teresa Camou*

Notes

1. Yuyachkani director Miguel Rubio describes the moment somewhat differently: "Once, in the mining encampment of Allpamina, after a performance of *Puño de Cobre*, while we were speaking with the miners, one worker said to us 'compañeros, your work is very beautiful; too bad that you forgot your masks'" (Yuyachkani 1985:9).
2. Boada spoke as a panelist in a symposium on "Theatre under Soft Dictatorships in the Americas," at the 1997 EITALC workshop at the Bread and Puppet Theater in Vermont.

Reference

Grupo Cultural Yuyachkani
1985 *Allpa Rayku: Una Experiencia de Teatro Popular*. Lima: Escuelas Campesinas de la CCP (Confederación Campesina del Perú).

The Art of Puppetry in the Age of Media Production

Steve Tillis

The figure I have just created has the beautiful sheen of polished wood. As it walks along, its face catching the light just so, I feel a little proud—and more than a little amazed. For I have neither touched nor carved into the figure, and I control it with neither strings nor rods. This figure—which, if I were to continue my labors, I could place amidst similar figures in a production of, say, *Hamlet*—has never had any tangible existence. It is nothing more, and has never been anything more, than a series of computer commands that have resulted in a moving image on a screen.[1]

The figure—my Hamlet, let us continue to say, who makes bold enough to tell the traveling Players "to hold [...] the mirror up to nature"—is not itself of nature: it is of a new breed of figures that perform primarily in the media of film, video, and cybernetics (i.e., computers). More specifically, it is like certain of the dinosaurs in Stephen Spielberg's *The Lost World* (1997) and all of the characters in John Lassiter's *Toy Story* (1995), being a figure of computer graphics (Duncan 1997:81 and passim; Pixar/Walt Disney Pictures 1995).

Computer graphics figures (also known as CGI, "computer graphics images") are not the only members of this new breed. Somewhat older in their technological origination are the kind of figures in Tim Burton's *The Nightmare Before Christmas* (1993) and in the central portion of Henry Selick's *James and the Giant Peach* (1996): stop-action (also known as stop-motion) figures. For the moment, let me speak of the characters created through computer graphics and stop-action as "media figures": figures whose performance is made possible through technological mediation. Indeed, there is yet another kind of figure that in many respects may be said to belong to this new breed, and though it is not strictly a media figure, it is most often to be found on film or video. One can see these figures in a great many contemporary films, including Barry Sonnenfeld's *Men in Black* (1997), but also among the resident nonliving characters at Disneyland: these are animatronic figures (Pourroy 1997; Anderson 1997).

It might seem that the various figures I have mentioned do anything but "hold a mirror up to nature"—being, in the main, figures of fantasy; but this is as much a function of economics as artistry: Why bother with the expense of a "naturalistic" media image when an actor can perform such roles easily enough? Media figures are, thus, left most often to enact non-naturalistic roles, at which they happen to excel. In this regard, the figures are rather similar to puppets as we have known them, which have frequently held up the mirror less to nature than to the untrammeled imagination of the puppet-artist.

It has proved difficult, however—at least from the perspective of puppetry—to make much theoretical sense of media figures: How are they like or unlike puppets as we have known them, and on what basis might some or all of them be considered puppets? Media figures share with puppetry the crucial trait of presenting characters through a site of signification other than actual living beings.[2] While this trait is certainly necessary for their inclusion into the world of puppetry, is it sufficient? What follows is a preliminary attempt to answer these questions. As computer graphics figures seem to offer the greatest challenge to puppet theory, they will be the primary subject of my remarks. What I have to say, however, will have a bearing on stop-action and animatronic figures as well, and so I will mention them again toward the end of this essay.

It seems almost obligatory to refer, preferably in one's title, to Walter Benjamin's landmark essay of 1933, "The Work of Art in the Age of Mechanical Reproduction."[3] Such a reference, however, is useful here primarily to show how Benjamin's critique of mechanical reproduction (most especially as it occurs in film) is inapplicable to media figures, and so to suggest that these figures present a new problem for theory.

"Even the most perfect reproduction of a work of art," Benjamin writes, "is lacking in one element: its presence in time and space, its unique existence at the place where it happens to be" ([1933] 1969:220). For the actor working on film—and, by extension, for the film puppet as well—this "presence" is spoken of as an "aura"; Benjamin makes much of the actor's "feeling of strangeness [...] before the camera," occasioned by the fact that, in front of the camera, one must forgo one's "aura"—that is, one's actual presence (229–30). Again, by extension, one might speak of the puppet's aura as well, with the puppet conceived of as a "work of art" that, as with all works of art, "has its basis in ritual, the location of its original use" (224). Puppets cannot, of course, feel strange in front of a camera, but their lack of feeling does not obviate the estrangement that takes place when the actuality of their physical presence is reduced to a mere two-dimensional look-alike. Media figures, however—most obviously those created through computer graphics—cannot generally be said to lose their presence in time and space when presented by their particular medium, for their presence is actually created by the medium. They are not media reproductions, that is, but original productions made possible through media. "That which withers away in the age of mechanical reproduction," writes Benjamin, "is the aura of the work of art" (221); but in the age of media production, it is the aura of the work of art—a work without any "unique existence" in time and place—that is created. Media figures are something new, not only chronologically but also conceptually, and just as Benjamin's analysis is incapable of accounting for them, neither are they accountable by concepts of puppetry that have their basis in the puppets we have heretofore known. For better or for worse, the age of media production is a new age that must be accounted for on its own terms.

There have been at least two serious attempts to provide something of an accounting from the perspective of puppetry. In 1991, the Board of the North American Center for the Union Internationale de la Marionnette (UNIMA-USA) voted to create, along with its Citations of Excellence for "live" puppet performance, a citations category for "puppetry in video," later expanded to encompass all "recorded media" (Levenson 1992:1). Pursuant to that end, Mark Levenson, then Chair of the UNIMA-USA Citations Committee, devised criteria for entries in the new category, and confronted, along with other matters of eligibility, the vital question of what, in the context of "recorded media," constitutes a puppet (2). The "test" that Levenson proposes runs as follows:

> Technology must not be used to create the puppetry, only to record it. That means that the performance must be at all times under the control of a live, human puppeteer, performing in what computer folks call "real time." This performance is recorded and the recording may be manipulated (i.e., edited) prior to presentation to the audience. (2)

Levenson goes on to note that his proposed test would "exclude traditional and stop-motion animation," but would "include animatronic figures if their animation were created by an operator in real time" (2); he does not address computer graphics figures, which had already come into being at the time of his writing, but it is obvious that he would exclude them also from the realm of puppetry. I should add that Levenson's criterion of "real time" (hereafter to be written as "real-time") apparently refers to a synchronicity between the puppeteer's control and the puppet's resultant movement. (Curiously, Levenson is not concerned with real-time vocal performance, probably because it is so rare in film and video.) An alternate meaning of real-time would refer to a synchronicity not only of control and movement, but of audience reception as well. When computer graphics figures are employed for such "real-time operation and reception" performance, as I will discuss below, the generally accepted term for them is "performance animation" (see, for example, Luskin 1997).

One of the most striking aspects of Levenson's "test" is how it echoes Benjamin's argument. The dictum that "technology must not be used to create the puppetry, only to record it" seems but another way of saying that eligibility for the Citation should be limited specifically to puppetry that is "mechanically reproduced" on video or film. No doubt Citations honoring excellence in recorded puppetry are a valuable function of UNIMA-USA, and no doubt Levenson has proposed a useful test of inclusiveness. But the inability of Benjamin's argument to account for media images is reflected in Levenson's near-categorical exclusion of them from consideration. Levenson recognizes that media figures are in some way fundamentally different from puppets as we have known them; his preference (which arises at least in part from the institutional context for which he proposes his test) is simply to put them aside, as a rule, rather than to consider them as—at least potentially—the puppetry of tomorrow.

The second serious attempt to grapple with media figures and puppetry was undertaken in 1994 by Stephen Kaplin, in an essay entitled "Puppetry into the Next Millennium." Kaplin's approach to media figures is diametrically opposed to Levenson's, as evidenced by his focus on "computer-based, cybernetic technology" (1994:37). While Levenson draws a strict distinction between puppetry and media figures (not even bothering explicitly to mention computer graphics), Kaplin concerns himself exclusively with such figures as puppets.

Kaplin writes of four "aspects of the new technology that can be applied to puppet performance in the near future" (37); alternately, he calls these aspects "emerging sub-genres" (39). The first is "docu-puppetry," which makes use of "sampling, cropping, and re-editing" of media images and involves the "depiction in puppet performance of factual and authoritative material, illustrating historical, social or cultural phenomena" (37). The second emerging subgenre is "virtual puppetry," which involves "performing objects that exist only within the computer, generated out of digitized bitmaps, given tightly controlled behavior parameters and linked by manual controls to the outside, human world" (38); this is, in essence, a description of computer graphics figures. The third of Kaplin's subgenres is "hyper-puppetry," which is "a collective extension, a corporate entity [of a computer-generated puppet], created

out of the merged energies of [a theoretically "unlimited" number of] users/ participants" (38). Finally, Kaplin writes of "cyber-puppetry," by which he means networked-computer puppetry with an online, "interactive" dimension that "allows for the artist to conceive of performances as collaborative creation[s] with the audience" (38).

It is exciting to read Kaplin's vision of emerging forms of artistic creation, but worth noting that all four of his subgenres are fundamentally related. Docu-puppetry, hyper-puppetry, and cyber-puppetry, that is, are but variations of the virtual puppetry that he discusses: in each case, Kaplin envisions the creation and/or manipulation, by one or more persons, of computer graphics figures. It is also worth noting the ease with which Kaplin writes of these figures as puppets. There seems to be an implied definition of puppetry here, which runs: if the signification of life can be created by people, then the site of that signification is to be considered a puppet. This definition—which, I should emphasize, I have read into Kaplin's essay—is revolutionary, expanding the realm of puppetry beyond all definitions that center upon the materiality of the puppet (or, to employ Benjamin's terms, the "unique existence" of the puppet as an object in a "specific time and place"). It would seem to encompass not only computer graphics images (and stop-action and all animatronics as well), but also forms of art that have been almost universally held distinct from puppetry, such as the cel (also known as cell) animation popularized by Walt Disney.

Media figures share with puppetry the crucial trait of presenting characters through a site of signification other than actual living beings.

Our efforts to make sense of the relationship between media figures and puppets as we know them, stimulated as these efforts might be by categorical statements (and implications) of one kind or another, must derive ultimately from an understanding of what media figures actually are. To that end, we will do well to attend to the details of such figures, looking especially at how they are created and controlled.

Computer graphics figures, such as the Hamlet I mentioned at the start of this essay, involve, in effect, three processes of creation. First, a three-dimensional abstract model of the figure is created in the form of multiple polygons or a digital wire-frame;[4] the model can be constructed from the computer keyboard (by which term I also include the computer mouse) out of geometric shapes and/or lines, or can be imported into the computer through three-dimensional shape-capture (the "capturing" of the look of a real-world object). I created the model for my Hamlet from the keyboard, using geometric shapes that I stretched and "deformed" into an approximation of the shape of human limbs and then linked together; the model for the head of *Toy Story*'s Woody, on the other hand, was based on a clay sculpture whose shape was captured by being scanned into a computer (Pixar/Walt Disney Pictures 1995:8). There are, I need scarcely say, extremely sophisticated computer programs, commercially available, that include "resident" polygon and/or wire-frame bodies (some constructed, some captured from life) and therefore greatly simplify the task of constructing a model.

Designed into the model of the figure are the means for controlling its gestural movement;[5] these are known as "articulation variables" (or, more casually, as "avars"). One writer likens the avars to "the strings of a marionette" (Pixar/

Walt Disney Pictures 1995:6), but they are actually more like the articulation points of puppets as we have known them; indeed, computer graphics programs offer a selection of joint-types quite like those available to the puppet-builder, including hinge joints, spherical (ball-and-socket) joints, and so on, all of which can be defined for their stiffness and range of movement. The number of avars that might be involved in a complex model is astonishing: the model for *Toy Story*'s Woody had 212 avars in his face alone, 58 of which were dedicated to his mouth, allowing him an exceptional range of expression and a capacity for shaping his mouth for each particular phoneme he would speak (8).

The second process in the creation of a computer graphics figure is the definition of surface features for the geometric model or wire-frame. The surface features might be selected out of individual characteristics of color, texture, pattern, and reflectivity that are resident in the computer graphics program (and are known as "shaders"), or might be imported into the computer through image-scanning (e.g., the "capturing" of real-world images such as photographs). I created my Hamlet's surface features out of resident characteristics; the computer graphics figure of *Men in Black*'s Jack Jeebs, on the other hand, has the surface features of the "real" actor (in makeup) who also plays the character (Pourroy 1997:20). The third process in creating the figure is known as "rendering," and is the frame-by-frame compositing of the model and its surface features, along with the definition of one or more light sources and whatever worldly effects, such as shadows and fog, and camera effects, such as lens flare and depth of focus, are desired.

Now if the avars of a computer graphics figure are like a puppet's articulation points (i.e., joints), we must ask what control mechanics are used to create movement at those points and how those mechanics are themselves operated. Or, to put the matter in terms of a marionette, what are the "strings" and how are they "pulled" to give the computer graphics figure its frame-by-frame movement (generally referred to in the computer world as "animation")? Two kinds of movement are relevant here: gestural movement, which, as I have already explained, is movement pertaining to the "body" of the figure; and proxemic movement, which is movement of the figure as a whole from one virtual location to another.

There are, in effect, two basic control mechanisms, each deriving from a different source of control, although in practice these mechanisms and sources are often used in combination. The first mechanism is known as "kinematics," and its source is the computer keyboard. Until a few years ago, "forward" kinematics were accomplished by defining a figure's movement at each avar, generally working from the larger to the smaller limbs. For example, to have a figure touch its nose, one would enter commands first to rotate the upper arm, then the forearm, then the finger that would touch the nose (with each rotation occurring at an avar). Recently, however, the development of "inverse kinematics" has allowed one simply to attach a "handle" to a certain part of the figure, "grab" it with the computer mouse, and "drag" it to its desired location, with the necessary movement at related articulation points following naturally along, the various joints operating according to their defined stiffness and range of movement. To have a figure touch its nose, for example, one need only grab a handle at the figure's fingertip and drag it to the nose; the wrist, elbow, and shoulder (and, if desired, the upper torso as well) will rotate accordingly. Inverse kinematics, thus, has made the gestural-movement mechanics of computer graphics figures truly analogous to the strings or rods of puppets as we know them.

Once a gesture has been "defined," it can be saved for later use in the computer's memory: once one has defined nose-touching, say, or the movement of the lips for the phoneme "em," one can easily recall it for usage as of-

ten as one wants. More complex gestural movements such as walking require the integration of multiple movement definitions, such as for the arms and the legs. The task is slightly less complicated than it might seem, however, since the movement defined for one limb can be recalled (and "flipped," if necessary) for its opposite; also, inverse kinematics will allow certain aspects of the movement to follow naturally. On the other hand, the walking gesture of a well-made computer graphics figure involves far more than the motion of arms and legs: there are myriad details to consider as well, including patterns of breathing, the flexing of individual muscles, and so on.[6]

Proxemic movement is generated from the keyboard primarily through the definition of "animation paths," in which one describes the route that the figure will take from one location to the next. The speed at which the figure will move is a function of the number of frames that it will take to traverse the distance, and must also be defined. Since computer graphics figures exist in a three-dimensional virtual space, their animation paths can take them in front of objects, thus "blocking" the objects from view, or behind them; also, as they move "toward" or "away from" the virtual "camera," they will appear to grow larger or smaller, respectively. Another approach to proxemic movement involves defining certain "physical" qualities for the figure, such as center of gravity, weight, and rebound characteristics (e.g., like rubber, steel, etc.). The figure can then be dropped, as it were, or tossed or spun, and it will act in accordance with its defined qualities.

To create from the keyboard the walk of a figure across a room—as I created the walk of my Hamlet—involves the bringing together of separately defined gestural and proxemic movements: first one uses handles to define the gestures that constitute walking, and then one defines the animation path and speed of the walk. This bringing together of movements is analogous to the way that puppets are moved. A marionette, for example, also has specific gestures of walking, created primarily with its leg strings; these walking gestures are brought together with a proxemic path along which the marionette is transported by its main support strings. If, at the end of the computer graphics figure's walk, one wanted to have it collapse on the floor, one could simply let it drop freely, with its fall governed by its defined physical qualities; likewise, a marionette would collapse to the ground, according to its real physical qualities in the natural world, with a sudden slackening of the tension on its support strings. The main difference between the keyboard-created walking of a computer graphics figure and a puppet is that the walk of the former is painstakingly composed over an extended period of time, while the walk of the latter is created all at once, in real-time.

The second control mechanism for the movement of computer graphics figures is known as "motion-capture," and the source of control is the human body. Motion-capture refers to the digital "capturing" of real-world motion—gestural and/or proxemic—for its application to the computer graphics figure. The "capture" itself is made possible by a series of tiny transmitters or reflectors that are placed on a device manipulated by the performer; alternately, the transmitters or reflectors can be placed directly on the performer's body, and the body itself "manipulated," as it were. In either case, the transmitters or reflectors are mechanically, magnetically, or optically tracked for their exact motion; analogous points are defined for the figure that will be moved.

The most well-known motion-capture device is the "Waldo" (a name trademarked by The Character Shop), although the principles behind the Waldo are in wide usage. The Waldo is advertised, perhaps with tongue partly in cheek, as an "ergonomic-gonio-kineti-telemetric device." "Ergonomic" means that the device is engineered to fit ("comfortably") the performer's body; "gonio-" and "kineti-metric" mean that it "measures the angle and movement of the wearer's joints and limbs," or, for that matter, the lips, eyes,

or whatever; and "telemetric" means that "the movement data is [*sic*] measured and sent via remote control" to the computer. The digitized data are then applied to the computer graphics figure, with the result that the figure's "movement" echoes, in "real-time," that of the performer.

Waldoes, according to Character Shop literature (1997), seem to be concerned primarily with gestural movement and, indeed, offer two ways of controlling such movement. The first might be termed a "physiognomic analogue," and involves a one-to-one relationship between the body of the performer and that of the figure: the opening and closing of the performer's mouth results in an analogous movement by the figure's mouth. The second way of generating gestural movement might be called "movement analogue," and involves a one-to-another relationship between the movement of a particular part of the performer's body and that of a different part of the figure: the opening and closing of the performer's hand, within a device rather like a standard Muppet (or a hand-in-sock puppet), results in the opening and closing of the figure's mouth.

There seems to be an implied definition of puppetry here, which runs: if the signification of life can be created by people, then the site of that signification is to be considered a puppet.

Proxemic movement can also be generated through motion-capture. Polhemus, Inc., for example, advertises a motion-capture system that allows two performers to "interact together [...] and to move freely within a 25 foot by 50 foot space" (Polhemus 1997). Indeed, given that this system can involve up to 32 receivers (placed on the performers' bodies), it can be said to track much of the gestural movement that naturally occurs along with proxemic movement. There is a paradox here that might be worth noting. Movement generated from the keyboard is, as we have seen, unlike puppet movement in that it must be painstakingly composed over a long period of time. It is, however, quite like puppet movement in that its gestural and proxemic aspects are generally treated as individual problems. Movement generated through motion-capture, on the other hand, can be quite like puppet movement in that it is generated, in real-time, through the bodily exertions of a living being. It is, however, unlike puppet movement in that its gestural and proxemic movements need not be treated individually, but can be dealt with all at once.[7]

Motion-capture not only allows for real-time control of the computer graphics figure, but, with recent developments, now allows even for the kind of virtual "live" performance (i.e., a synchronicity of control, performance, and reception) referred to earlier as "performance animation." Silicon Graphics, Inc. (1997), for example, has been among the pioneers in performance animation, which they can characterize as the use of motion-capture applied to a computer graphics figure that allows the figure (on a video screen) to interact with a live audience.[8]

Should computer graphics figures be considered puppets? We recall that Levenson would exclude them if only on the basis of the use of technology in their creation, while Kaplin predicates his entire discussion of new subgenres on their inclusion. The question might best be approached by breaking it down into two distinct issues: the nature of these figures and the relationship between them and their operators.

In dealing with the first issue, it will be helpful to make use of the concept of tangibility, with the root-sense of "tangible" being "capable of being touched." Computer graphics figures are not tangible—there is no touchable

"there" to them. As we have seen, there are striking similarities in the creation of computer graphics figures and puppets: the creation of both involves the construction of a figure imbued with articulation points that is then given surface design features. Both, in short, are artificial human constructs designed for manipulation (of one sort or another) by people. And, as I suggested earlier, both share the crucial trait of being sites of signification other than "real" living beings (or of images that are directly referent to such beings); that is, in both cases the signs of life have been abstracted from sites of actual life to be deployed by sites that have no actual life. On the other hand, however, even if a figure's model were to be derived from 3D scanning (e.g., a clay sculpture), and even if its surface features were to be imported from a tangible source (e.g., an actor's face), the figure itself would remain without tangibility—a "virtual object" that would be, at most, an indirect referent to material or corporeal objects. Now it might be argued that the conventional film or video image of a traditional puppet or an actor is also without tangibility, but in such a case, the image is a direct referent to a material or corporeal object, notwithstanding the ways in which directors and editors might make use of that referent.

Here then is a point that seems to be of fundamental importance: puppets as we have known them—fabricated out of wood, cloth, the much lamented celastic, or whatever—are tangible objects, while computer graphics figures are not. This difference provides sufficient theoretical basis, despite the many similarities shared by these two kinds of figures, for distinguishing between them. But I think the distinction needs to be more subtly put than simply to declare puppets and computer graphics figures to be intrinsically different, because tangibility seems to be the only significant and invariable difference between these two kinds of figures. Thus, I propose that puppets as we have known them be thought of as "tangible" puppets, while computer graphics figures be thought of as "virtual" puppets (to borrow Kaplin's term). These usages will, I think, assuage traditionalists such as Levenson, since the semantic overtones of the modifiers "tangible" and "virtual" are, respectively, "real" and "not-quite-real," and reflect the fundamental difference between the two kinds of figures. But I trust these usages will also satisfy visionaries such as Kaplin, since the shared employment of the word "puppet" recognizes crucial similarities between the two kinds of figures. Computer graphics figures—virtual puppets—are, as I have suggested, conceptually new and owe their conception to the newness of the medium in which they exist; but as with everything new, they are not at all unassociated with what has gone before them.[9]

If I am willing to accept computer graphics figures as virtual puppets before I even address the issue of the figures and their operators, it is because this issue—generally cast in terms of "real-time" control by the operator—seems to me to be a red herring. As a rule, tangible puppets are operated in real-time; as we have seen, however, virtual puppets might also be operated in real-time—indeed, even "live."[10] One respondent to Levenson's proposal suggests that the criterion of real-time operation is significant in discussing computer graphics figures because the control of them "lacks the possibility of mistakes—mistakes being the arbiter of good and bad performance" (Levenson 1992:3). Even for live performance, this seems a strange criterion: certainly the making of mistakes will mar a performance, but just as certainly a great performance can contain more mistakes (a flubbed line, a misplaced prop, etc.) than a mediocre performance that is errorless but without passion or intelligence. More to the point, the very idea of mistakes seems obsolete for all non-live performance, whether mechanically reproduced or produced through media: mistakes can be edited out or relegated to unused "takes" just as easily as they can be "erased" in media production. And, as a matter of fact,

mistakes remain in all kinds of non-live performance when the replacement of those mistakes does not seem worth the cost and/or effort.

The issue of real-time control seems less an issue of "What is a puppet?" than one of "What is a puppeteer?" A person operating a puppet (tangible or virtual) in real-time is palpably doing what puppeteers have always done; but a person working at a keyboard with a virtual puppet—despite the fact that one is controlling the movement of the puppet—does not seem to be engaged in the same activity, despite the fact that the result (i.e., movement of the figure) is the same. This leads us to a paradox: the prospect of puppetry (or of virtual puppetry, at any rate) without recognizable puppeteers. Computers have, one might say, freed the puppet from its dependence on conventional puppeteers. But computers have not, of course, freed the puppet from the necessity of human control of one sort or another—only from the real-time control of the puppeteer.

To create from the keyboard the walk of a figure across a room involves the bringing together of separately defined gestural and proxemic movements: first one uses handles to define the gestures that constitute walking, and then one defines the animation path and speed of the walk.

Pursuant to the line of reasoning I have been developing, it might now be worthwhile to consider the other kinds of media production mentioned near the beginning of this essay: stop-action animation and animatronics. Indeed, it will be best to begin with at least a brief consideration of a form of media production I have noted only in passing: cel animation.

As we have seen, Kaplin's implied definition of puppetry provides no apparent grounds for excluding cel animation from the realm of puppetry. Does it have a place within my framework of tangible and virtual puppetry? I suggest not, and make this suggestion without taking recourse to the criterion of real-time control. The principle behind the movement of cel-animation figures is fundamentally different from those of tangible and virtual puppets. Cel-animation figures, owing to their nature as works of painterly art, have neither articulation points nor control mechanics of one sort or another, as do both tangible and virtual puppets. In fact, their movement is not really "controlled" at all, but is strictly an optical illusion: they do not "act" like puppets, but like the drawings they are. While I would not hesitate to recognize an affinity between cel animation and puppetry—especially since each sites the signification of life in a place that is not life itself—I think that their differences require them to be considered as different forms of art. The figures of cel animation are obviously what I have termed media figures, since without technological mediation they cannot "act" in the least; not all media figures, however, need be thought of as puppets.

Turning now to stop-action figures, a brief glance at their history will establish them as the chronologically earliest of media figures. J. Stuart Blackton made use of them in a 1907 short, *The Haunted Hotel*, and they had an extended vogue in Russia, in the films of Ladislas Starevich as early as 1912 through Ptushko's 1935 *The New Gulliver*. They appeared in the 1933 classic *King Kong* and the Czech filmmaker Jiri Trnka employed them to great effect in a series of films in the post–World War II era. They are also long familiar, of course, in American television, having been used for such staples as Gumby

and the Pillsbury Doughboy (Touchstone Pictures 1994:4). Given their early history, it is interesting that Benjamin made no mention of them—but if he had, he would have had to reconsider his thesis that film can only reproduce (and so, dislocate) works of art, for stop-action provides a classic case of technology being used to create original productions.

The basic principle of stop-action animation will be familiar to most readers: A material object without any visible means of control is set in a particular pose and shot with a single frame of film. The figure is then given a minutely different pose, the film is advanced, and another single frame is shot. And on and on, until the finished sequence of frames, when viewed at projected speed, gives the illusion that the figure is moving of its own accord, while in fact, the film does not actually record any movement, per se, of the figure, but only a sequence of still positions. Stop-action figures belong, I suggest, to the new breed of media images because, despite the relatively old technology used in their creation, they are quite literally the creation of that technology. They are not, that is, "mechanical reproductions," for their visible movement is not being reproduced at all, but produced for the first time through the medium of film.

Stop-action figures are material objects in precisely the same sense as tangible puppets: the principles of their construction are identical to those of such puppets, involving the fabrication of a body that is imbued with articulation points and given surface features. What differences exist in construction are of degree rather than of kind. Most importantly, the stop-action figure will usually be given more articulation points than is common in puppets: the centipede in *James and the Giant Peach* (1996), the most complex of the figures used in the film, has 72 such points (Disney Studios 1996:8). Two additional differences are also worth noting. First, a figure will frequently be given a set of interchangeable heads: the title character in *James and the Giant Peach* has 45 different heads, each of which has a particular base expression and set of articulation points (5). Second, a figure might be created in multiple versions, to be used variously depending on the demands of the shot: 15 different figures were fabricated for each of the seven leading characters in *James and the Giant Peach* (5). These characteristics of stop-action figures—extra articulation, interchangeable parts, and multiple figures for the same character—are not, however, required for the creation of stop-action, and are really only elaborations of practices that are available with tangible puppets.[11]

Are stop-action figures puppets? The actual manipulation of such figures is quite similar to that of tangible puppets, being nothing more or less than the physical moving of various parts from one position to another. The difference between stop-action figures and puppets, which is significant and invariable, is that by the very process of their animation, stop-action figures cannot be operated in real-time, or in anything close to it. In *The Nightmare Before Christmas*, "a typical shot would take three days [to create] and end up lasting about five seconds on the screen" (Touchstone Pictures 1993:3). The manipulation of a stop-action figure does not take place in front of the audience (or of the film camera that is the stand-in for the audience), but is, quite literally, hidden away, taking place as it does between the individual frames of film. What the audience sees, as it views a stop-action film, is not the recorded image of movement, but the illusion of movement created through the recording.

Stop-action figures, I suggest, are puppets to the same degree as computer graphics figures; that is, they are closely related to puppets as we have known them except in one crucial regard that arises from the newness of the medium in which they exist. It was relatively easy to discount the issue of real-time control when speaking of computer graphics figures, since such figures can be controlled either in real-time (e.g., through motion-capture) or not (e.g., from the keyboard) without any significant difference in the figure's move-

ment. When speaking of stop-action figures, however, it is not so easy to overlook the matter, since the absence of even the possibility of real-time control is the defining characteristic of these figures. It will be more useful, however, to think of the difference not in terms of real-time, per se, but rather in terms of the tangibility (or lack thereof) of the movement given to puppets and stop-action figures: one sees a puppet actually move, but all one can see with a stop-action figure is the effect of its movement.

I am suggesting that we think in terms of a third category: tangible puppets, virtual puppets, and stop-action puppets.

Just as I have proposed distinguishing between the tangible and the virtual puppet on the basis of what I take to be the only significant difference presented by the latter (i.e., its lack of material tangibility, which is a function of its medium), so I now propose to distinguish between the tangible and the stop-action puppet on the basis of the only significant difference that exists between them: the stop-action puppet's mediated illusion of movement. I am suggesting, that is, that we think in terms of a third category: tangible puppets (i.e., tangible objects that are tangibly moved), virtual puppets (i.e., intangible objects that are tangibly moved), and stop-action puppets (i.e., tangible objects that are intangibly moved). As with the distinction drawn between tangible and virtual puppets, I hope the distinction I now draw between tangible and stop-action puppets will be strong enough to mollify the traditionalists who want to emphasize the uniqueness of puppets as we have known them, but will also encourage the recognition of the basic similarities between the two kinds of figures.

It remains to offer a few words on animatronic figures, a subject on which I can be relatively brief. Animatronic figures, by which term is meant figures whose control is based on electronics transmitted through wire and/or radio signals, are tangible puppets, as a rule, having both material and movement tangibility. The fact of their electronically based control renders them a distinct type of tangible puppet (along with other types such as hand puppet, rod puppet, etc.), but this is a minor matter compared to the differences that exist between tangible, virtual, and stop-action puppets. It is worth observing that animatronic puppets differ from many other tangible puppets in successfully obscuring their control mechanics and in attaining an exceptional degree of verisimilitude—they generally do not "look" like puppets—but these are differences of degree and not of kind. It is also worth observing that animatronic puppets might be controlled either through the computer keyboard or motion-capture (or both together, sometimes supplemented by more traditional means as well, such as strings and rods), but that in either case their movement is tangible, so that one need not be concerned with the red herring of real-time control.

There are some animatronic figures, however, that need to be differentiated from puppets: these figures are automata, such as the aforementioned characters to be found at Disneyland, or the disagreeably raucous creatures at establishments such as the Chuck E. Cheese pizzerias. The distinguishing characteristic of the automaton is that its movement possibilities are "closed." With puppets of all kinds—even those with a limited range of possible movements—the nature and duration of each movement is open to the control of the operator, whether the operator sits at a computer, wears a Waldo, or squats behind a playboard. With an automaton, however, the program of movements, once laid down either electronically or mechanically, is invariable: first it will nod its head, let us say, then wave a hand, then rise in greeting, and so on. The automaton's program might

indeed be altered, but it then would have only a new invariable program. The difference between puppets and automata is not the function of a new medium of presentation, as are the differences presented by virtual and stop-action puppets; thus, a distinction should be maintained between the automaton and all categories of puppet, with an automaton (whether controlled through animatronics or mechanics) being considered a kind of kinetic sculpture.

Tangible puppets, virtual puppets, stop-action puppets (and the use of animatronic controls for any or all of them as well): What, finally, is one to think of the art of puppetry in the age of media production? Back in the age of mechanical reproduction, Walter Benjamin's thoughts seem to have verged on the apocalyptic: he concludes his essay with the strong implication that mechanical reproduction is associated with fascism, and thus with war ([1933] 1969:241–42). While I am certain that media production is a function of, and an influence upon, contemporary society, I hesitate to draw any profound conclusions from its development. Rather, I think it has developed simply because its development was possible: artists saw some possibilities in the new media and rushed to take advantage of them, just as they have always done when presented with new possibilities.

Traditionalists such as Mark Levenson (at least in his formal role with UNIMA-USA) seem to fear for tangible puppetry in the face of the various kinds of media puppets, and so seek to maintain a sphere of exclusivity for it. Visionaries such as Stephen Kaplin are more sanguine. The new forms of puppetry, writes Kaplin, will not mean "death of traditional [forms of] puppetry," but will probably lead them to be "preserved for their historic, spiritual or folkloric value, like endangered species on a game preserve" (1994:39). Such preservation does not seem to me like a terribly happy fate; but neither does it seem likely. One is hard pressed to name three traditions of puppetry that have successfully been "preserved" after their audience has deserted them.[12]

In fact, however, I do not think that media puppetry spells the end of puppetry as we have known it. There is a pleasure still to be found in the live performance of a tangible puppet—the direct confrontation between an audience and a "living" object—that is distinct from the particular pleasures of media puppets. I foresee a future in which tangible puppets and media puppets can coexist, each stimulating and challenging the other. My virtual Hamlet is not itself of nature; neither, in its own way, would be a stop-action Hamlet. But both, just like a marionette Hamlet or, for that matter, a living Hamlet, serve the same essential function (albeit by differing means): not so much the holding up of a mirror to nature as the opening up of a window for human artistry.

Notes

1. I created this figure using a computer graphics program called Caligari truSpace; see <http://www.caligari.com/>, where a demonstration version of the program is available as of this writing (Caligari, Inc. 1997). A series of powerful computer graphics programs are also sold by Alias|Wavefront (1997). My discussion of computer graphics below has been greatly informed by the literature, available on the web, put out by these two companies, as well as by web literature from Silicon Graphics, Inc.

2. See my "The Actor Occluded: Puppet Theatre and Acting Theory" (Tillis 1996) for a discussion of signification siting.

3. See, for example, Weissberg (1996).

4. Although I speak of the model as being "three-dimensional," it should be understood that I refer to three dimensions within virtual, not real, space: the computer screen image of the model has, literally, only two dimensions.

5. By "gestural movement" I mean all movements that pertain to the "body" of the figure, from gross movements such as walking and jumping up and down to exceedingly fine movements such as the twitching of a muscle.

6. It might be noted that another approach to creating gestural movement from the keyboard involves defining certain closely related poses rather than actual movements. Using a shape-shifting program (such as the ones that are used for "morphing" one person's face into another's), these poses are then blended together in sequence to create the movement.

7. It is, perhaps, not surprising that a tension exists between practitioners of keyboard-generated movement and those who work with motion capture. Richard Cray, in a personal correspondence (1997), writes that Steph Greenberg, of Walt Disney Productions, has referred to motion capture as "Satan's Rotoscope."

8. Among the people (and companies) instrumental in developing performance animation, in addition to Silicon Graphics, are Brad deGraf (Protozoa), Michael Wharman and Chris Walker (Mr. Film/Modern Cartoons), David Sturman (Media Lab), and Mike Fusco (Simgraphics). Richard Cray's website for the Performance Animation Society (www.PASociety.org) has perhaps the fullest set of web-links available on the subject of performance animation.

9. I should at least note a pair of possible arguments concerning tangibility. It might be argued that computer graphics figures are not just like, but are the same as, shadow puppets—both being images on a screen—and that therefore there are no grounds for distinguishing at all between such figures and puppets. But contra this argument, while the shadows in shadow puppetry are indeed only images, the puppets in shadow puppetry are not the shadow images themselves, but the tangible puppets—the material entities—that are the direct referents of the shadows. Also, it might be argued that computer graphics are just like tangible puppets after all, since they are predicated on the tangibility of the computer screen or the projector screen. But contra this argument, neither of these screens is actually the computer graphics figure; they are only the tangible surfaces by which the puppet—which itself has only a virtual "existence" as a computer code—is made visible.

10. The origin of a real-time criterion for puppetry seems to have originated in a desire to distinguish between puppets and automata. See below for a discussion of this issue.

11. The overall effect of these distinctive aspects of fabrication is to allow the stop-action figure a far more detailed level of movement than is typical for even the most articulated marionette. One might note, however, that for all of the possible nuance of its movement, the stop-action figure will still lack the articulation of a well-designed computer graphics figure: Woody, in *Toy Story*, has a remarkable 712 avars (Pixar/Disney Pictures 1995:8).

12. Consider the fate of the karagöz shadow theatre, for example, despite the cultural preservation efforts of the Turkish government.

References

Alias | Wavefront, Inc.
1997 <http://www.aw.sgi.com>.

Anderson, Paul
1997 "Audio-Animatronics 101." <http://www.sgi.com/>.

Benjamin, Walter
1969 [1933] "The Work of Art in the Age of Mechanical Reproduction." In *Illuminations*, translated by H. Zohn, 217–51. New York: Schocken Books.

Burton, Tim
1993 *The Nightmare Before Christmas*. Touchstone Pictures.

Caligari, Inc.
1997 "On-Line Help for Caligari truSpace." <http://www.caligari.com/>.
Character Shop, Inc., The
1997 <http://www.character-shop.com/>.

Cray, Richard
1997 Personal correspondence with author. 8 September.

Disney Studios
1996 "*James and the Giant Peach*." *The Puppetry Journal* 47, 4:4–6.

Duncan, Jody
1997 "On the Shoulders of Giants." *Cinefex* 70:72–109.

Kaplin, Stephen
1994 "Puppetry into the Next Millennium." *Puppetry International* 1:37–39.

Lassiter, John
1995 *Toy Story*. Walt Disney Pictures.

Levenson, Mark
1992 "Memorandum re: Puppetry in Other Media." Unpublished paper presented to the Futurism Conference, San Luis Obispo, CA, 15 May.

Luskin, Jonathan
1997 "Protozoa and the Future of Performance Animation." *Innovation³*, Summer:48–51.

Pixar/Walt Disney Pictures
1995 "The Toy Story." *The Puppetry Journal* 47, 2:6–8.

Polhemus, Inc.
1997 <http://www.polhemus.com/>.

Pourroy, Janine
1997 "Basic Black." *Cinefex* 70:15–44, 155, 166.

Selick, Henry
1996 *James and the Giant Peach*. Walt Disney Pictures.

Silicon Graphics, Inc.
1997 <http://www.sgi.com/>.

Sonnenfeld, Barry
1997 *Men in Black*. Amblin Entertainment, Inc.

Spielberg, Stephen
1997 *The Lost World: Jurrasic Park*. Amblin Entertainment, Inc.

Tillis, Steve
1996 "The Actor Occluded: Puppet Theatre and Acting Theory." *Theatre Topics* 6, 2:109–19.

Touchstone Pictures
1994 "Stop-Motion Animation—Then and Now." *The Puppetry Journal* 45, 3:4–6.
1993 "*The Nightmare Before Christmas*." *The Puppetry Journal* 45, 2:2–4.

Weissberg, Jed
1996 "The Art of Puppetry in the Age of Digital Manipulation." *Puppetry International* 2:39–40.

Biographies

John Bell is a member of Great Small Works theater company and Assistant Professor of Performing Arts at Emerson College. He has worked with Bread and Puppet Theater since the 1970s.

Pyotr Grigor'evich Bogatyrev (1893–1971) cofounded the Moscow Linguistic Circle with Roman Jakobson in 1915, and later made major contributions to the Prague Linguistic Circle (or "Prague School"), which was active from 1926 until the late 1940s. Bogatyrev was particularly interested in the linguistic and physical aspects of folklore, specifically including puppet theater, folk costumes, games, songs, riddles, and carnivals.

Teresa Camou is a puppeteer and dancer from Chihuahua Mexico, who is currently a member of the Bread and Puppet Theater.

Stephen Kaplin designs, builds, performs and directs for puppet theater. He has built and/or performed in productions by Julie Taymor, Lee Breuer, George C. Wolfe, Theodora Skipitares, Bread and Puppet Theater, and others. He is co-artistic director of Gold Mountain Institute for Traditional Shadow Theater, technical director of Chinese Theatre Workshop, and a cofounder of Great Small Works.

Michele Minnick is a theatre director, producer, writer, teacher, performer and Russian translator. Translations include Chekhov's *Three Sisters* for East Coast Artists' production directed by Richard Schechner at La Mama, NYC, and Nikolai Erdmann's *The Suicide*, directed by Josh Tarjan at Columbia University. She has directed, performed, and taught workshops at La Mama, The Performing Garage, HERE and P.S. 122 in New York City, at Vassar, Dartmouth, Cornell, and Trinity Colleges, and at universities in Montreal and Belgrade, Yugoslavia. Michele is Producing Director of East Coast Artists, founded by Richard Schechner in 1991. She recently finished the certification program at the Laban/Bartenieff Institute of Movement Studies in NYC, and is currently getting her master's degree in Performance Studies at NYU.

Edward Portnoy is currently a PhD candidate in Modern Jewish Studies at the Jewish Theological Seminary in New York. He is writing his dissertation on Yiddish humor and satire journals published in New York and Poland from the turn-of-the-century to 1939. He received an MA in Yiddish Studies at Columbia University in 1997 with a thesis on the lives and work of artists/performers Zuni Maud and Yosl Cutler.

Salil Singh is a playwright, director, and actor who has several years of professional puppetry experience. His productions have ranged from opera to new plays and puppet theatre. In 1998 at the University of Texas at Austin he completed his dissertation on the performer's art in Tolpava Koothu. He is a cofounder and Artistic Director of Kathanjali Productions, through which he has recently written, codirected, and produced the documentary film *Borrowed*

Fire (2000), about the shadow puppetry of Kerala, India (http://www.kathanjali.com).

Richard Schechner is *TDR*'s Editor and University Professor and Professor of Performance Studies, Tisch School of the Arts, NYU. Schechner is also a theatre director, the founder of The Performance Group, and artistic director of East Coast Artists. His books include *Environmental Theater, Performance Theory, Between Theater* and *Anthropology,* and *The Future of Ritual.*

Peter Schumann founded Bread and Puppet Theater in New York City in 1963. After seven years of touring the company throughout New York City, the U.S., and Europe, Bread and Puppet moved to Vermont, where they are currently based. In Glover, the company continues to build and rehearse shows, organize parades, and to tour internationally. Among his many awards are two *Village Voice* Obies (1968 and '78) and a Guggenheim Fellowship (1986).

Theodora Skipitares is a multimedia artist and theater director who has been creating her works for over 20 years. She is the recipient of numerous awards, including Guggenheim, Rockefeller, and NEA Fellowships, as well as the American Theater Wing Design Award in 1999. In 2000, she was a Fulbright Fellow in India. Her work has been presented in the United States, Europe, and Asia.

Mark Sussman is a scholar, teacher, and artist living in New York City. A founding member of the Lower East Side collective Great Small Works, he most recently directed their adaptation of G.K. Chesterton's epic novel *The Man Who Was Thursday: A Nightmare.* His dissertation for NYU's department of Performance Studies is entitled "Staging Technology: Electricity and Modern Magic in the 19th Century."

Steve Tillis is the author of *Toward an Aesthetic of the Puppet* (Greenwood Press, 1992) and *Rethinking Folk Drama* (Greenwood Press, 1999). He received his PhD in Dramatic Art from the University of California, Berkeley, and currently is a fellow in the Humanities at Stanford.

Index